20th Century
Glass Candle Holders

Roaring 20's, Depression Era, and Modern Collectibles

Sherry Riggs & Paula Pendergrass

Schiffer Publishing Ltd

4880 Lower Valley Road, Atglen, PA 19310 USA

Dedication

This book is dedicated to the many authors who have documented the marvelously rich treasure of glassware produced by U.S. manufacturers.

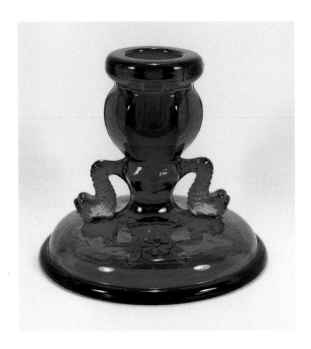

Designed by Anne Davidsen
Type set in Dutch801 SeBd BT/Lydian BT

ISBN: 0-7643-0748-7
Printed in China
1 2 3 4

Published by Schiffer Publishing Ltd.
4880 Lower Valley Road
Atglen, PA 19310
Phone: (610) 593-1777; Fax: (610) 593-2002
E-mail: Schifferbk@aol.com
Please visit our web site catalog at
www.schifferbooks.com

This book may be purchased from the publisher.
Include $3.95 for shipping. Please try your bookstore first.
We are interested in hearing from authors
with book ideas on related subjects.
You may write for a free catalog.

In Europe, Schiffer books are distributed by
Bushwood Books
6 Marksbury Rd.
Kew Gardens
Surrey TW9 4JF England
Phone: 44 (0)181 392-8585; Fax: 44 (0)181 392-9876
E-mail: Bushwd@aol.com

Contents

Acknowledgments

Collectors and Consultants:
C.J. Bodensteiner, Jackie Brown, Bill and Diane Haight, Sharon Hosack, Barbara Kane, Sim Lucas, Robert Meador, Janet and Dale Rutledge, Cheryl Sedlar, Pam Sherwood, Margaret Speight, Edna Staton, Matzi Thrasher, Susan Turner, David Vance, and Jean Westbrook.

Malls:
J.T. Texas, Tomball, TX; Sherry Riggs Antiques, Houston, TX; Sisters 2 Too, Alma, AR; Sweet Memories Antique Mall, Russellville, AR; The Antique Company Mall, McKinney, TX; Timely Treasures Antiques, Houston, TX; This and That and Something Else, Russellville, AR; and We Love Antiques, Dover, AR.

Technical Support:
Bill Belovicz; Ken Riggs; Heather Hawkins; Mark and Bridgitt Ussery: Express Foto, Russellville, AR; Wendolin Mercado: North Light Studio, McKinney, TX; and Ken Wallis and A. J. Pumphrey: Eckard Photo, Houston, TX. A special thanks to Ken Wallis for his continued enthusiasm and support.

Editorial Support:
The Schiffer Publishing Group and its staff; Peter Schiffer; and our editors, Donna Baker and Jennifer Lindbeck.

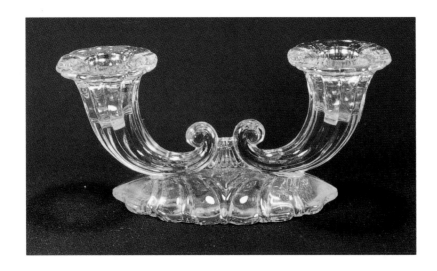

Introduction

The authors attempting to identify a foreign candle holder.

It's gorgeous! You love it. You bought it. Now, what is it? How much is it worth? Did you get a good buy? Here comes the frustration.

We decided to write this book after discovering how difficult candle holder identification can be. Many books written about a specific manufacturer show a limited number of candle holders; or, worse, they list them but do not show them; or they may show them, but not list them. Moreover, most glass manufacturers from the 1930s-70s are now out of business, making documentation of candle holder lines even more difficult.

At the turn of the 20th Century, there were very few candle holders, but beginning with the Depression Era, the popularity of candle holders blossomed. There are now literally thousands of candle holders on the market, not only from U.S. makers, but from other countries as well. Interestingly, lead crystal has not been manufactured in the U.S. since the mid-1980s because of OSHA (Occupational Safety and Health Administration) regulations; consequently, items marked 'Lead Crystal' are either from existing warehouse inventories or have been imported from other countries, primarily countries in Europe. In addition to candle holders and candlesticks, many votives of very good quality are popular, along with toothpick holders, which are often sold as votives. Another popular trend now is toward bases or platforms for large, wide pillar candles. Some manufacturers

are redesigning their ashtray molds as pillar bases, and large crystal and colored ashtrays are being purchased to hold pillar candles.

With so many antique and collectible candle holders available, you may find yourself buying new books to identify just one or two new purchases. However, through this new book, we make it possible for you to cut down on the expense required for the identification of candle holders, especially those that are U.S. made and commonly found in malls and antique shops. So, now with candle holder identification easier than ever, good hunting, and good luck!

Using This Book

The candle holders in this book are primarily from U.S. manufacturers with emphasis also placed on more commonly found items that are representative of the entire 20th Century. Identification of U. S. candle holders is based on published data, manufacturers' marks, and affixed labels. The prices of the items featured are moderate in range with affordable candle holders for beginners and experts alike.

The candle holders are organized alphabetically by maker. The general progression is from shorter to taller, and from single to double and triple candle holders; however, similar candle holders have been grouped by line number or by style in many places.

All measurements in this book are actual measurements of the candle holders shown, not catalog listings. A **word of caution**: candle holders from the same line commonly vary \pm 0.5 inches; so a candle holder described in the literature as being 3" could be as short as 2.5", while another one could be as tall as 3.5". (Here's a **tip** from Sim Lucas: if you don't have a tape measure, you can use a dollar bill which is 6" long on the button!)

Since some molds have changed hands many times, it is not always possible to identify the maker except when a particular color or pattern appears. Where possible, we have identified the manufacturer that actually sold the candle holder. However, we are well aware that our information is incomplete, and hope that knowledgeable readers will share identifying information with us. We have indicated when possible if an item is marked. With so many candle holders being reissued, a mark can sometimes be used to verify the actual manufacturer and therefore the age of the candle holder; importantly, the presence or absence of a mark can change the value of a candle holder substantially.

A **bobeche** is a ring placed or molded around the base of the light; prisms are generally attached. For consistency, we have used the term '**candelabra**' to refer to holders with bobeches and prisms attached. The term '**luster**' refers to candle holders with a molded bobeche. An **epergne** is a vase that fits into the light, in place of a candle. A **nappy** is a candle dish with a handle.

Many candle holders have identifiable etchings or cuttings. An **etching** is a roughened surface pattern usually created by sandblasting or application of acid. A **cutting** is engraved into the glass with a sharp instrument.

Prices in this book are intended as a guide only. We have suggested prices based on: 1) Actual prices in malls, primarily in the mid-south; 2) Price guides from nationally published glassware books; 3) Price guides from glass club publications; 4) Prices at glass shows and auctions; and 5) Advice from individual expert collectors and dealers. Dates in this book are based on published material and on the presence of items in outlets.

Prices are given as a suggested range for mint condition items, with the upper price pertaining to the most desirable colors and/or treatments. Please note that regional differences cannot be accounted for and that future values cannot be predicted from our guide.

Candleholders From A to Z

A & A Imports

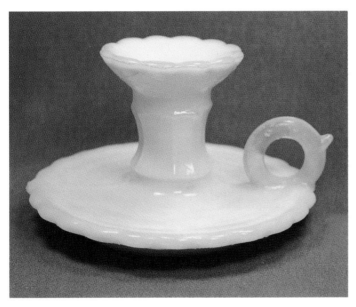

A & A Imports 3.25" single light chamber stick. Pink milk glass, cobalt, crystal: $15-17 each. (1990s).

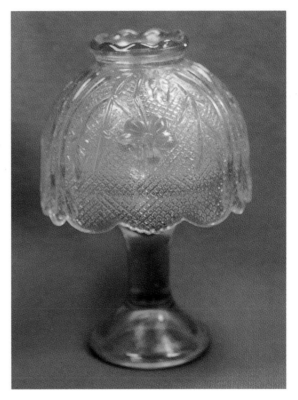

A & A Imports 6" single light candle globe. Pink, crystal: $7-9 each. (1990s).

Avon

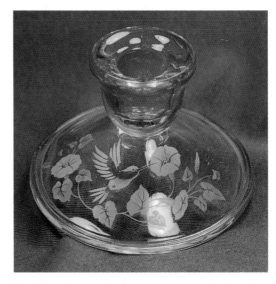

Avon 2.5" 'Hummingbird' single light candle holder. Crystal: $8-10 each. (1987).

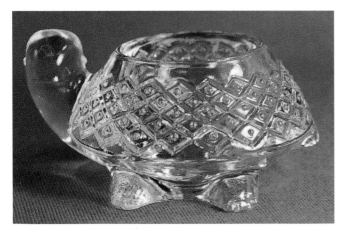

Avon 2" 'Sparkling Turtle' votive. Crystal: $6-9 each. (1978-79).

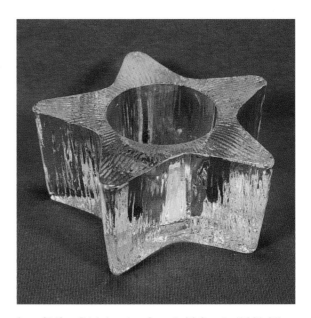

Avon 2" 'Star Bright' votive. Crystal: $6-9 each. (1980-81).

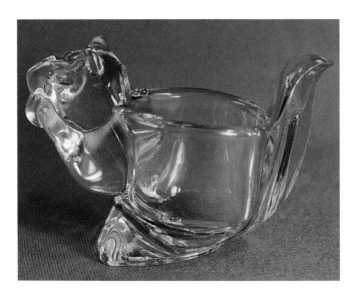

Avon 3" 'Bright Chipmunk' votive. Crystal: $6-9 each. (1978-79).

Avon 3.5" 'Buccaneer' single light votive. Crystal: $6-9 each.

Avon (by Fostoria) 4.5" 'Coin Glass' single light candle holder. Crystal with Avon motifs: $35-40 pair. (1961-77).

Avon 4" 'Crystal Glow' votive. Crystal: $9-11 each. (1972-73).

Avon 4.125" 'Personally Yours' candle block. Crystal: $11-13 each. (1980-82).

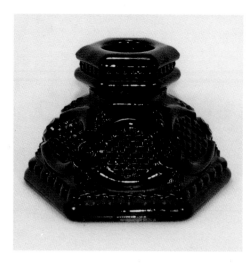

Avon 2.25" 'Cape Cod' single light candle holder. Red only: $15-20 pair. (1983-84).

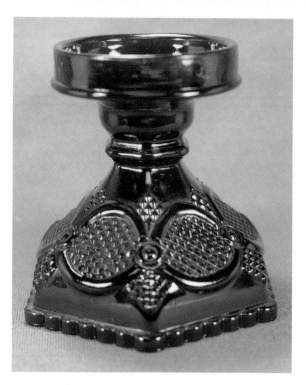

Avon 4.25" 'Cape Cod' hurricane lamp base. Red only: $22-25 pair; with globe: $25-30 pair. (1985).

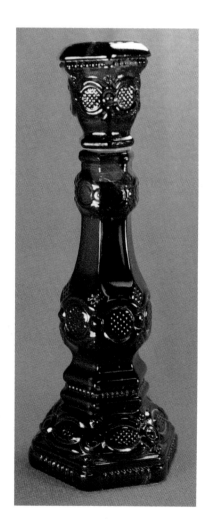

Avon 8.5" 'Cape Cod' single light candlestick. Red only: $20-25 pair. (1975-80).

Avon 5.375" dual candle holder/vase. Crystal: $6-9 each.

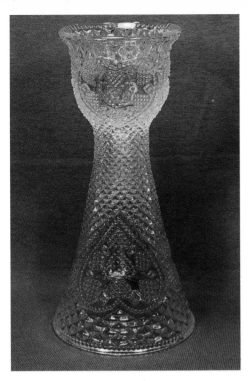

Avon (by Fostoria) 7" 'Heart & Diamond' single light candlestick. Crystal: $14-16 each. (1978-79).

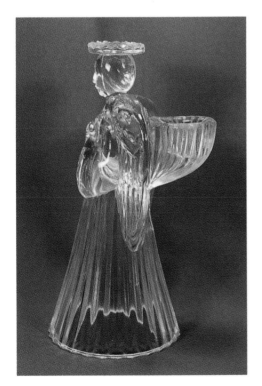

Avon 7.25" 'Glowing Angel' single light candle holder. Crystal: $15-18 each. (1992).

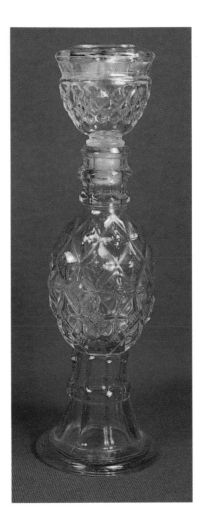 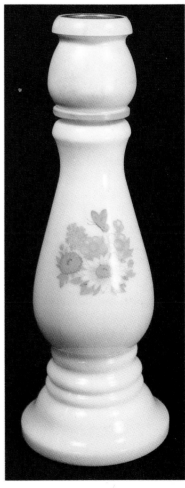

Avon 8.25" 'Regency' single light candlestick. Crystal: $9-11 each. (1973-74).
Avon 7.5" 'Buttercup' single light candlestick. Milk glass: $7-9 each. (1974-75).

Cambridge

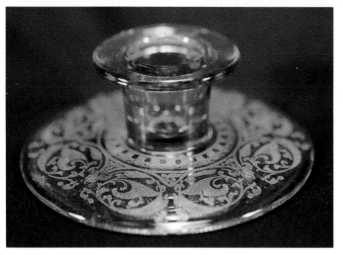

Cambridge 1.5" #227-1/2 single light candle holder. Amber with #704 etching, topaz: $38-42 pair. (1920s).

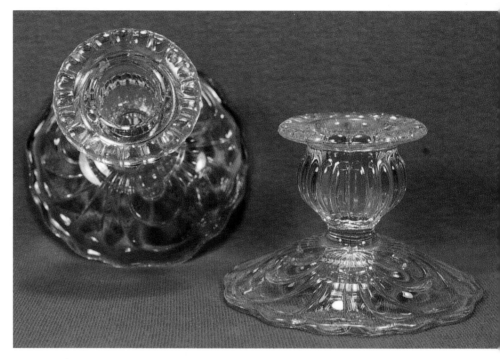

Cambridge 2.5" #67 'Caprice' single light candle holder. Crystal: $14-16 each; moonlight blue: $32-35 each; la rosa: $28-32 each.

Cambridge 1.375" #1715 single light dual candle holder/ashtray. Emerald green, Mandarin gold: $18-20 each. (c.1949-1958).

Cambridge 1.75" #492 'Square' line #3797 single light candle block. Crystal: $12-15 each; black: $15-18 each. Also in 2.75"(#493) (crystal: $13-16 each; black: $19-22 each) and 3.75" (#495) (crystal: $15-18 each; black: $22-25 each; Mandarin gold: $26-29 each). (c.1949-mid 1950s).

Cambridge 3" #67 'Square' line #3797 single light candle holder. Crystal: $28-32 pair; crystal with etching: $35-40 pair; red, ebony: $45-50 pair. (c.1949-mid 1950s).

Cambridge 3.25" #628 single light candle holder with embossed laurels. Pink, colors: $30-35 pair; crystal: $25-30 pair.

Cambridge 3.25" #628 single light candle holder. Dark amber, colors: $25-30 pair; crystal: $15-20 pair.

Cambridge 3.25" #628 single light candle holder. Cobalt, crystal with etching, pastels, colors: $25-30 pair; pastels with etching: $45-50 pair; crystal: $15-20 pair.

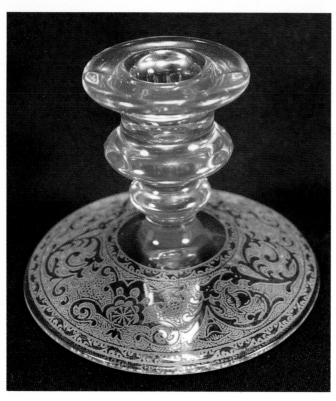

Cambridge 3.125" #628 single light candle holder. Green or pink with heavy #726 etching: $45-50 pair.

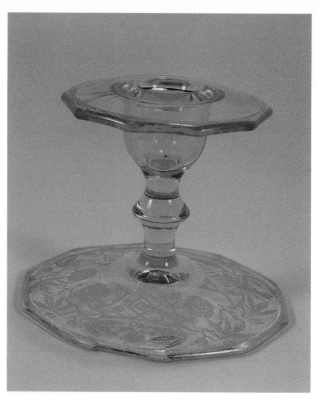

Cambridge 3.75" #878 decagon single light candlestick. Green with #731 etching, colors: $45-50 pair; crystal: $35-40 pair.

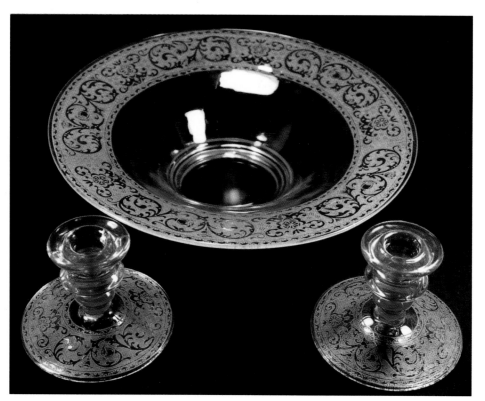

Cambridge console set: $100-110.

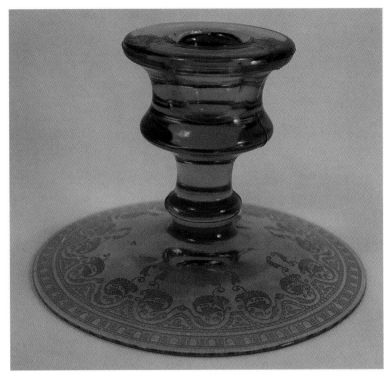

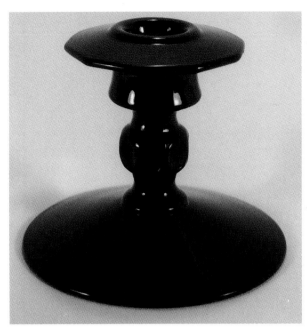

Cambridge 3.25" #628 single light candle holder. Blue with heavy #704 etching: $45-50 pair.

Cambridge 3.75" #727 Single light thumbprint candle holder. Black: $25-28 each; pastels: $20-23 each; crystal: $15-17 each. (1927-1936).

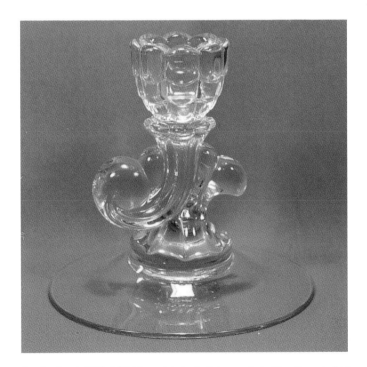

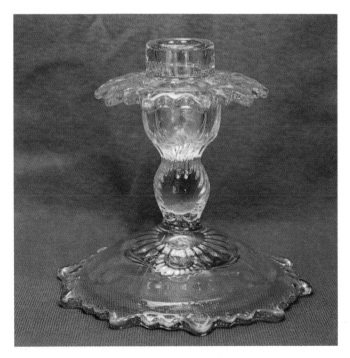

Cambridge 4.625" #67 'Cascade' single light candle holder. Crystal: $15-17 each; colors: $30-35 each; white milk glass: $35-38 each.

Cambridge 5" #617 'Martha' hurricane base single light candle holder with lip for hurricane globe. Crystal: $25-30 each.

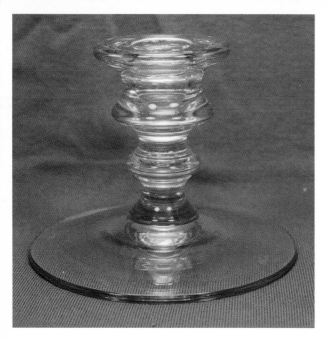

Cambridge 4.75" #628 single light candle holder used as 'Cambridge Arms' base. Crystal: $15-20 each.

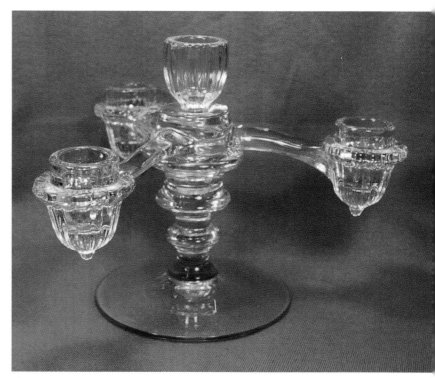

Cambridge 4.75" #628 single light candle holder assembled with 'Cambridge Arms'. Crystal: $40-50 each.

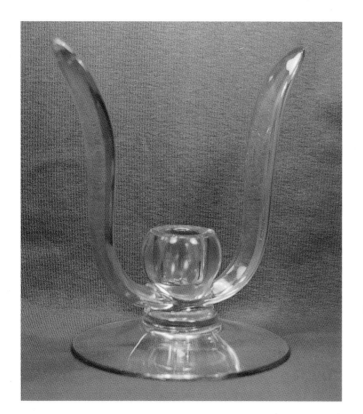

Cambridge 6.75" #500 'Pristine' single light candle holder. Crystal: $15-18 each; moonlight blue: $20-25 each.

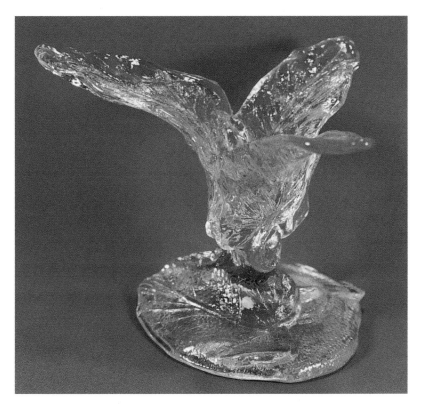

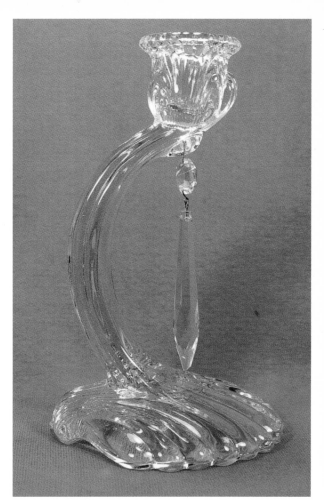

Cambridge 5.5" #32 'Everglade' single light candlestick. Crystal: $25-30 each; colors: $70-80 each.

Cambridge 7" #70 'Caprice' single light candelabra. Crystal: $24-27 each; moonlight blue, la rosa: $60-65 each.

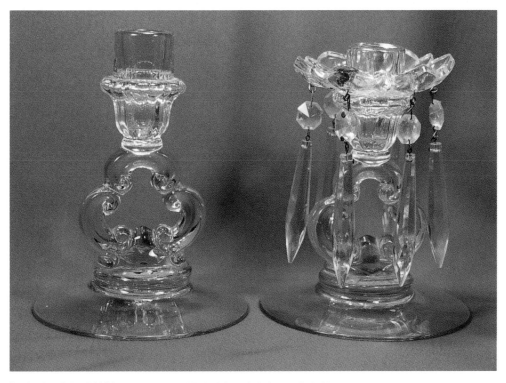

Cambridge 6.5" #1603 hurricane base 'Keyhole' single light candle holder with bobeche lip. Crystal: $35-40 each; colors/no lip: $32-37 each; crystal/no lip: $16-20 each. **Note:** Add $20-25 for each bobeche with prisms.

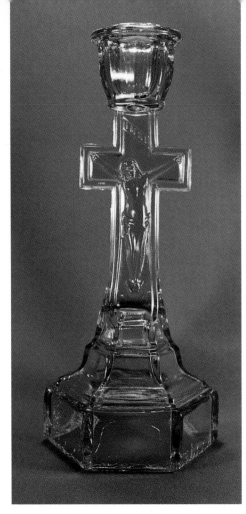
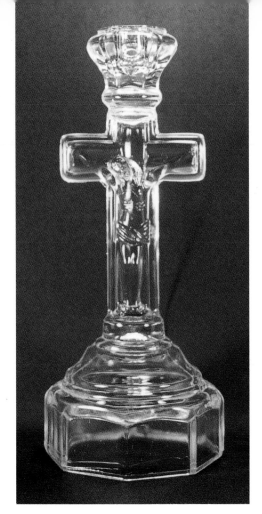

Cambridge 9.625" single light crucifix candlestick.
Pale lavender: $65-70 each.

Cambridge 9.5" #1602 single light crucifix candlestick.
Crystal: $60-65 each.

Cambridge console set with 7.75" #2862 single light candle holders and
console bowl: $100-120.

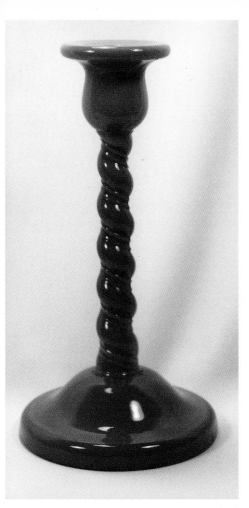 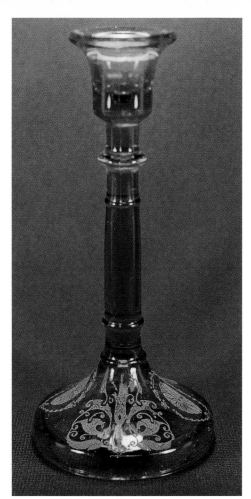 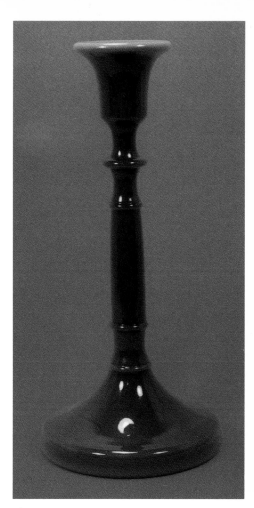

Left: **Cambridge** 8.375" 'Twist' single light candlestick. Jade, opaque colors: $35-40 each; transparent colors: $40-45 each.

Center: **Cambridge** 7.5" single light candlestick. Amber with #732 etching: $65-70 pair; transparent colors: $65-90 pair; rubina: $190-200 pair. Also made in 8.5", 9", and 11".

Right: **Cambridge** 9" single light candlestick. Helio (pale purple opaque): $250-265 pair; black, avocado opaque: $100-110 pair; primrose opaque: $250-265 pair.

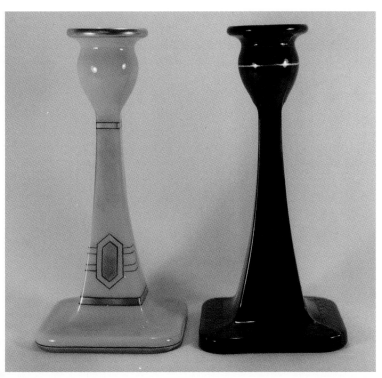

Cambridge 7.125" #200/2 single light candlestick. Primrose with gold, black with gold, helio (pale purple opaque): $32-35 each; carrara (white) opalescent: $45-50 each.

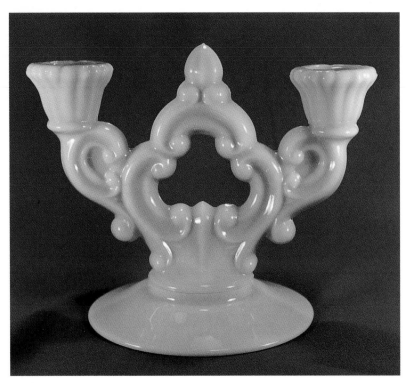

Cambridge 5.875" #647 double light candelabra. Crown tuscan, Windsor blue: $130-140 each; ebony and transparent pastels: $65-70 each; crystal: $20-25 each.

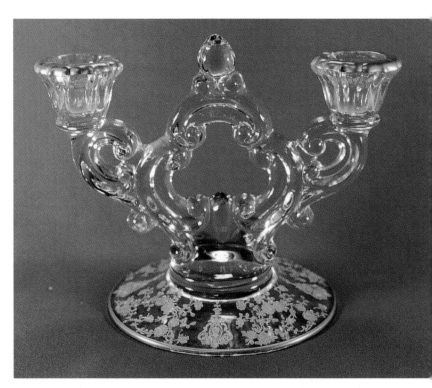

Cambridge 6" #647 'Keyhole' double light candelabra. Crystal with gold 'Rose Point' deposit: $240-250 pair.

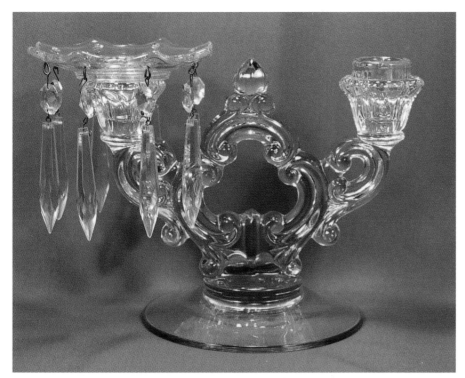

Cambridge 6" #647 'Keyhole' double light candelabra with single bobeche. Crystal: $45-50 each (add $25 for each bobeche with prisms); crystal without bobeches: $20-25 each.

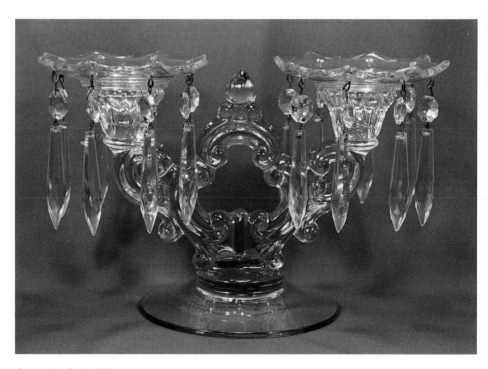

Cambridge 6" #1268 double light candelabra. Crystal with #19 bobeches and #1 prisms: $75-80 each . (Candle holder is #647). (1936-1945).

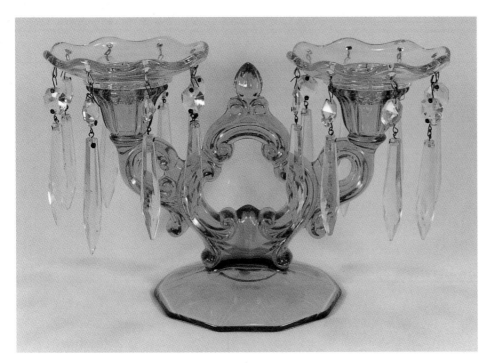

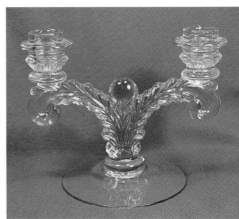

Cambridge 6.5" #647 double light candelabra with decagon base and locking bobeches. Amber: $115-125 each.

Cambridge 6.5" #495 'Martha' double candle holder. Crystal: $25-30 each; moonlight blue: $35-40 each.

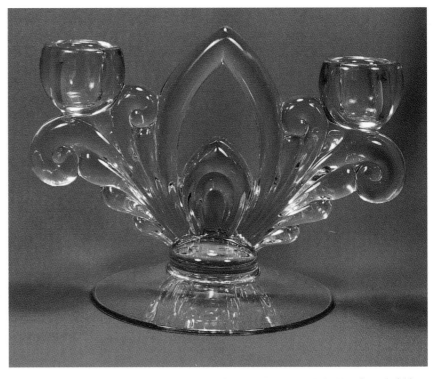

Cambridge 6" x 10" #78 'Caprice' double candle holder with bobeche rims. Crystal: $40-45 each. (1941-1945).

Cambridge 6" x 8.25" #72 'Caprice' double candle holder. Crystal: $40-45 each; moonlight blue, la rosa: $90-95 each. (1941-1954).

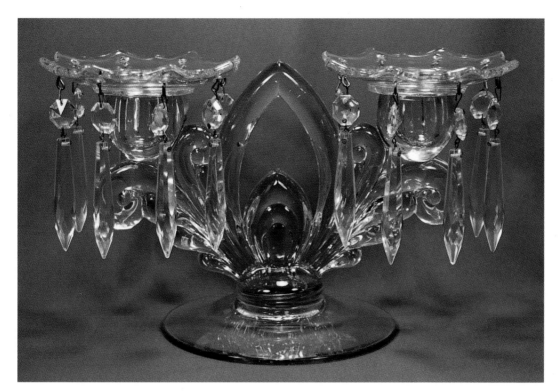

Cambridge 6" x 10" #78 'Caprice' double candle holder. Crystal with bobeches and prisms: $80-95 each; moonlight blue, la rosa: $140-150 each. (1941-1945).

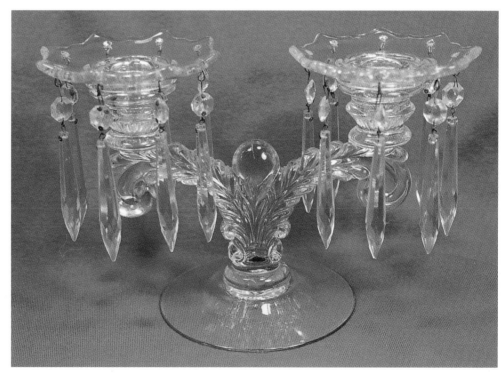

Cambridge 6.5" #496 'Martha' double candelabra. Crystal: $75-80 each.

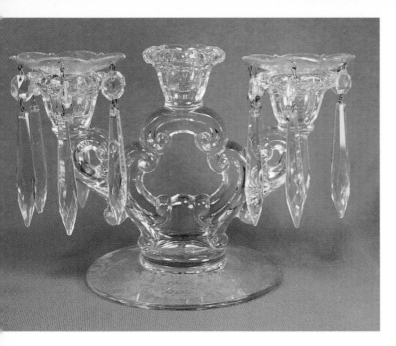

Cambridge 5.75" #638 triple light candelabra. Crystal with #748 'Lorna' etching: $85-90 each. Here Cambridge used the same blank as for #1307, but added different etchings for several lines.

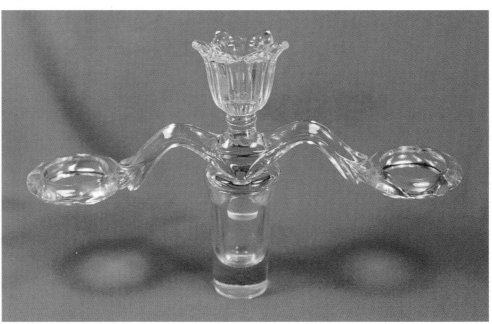

Cambridge 4" 'Candle Arms' (on shot glass support). Crystal: $20-25 each.

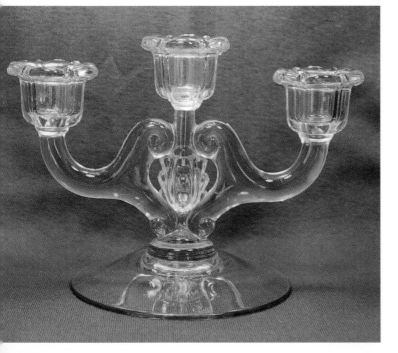

Cambridge 5.375" #74 'Corinth' line #3900 triple light candle holder. Crystal: $30-35 each.

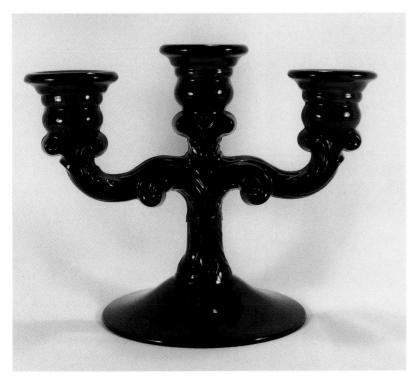

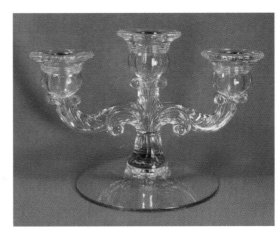

Cambridge 6.125" #1307 triple light candle holder. Royal blue, crown tuscan: $130-140 each.

Cambridge 4.25" #1307 triple light candelabra blank. Crystal: $40-45 each; transparent pastels: $65-70 each. (1936-1953).
(A blank is an undecorated piece that once decorated is part of an identifiable line. They are usually limited to one pattern, but not always.)

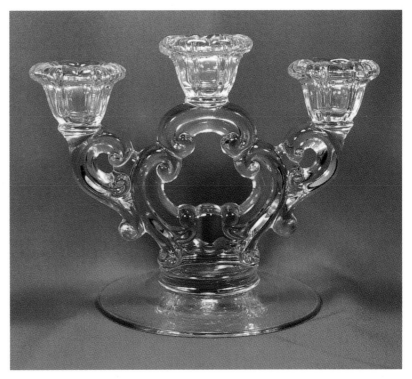

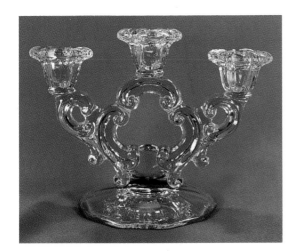

Cambridge 5.875" #638 triple light candelabra with decagon base. Peach-blo, transparent colors: $45-50 each; crystal: $25-30 each. (1920s-1930s).

Cambridge 6" #638 triple light candelabra with round base. Crystal: $25-30 each. (1939-1945).

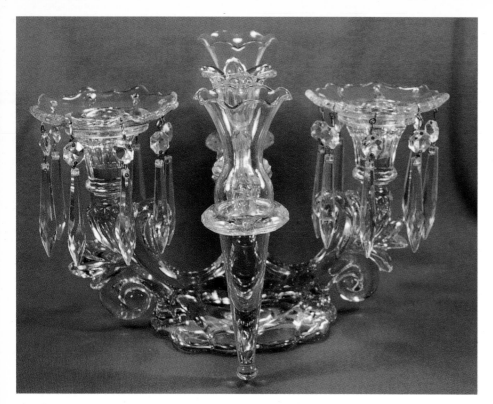

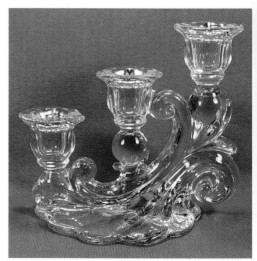

Cambridge 8.25" #1357 'Caprice' triple light epergne. Crystal with #1438 arm, #1358/8 vases, #19 bobeches, and #1 prisms: $200-225 each. (Vases vary from 6"-8".)

Cambridge 6" #1338 'Caprice" tiered triple light candle holder. Crystal: $42- 47 each; moonlight blue: $ 75- 80 each; Mandarin gold: $55- 60 each; royal blue: $ 100- 110 each.

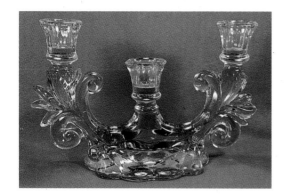

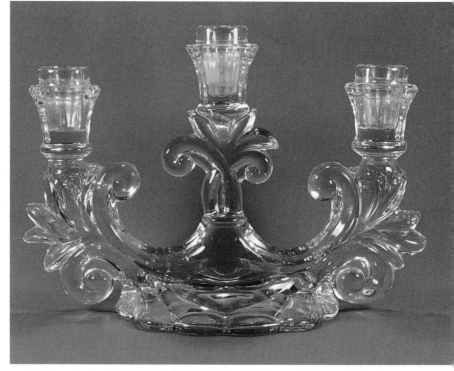

Cambridge 6.5" #1357 'Caprice' triple light candelabra. Crystal: $90-95 each.

Cambridge 8" #1458 'Caprice' triple light candelabra with bobeche rims. Crystal: $100-110 each.

Castle Imports

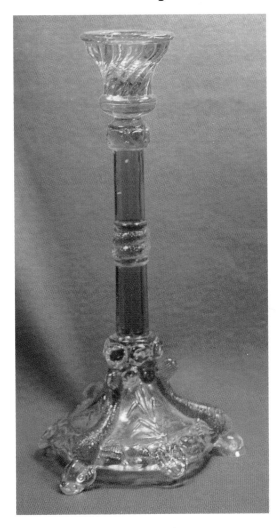

Castle Imports 9.125" dolphin single light candlestick. Pink: $35-40 pair. (1990s).

Consolidated Glass

Consolidated Glass 3.125" #1124 'Catalonia' single light candle holder. Yellow: $40-45 pair.

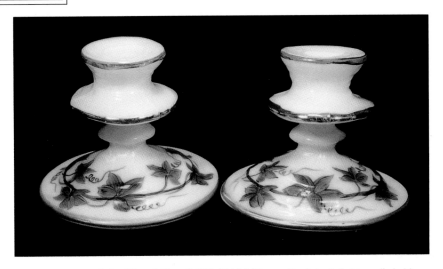

Consolidated Glass 3.25" #1124 'Regent Line' single light candle holder. White milk glass with #1330 decoration and gold edging: $35-40 pair.

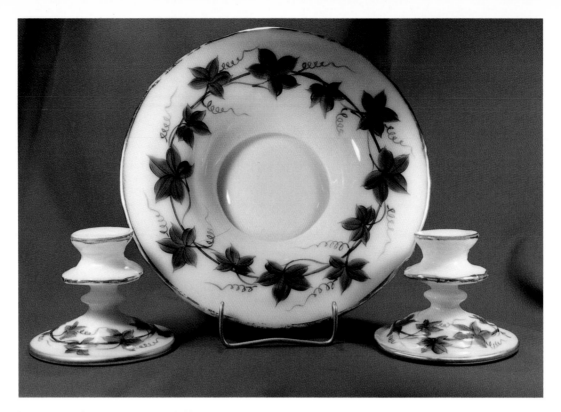

Consolidated Glass console set: $70-80.

Czechoslovokia

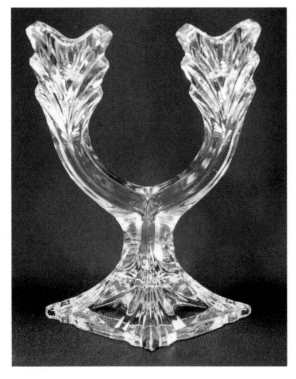

Czechoslovokia 6.875" double light candle holder. Lead crystal: $18-20 each.

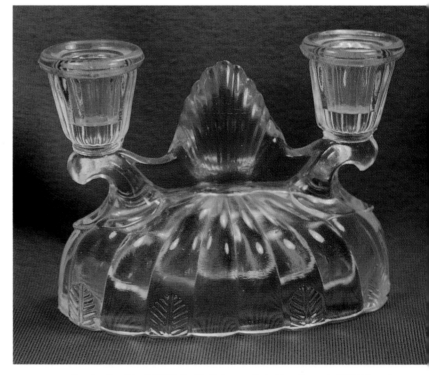

Czechoslovokia 4.375" double light candle holder. Crystal: $15-20 each.

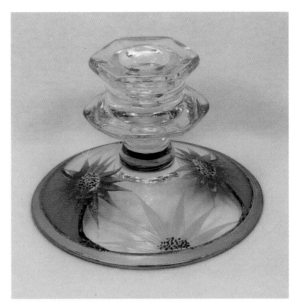

Diamond

Diamond 2.875" #713 candle holder. Crystal with hand decoration; blue, yellow, plum/black/gold: $45-50 pair. (1920s). **Note:** Both the top and bottom rims of the light are hexagonal.

Diamond 3" #713 single light candle holder. Crystal with gold and orange on both top and bottom of base: $45-50 pair. (1920s).

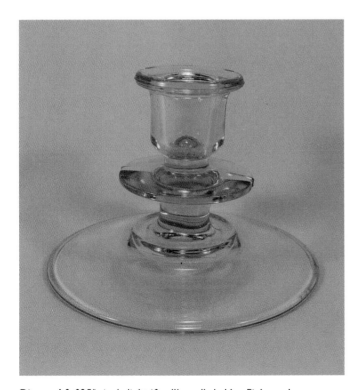

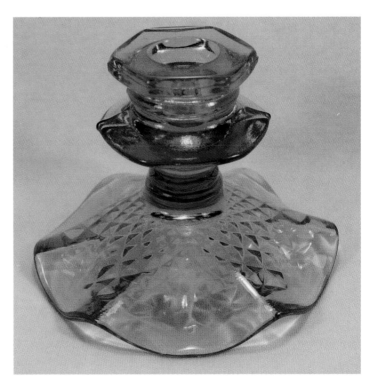

Diamond 3.625" single light 'Small' candle holder. Pink, apple green, amber: $35-40 pair; crystal: $30-35 pair. **Note:** The step in the base is shorter than Indiana's.

Diamond 3.25" #713 single light candle holder. Green: $45-50 pair.

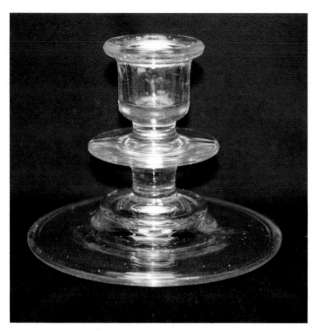

Diamond 3.625" single light 'Small' candle holder. Apple green: $35-40 pair.

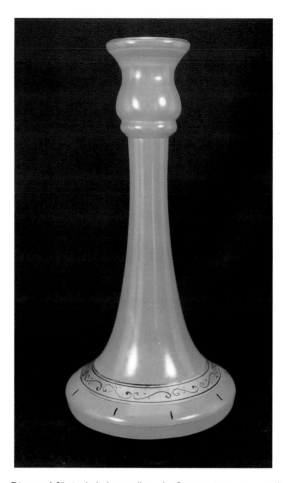

Diamond 9" single light candlestick. Green paint over crystal with black/gold decal: $35-40 pair; green, blue, orange, blue/lavender: $60-70 pair.

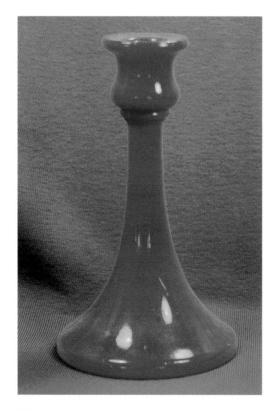

Diamond 6.375" single light candlestick. Pumpkin, jade: $60-65 pair.

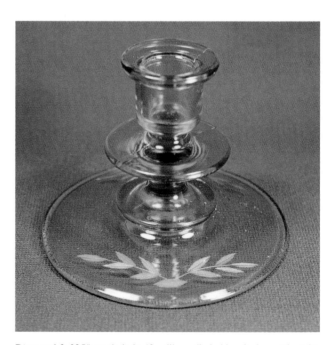

Diamond 3.625" single light 'Small' candle holder. Amber with etching: $35-40 pair.

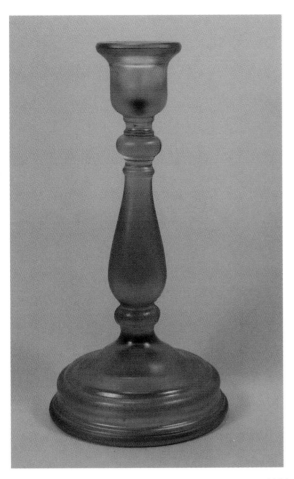

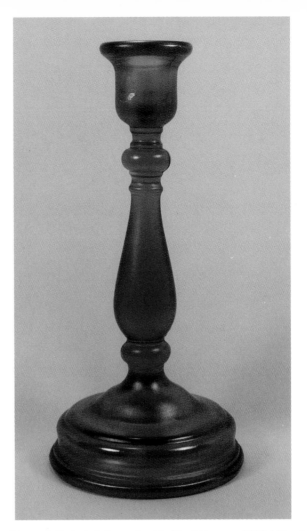

Diamond 9" single light candlestick. Green iridescent, blue iridescent: $100-110 pair; pink iridescent ('After Glow'): $95-100 pair.

Diamond 9" single light candlestick. Blue iridescent: $100-110 pair.

Duncan Miller

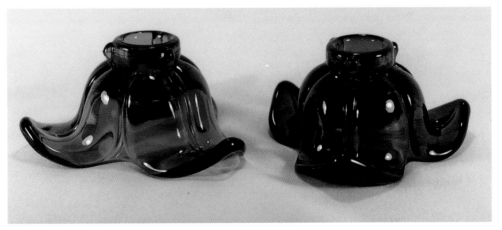

Duncan Miller 2" #71-D 'American Way' single light candle holder. Green: $30-35 pair; red: $45-50 pair.

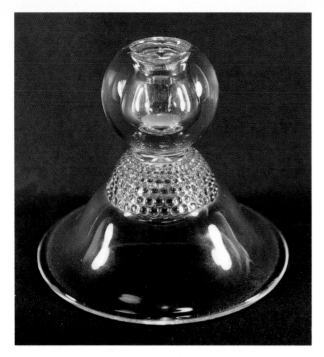

Duncan Miller 3.75" #301 'Teardrop' single light candle holder. Crystal: $30-35 pair.

Duncan Miller 3" #111 'Terrace' low candlestick. Crystal with or without etching: $50-55 pair; cobalt or red without etching: $130-140 pair. (1937).

Duncan Miller 4.25" #41 'Sandwich' single light candle holder. Crystal: $50-55 pair.

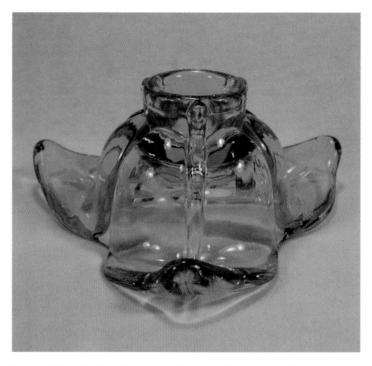

Duncan Miller 2" #71-D 'American Way' single light candle holder. Chartreuse, green: $30-35 pair; crystal: $25-30 pair; crystal satintone, ruby: $45-50 pair.

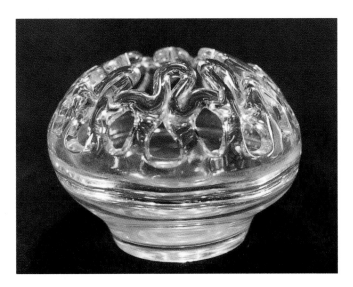

Duncan Miller 3.5" x 5" #127 'Murano' single light crown candlestick. Crystal: $15-20 each; colors: $20-25 each; opalescents: $30-35 each.

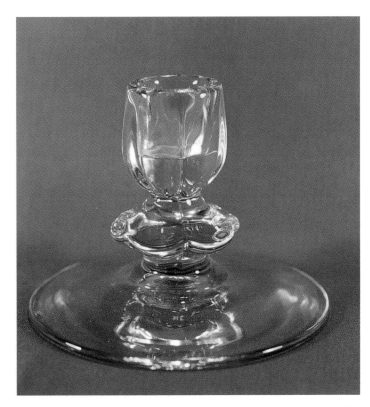

Duncan Miller 3.25" #115 'Canterbury' single light candle holder. Crystal: $12-15 each; colors: $28-32 each; opalescents: $40-45 each.

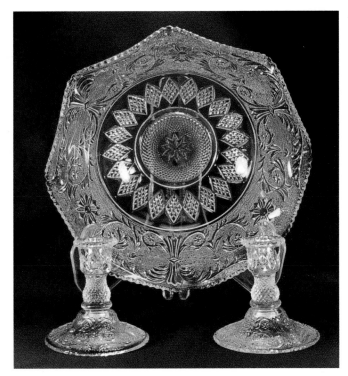

Duncan Miller console set: $95-110.

Duncan Miller 3.375" #118 'Hobnail' single light candle holder. Amber, blue, pink, crystal opalescent: $25-30 each; crystal: $14-19 each; white milk glass (#718-25): $22-27 each; pink opalescent, blue opalescent: $30-35 each.

Duncan Miller 8" #14 'Betsy Ross' single light candle holder. Satin with yellow, green, and rose accents: $65-70 pair.

Duncan Miller 8" #14 'Betsy Ross' #709 single light candle holder. Crystal: $60-65 pair; white milk glass: $55-60 pair; satin: $65-70 pair.

Duncan Miller 7.5" #14 single light lustre candlestick. Crystal: $65-70 each. **Note:** Compare to L.E. Smith's #1/18 lustre and variations.

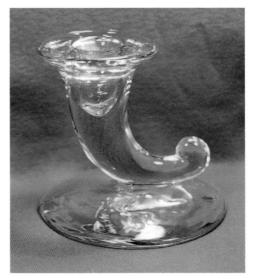

Duncan Miller 3.75" cornucopia single light candle holder. Crystal: $25-30 pair.

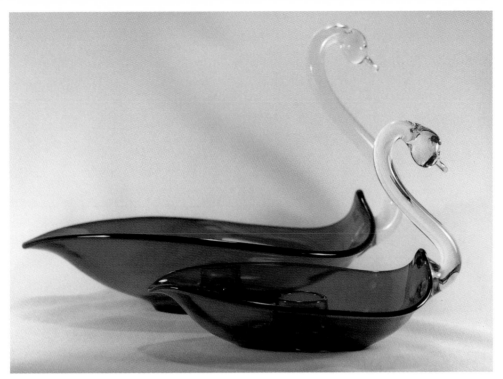

Duncan Miller 5.25" x 7.75" and 8.875" x 12" #30 'Ruby Swan' single light candle holders. Ruby/crystal: smaller: $95-105 each; larger: $200-215 each. (In 1943 catalog).

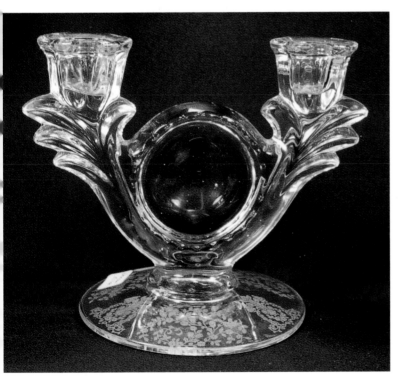

Duncan Miller 4.75" #30 double light candle holder. Crystal with 'Adoration' etching and bobeches: $110-120 each; crystal without etching/with bobeches: $95-100 each; crystal: $45-50 each; crystal with etching: $55-60 each.

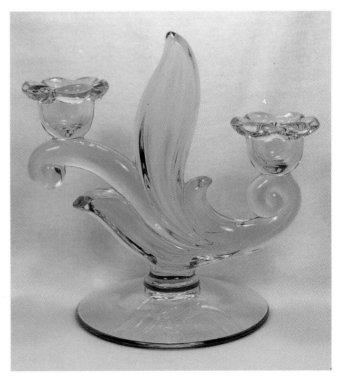

Duncan Miller 7" #115 'Canterbury' double light candelabra. Chartreuse: $45-50 pair; crystal: $40-45 pair.

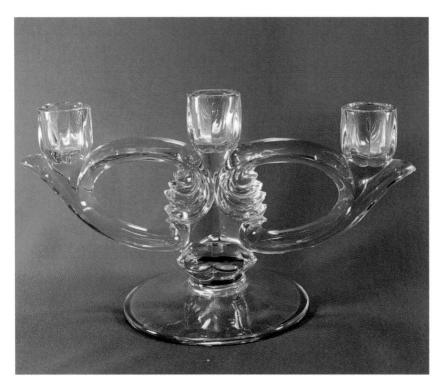

Duncan Miller 6.25" x 10" #115 'Canterbury' triple light candelabra. Crystal only: $50-60 pair. (c.1948).

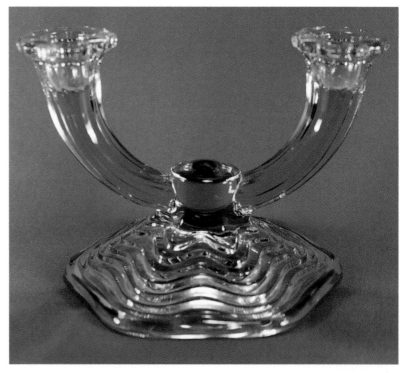

Duncan Miller 4.75" #112 'Caribbean' double light candle holder. Crystal: $40-45 each; crystal with bobeches: $95-100 each; light blue: $80-85 each; light blue with bobeches: $135-140 each.

England

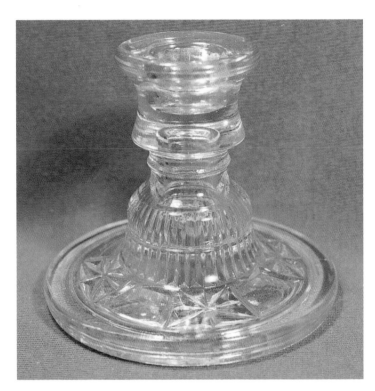

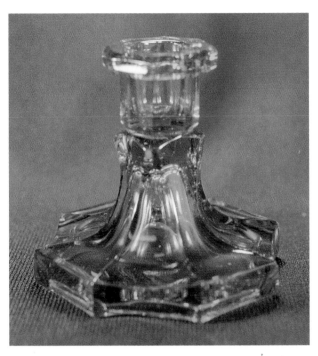

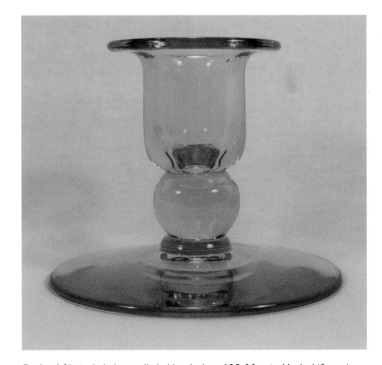

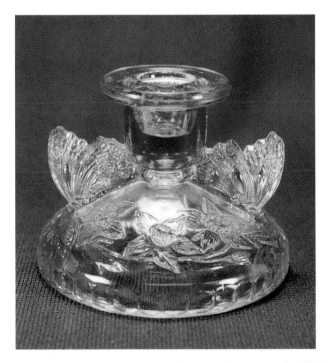

England 3.5" single light candle holder. Amber: $25-30 pair. Part of a dresser set.

England 3.75" single light candle holder. Crystal: $8-12 pair. Part of a dresser set.

England 3" single light butterfly candle holder. Amber, crystal: $25-30 pair. Part of a dresser set.

England 3" single light candle holder. Amber: $25-30 pair. Marked 'Stuart' on bottom of base.

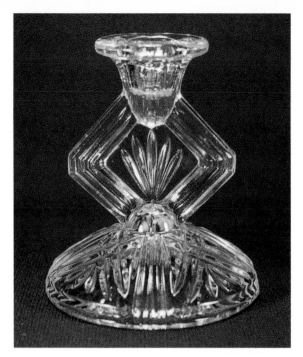

England 4.5" single light candle holder. Crystal: $10-15 pair. Part of a dresser set.

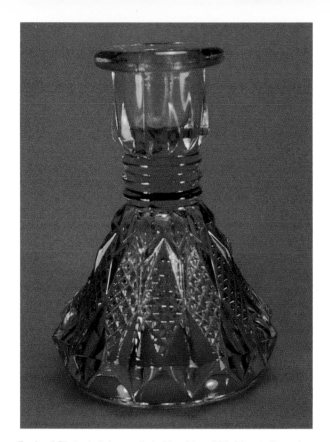

England 5" single light candle holder. Blue: $25-30 pair. Part of a dresser set.

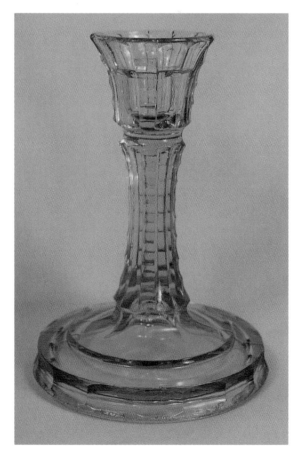

England 5.25" single light candle holder. Blue: $25-30 pair. Part of a dresser set.

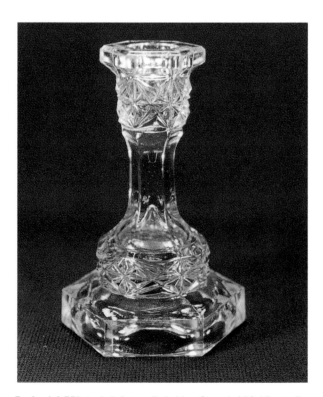

England 4.75" single light candle holder. Crystal: $10-15 pair. Part of a dresser set.

Federal

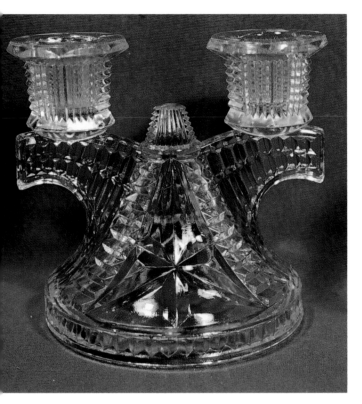

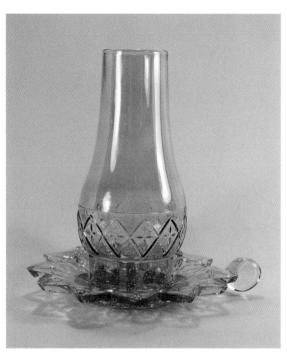

Federal 5.25" 'Petal' line #2829 mini hurricane lamp with globe. Amethyst, yellow: $18-20 each; crystal: $12-14 each. (1950s-1970s). The lamp base is easy to find, but the globes are scarce.

Federal 4.5" #2826 often called 'Wigwam' or 'Windmill' double light candle holder. Crystal $20-25 pair; pink: cannot price. (1936-1939).

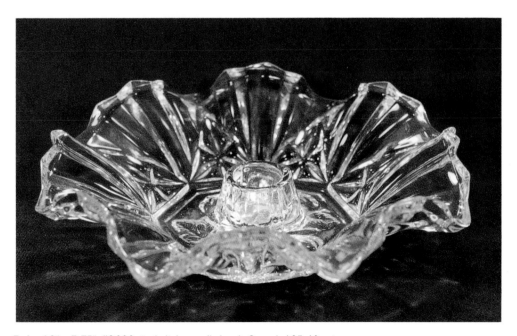

Federal 2" x 7.75" #2806 single light candle bowl. Crystal: $35-40 pair. (1941).

Fenton

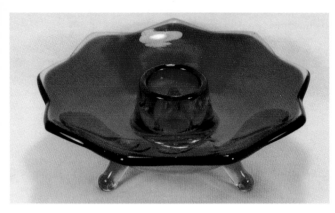

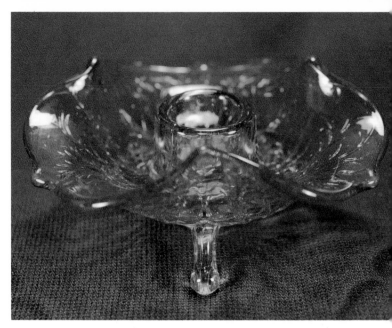

Fenton 1.625" x 4.5" #848 three-footed candle saucer with nine points. Ruby, crystal, jade, black: $11-15 each; moonstone, royal blue, green transparent, Chinese yellow: $20-25 each. (1933-1936).

Fenton for F.W. Woolworth 1.75" #1010 'Silvertone' three-footed single light candle holder. Amber: $40-45 pair; crystal: $30-35 pair; wisteria: $50-55 pair.

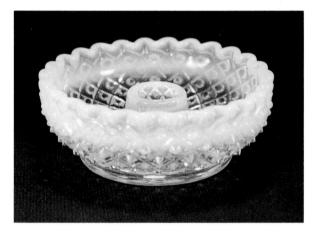

Fenton 1.25" x 5.125" single light base for hurricane lamp #389. Moonstone: $15-20 each. Complete with globe: moonstone: $50-55 each; white milk glass: $40-45 each; peach blo: $75-80 each.

Fenton 1.5" #1984 'Diamond Lace' single light candle dish. French opalescent: $50-55 pair; blue opalescent: $65-70 pair. (1949-1953).

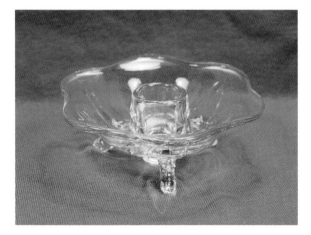

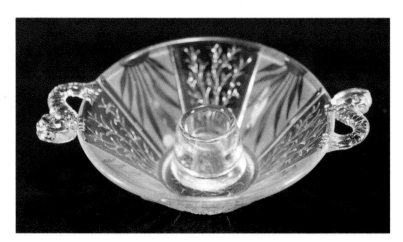

Fenton 2" #848 single light footed candle dish with six points. Crystal: $8-11 each; black, jade, ruby: $11-15 each; moonstone, transparent green, Chinese yellow, royal blue: $20-25 each.

Fenton 1.625" #1621 single light candle holder with dolphin handles. Crystal with satin decoration: $22-25 each; royal blue: $32-35 each. (1936).

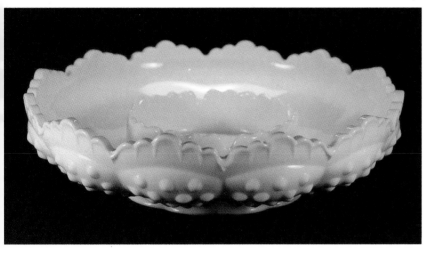

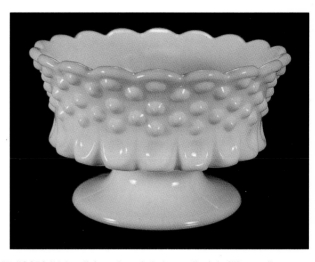

Fenton 2.25" x 8" #3748 'Hobnail' single light candle bowl. White milk glass: $20-25 each.

Fenton 2.25" #3673 'Hobnail' footed single light candle dish. White milk glass: $40-45 pair.

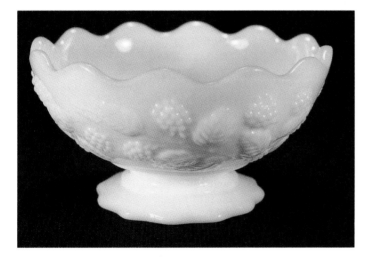

Fenton 2.25" 'Little Berries' footed single light candle dish. White milk glass: $40-45 pair.

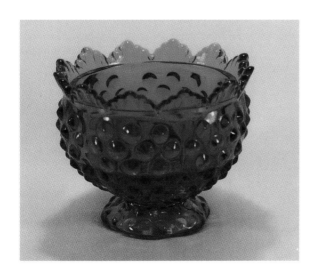

Fenton 3.25" #3873 'Hobnail' miniature single light candle bowl. Colonial blue, colonial amber, colonial green: $10-12 each; white milk glass: $22-24 each.

Fenton 2.5" x 4" #3873 'Hobnail' single light candle holder. White milk glass: $22-24 each.

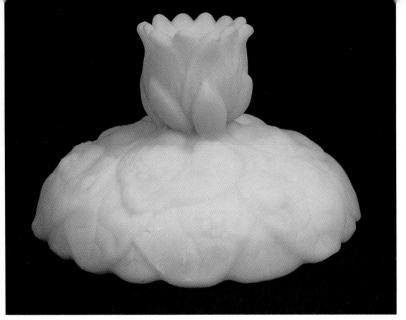

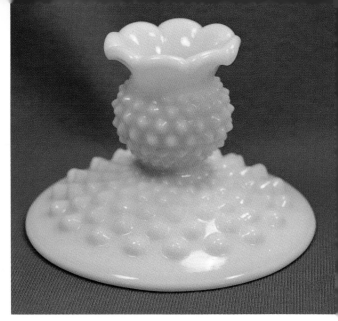

Fenton 3.125" #8473 'Water Lily' single light candle holder. Lime satin: $50-55 pair; turquoise and blue satin: $37-42 pair; rosalene: $60-65 pair; white satin: $22-27 pair; crystal velvet: $30-35 pair; red: $35-40 pair; blue opalescent: $40-45 pair.

Fenton 2.875" #3974 'Hobnail' single light candle holder. Rose pastel, white milk glass: $15-20 each; blue marble: $14-19 each.

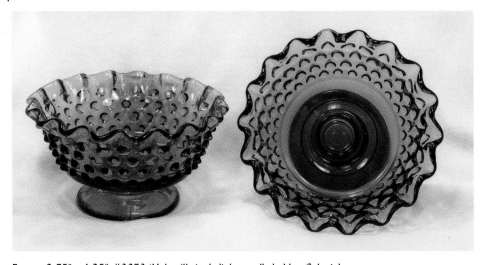

Fenton 2.75" x 4.25" #3873 'Hobnail' single light candle holder. Colonial green, colonial blue: $15-18 each; white milk glass: $22-24 each.

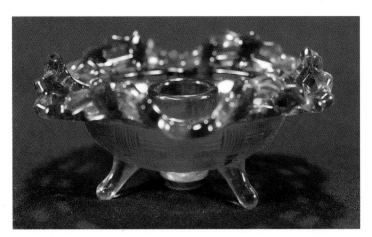

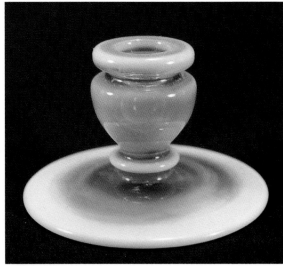

Fenton 2.25" 'Basket Weave with Open Edge' single light candle holder. Ruby, black, jade: $50-60 each; green opalescent: $45-50 each. (1930s).

Fenton 2.625" #318 single light candle holder. Cameo opalescent: $18-23 each; ruby: $22-25 each; green transparent, jade green, rose: $14-18 each; Persian pearl, velva rose, Chinese yellow, Florentine green: $30-35 each; tangerine, Pekin blue, Mandarin red: $40-45 each.

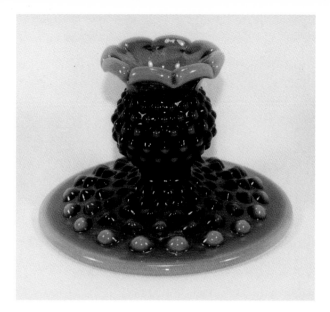

Fenton 2.875" #3974 'Hobnail' single light candle holder. Plum opalescent: $55-60 each.

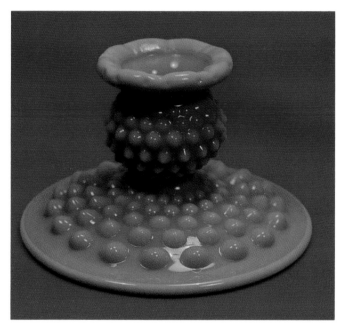

Fenton 2.875" #3974 'Hobnail' single light candle holder. Green pastel: $22-27 each.

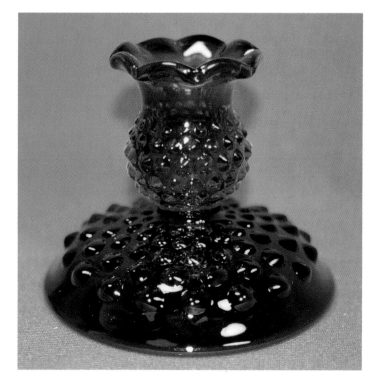

Fenton 2.875" #3974 'Hobnail' single light candle holder. Red: $15-20 each. Also as #5178 with domed base: jonquil yellow: $37-42 each; Pekin blue II: $47-52 each.

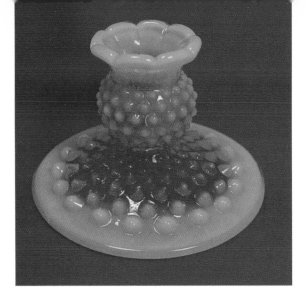

Fenton 2.875" 'Hobnail' single light candle holder. French opalescent: $14-18 each; blue: $17-22 each; green: $20-25 each; cranberry opalescent: $30-35 each; topaz: $35-40 each.

Fenton 3.25" #316 single light candle holder. Tangerine stretch glass, celeste blue stretch glass: $40-45 each; vaseline stretch glass: $45-50 each; Florentine green stretch glass, Persian pearl stretch glass: $30-35 each; velva rose stretch glass: $35-40 each; black opaque, cameo opalescent: $20-25 each; ruby: $25-30 each; transparent green, jade green, rose: $15-20 each.

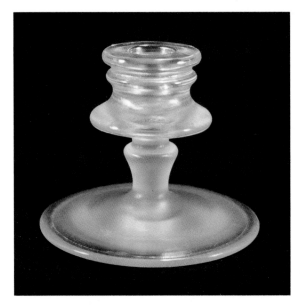

Fenton 3.25" #316 single light candle holder. Vaseline stretch glass: $45-50 each.

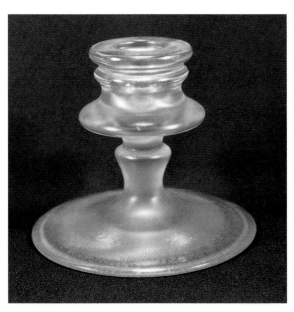

Fenton 3.75" #316 single light candle holder. Florentine green stretch glass: $30-35 each.

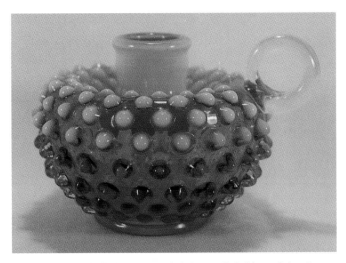

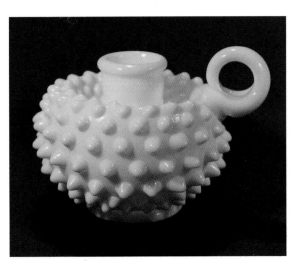

Fenton 5.75" #3870 'Hobnail' single light candle holder with handle. Cranberry opalescent: $75-80 each; French opalescent: $30-35 each; blue opalescent: $45-50 each; lime opalescent: $65-70 each; white milk glass: $25-30 each. (1950s-1970s).

Fenton 3.5" #3870 'Hobnail' single light candle holder. White milk glass: $25-30 each.

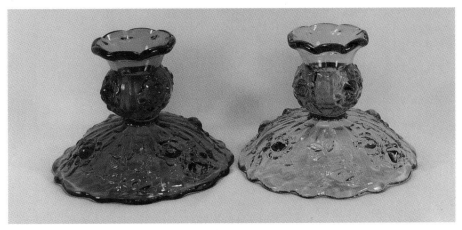

Fenton 3.25" #9270 'Rose Pattern' single light candle holder. Colonial blue, colonial amber, colonial green, colonial pink: $18-23 pair; white milk glass: $20-25 pair.

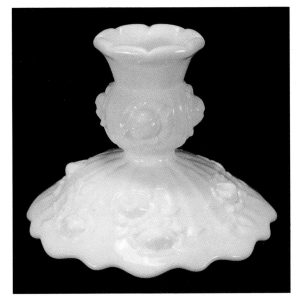

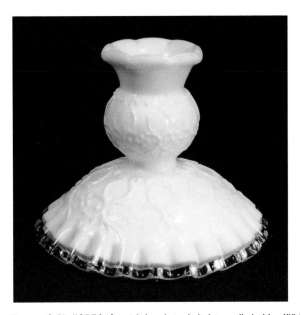

Fenton 3.5" #9270 'Rose Pattern' single light candle holder. White milk glass: $20-25 pair. (1967-1968).

Fenton 3.5" #3570 'Spanish Lace' single light candle holder. White milk glass with silver crest: $35-40 pair; teal with white milk glass crest: $45-50 pair.

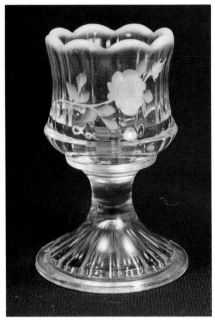
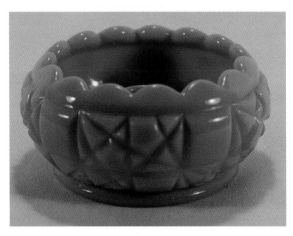
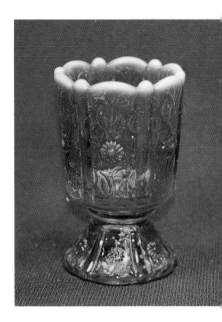

Left: **Fenton** 3.5" #7675 'French Opalescent' single light votive. Crystal opalescent with blue floral: $20-23 each. (1980s).

Center: **Fenton** 1.875" x 3.5" #5673 'Block & Star' single light candle holder. Turquoise milk glass, rose pastel, moonstone: $28-32 each; white milk glass: $24-28 each.

Right: **Fenton** 3.5" #8294 single light votive. Rose amber opalescent, amber opalescent, blue opalescent: $13-17 each.

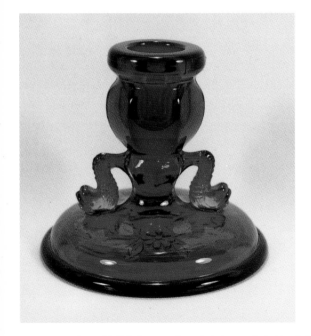
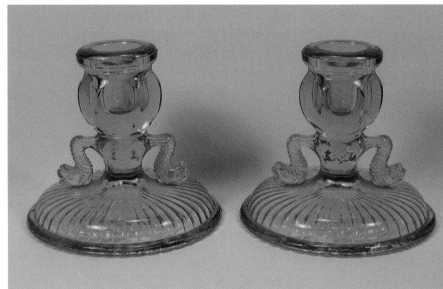

Fenton 3.5" #1623 'Dolphins' single light candle holder. Ruby red with floral pattern under base: $30-35 each; green transparent, rose: $20-25 each; jade green: $22-27 each; orchid: $25-30 each. (1927-1932).

Fenton 3.5" #1623 'Dolphins' single light candle holder. Gold with ribs under base, green: $18-23 each; rose: $17-22 each; jade green: $22-27 each; orchid: $25-30 each; ruby: $30-35 each; green stretch glass, rose stretch glass: $60-65 each.

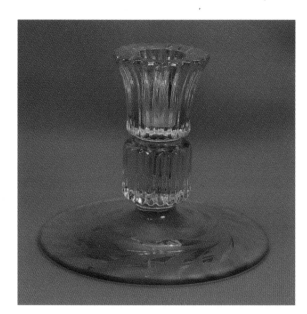 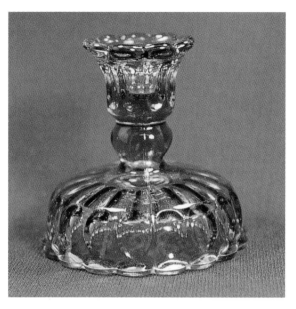

Fenton 3.625" line #1800 'Sheffield' single light candle holder. Blue with silvertone etching: $40-45 each; crystal: $15-20 each; gold: $20-25 each. Reissued in 1986 as #6672 'New Sheffield' in peaches & cream opalescent: $20-25 each.

Fenton 3.75" #4470 'Thumbprint' single light candle holder. Colonial green, colonial pink, colonial blue, colonial amber: $10-14 each. (1960s).

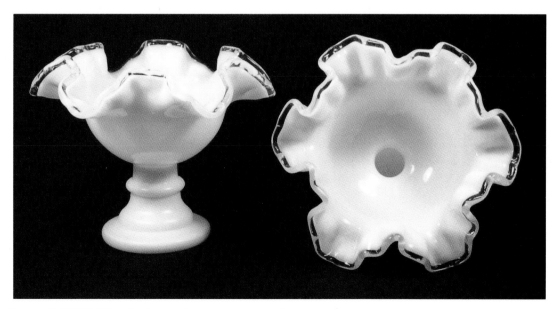

Fenton 4" #7272 'Silver Crest' single light candle holder. White with crystal edge: $25-30 each; pink crest: $40-45 each; goldenrod case glass (1956 only): $140-145 each.

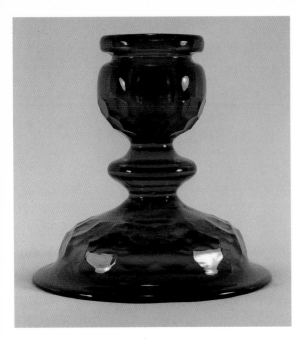

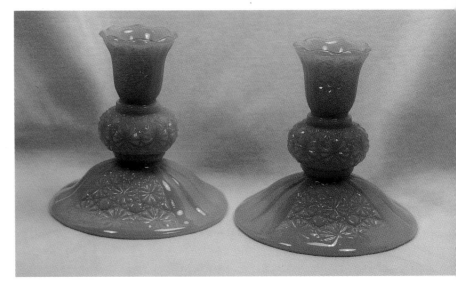

Left: **Fenton** 4.25" #1611 'Georgian' or 'Agua Caliente' single light candle holder. Ruby: $55-60 each; amber, crystal, green, rose milk glass: $30-35 each; royal blue, black, aquamarine, jade green: $65-75 each.

Right: **Fenton** 4.5" #1970 'Daisy & Button' single light candle holder. Blue milk glass, colonial amber, colonial blue, colonial green, orange, crystal: $22-25 each; white milk glass, custard: $15-20 each.

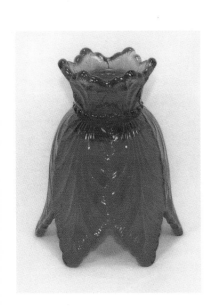

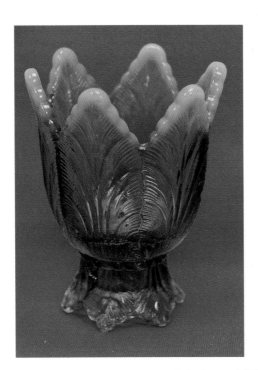

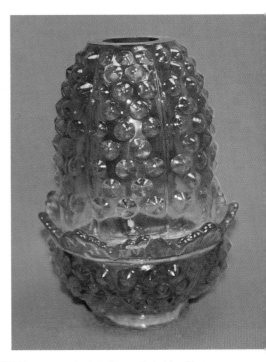

Left: **Fenton** 4.25" #9578 two-way single light candle holder. Blue opalescent, antique rose, red: $23-25 each; teal: $14-18 each.

Center: **Fenton** 4.25" #9578 two-way single light candle holder. Red: $23-25 each.

Right: **Fenton** 4.75" #3680 'Hobnail' two-piece fairy light. Orange, ruby, cameo opalescent, colonial blue satin: $20-25 each; jonquil yellow satin: $55-60 each.

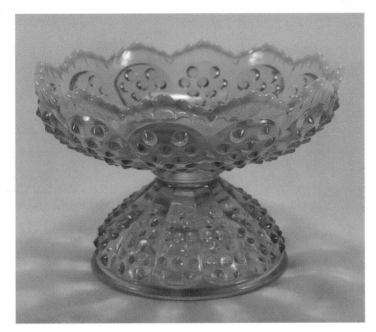 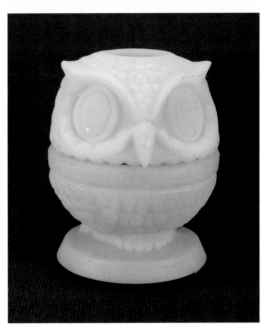

Fenton 5" x 7.375" #3971 single light footed candle bowl. Blue opalescent: $55-60 each; white milk glass: $50-55 each. Accommodates several different sized candles, a hurricane globe, and a candle ring.

Fenton 3.75" #5108 owl fairy light. Lime sherbet: $22-24 each; rosalene: $35-40 each.

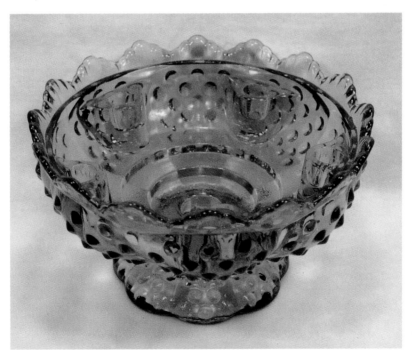

Fenton 3.625" x 6.5" #3872 'Hobnail' five-light candle bowl. Colonial green, white milk glass, black, colonial amber, colonial blue, colonial green, blue marble: $18-22 each.

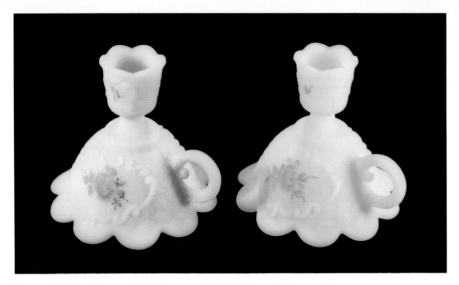

Fenton 4.5" base for #9504 'Basketweave' single light candle lamps. Blue satin with 'Love Bouquet' decoration, custard with floral decoration: $32-37 each; base plus insert and globe: $75-80 each.

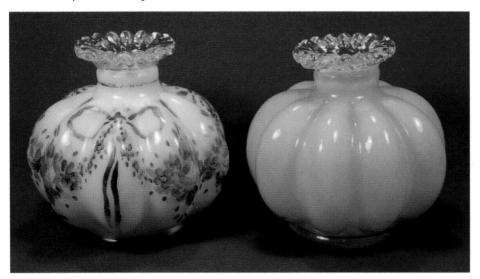

Fenton 4" #192 single light candle holders. White with hand decorated floral design, melon with silver crest: $65-70 each.

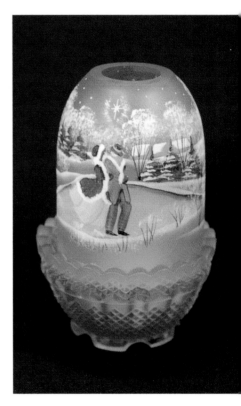

Fenton 4.75" #7300 'Snow Scene' two-piece fairy light. Gold satin glass: $50-55 each. (1990s).

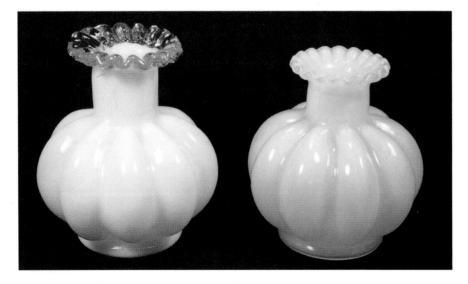

Fenton 3.75" #192 single light candle holder. White with aqua crest, light pink: $45-50 each.

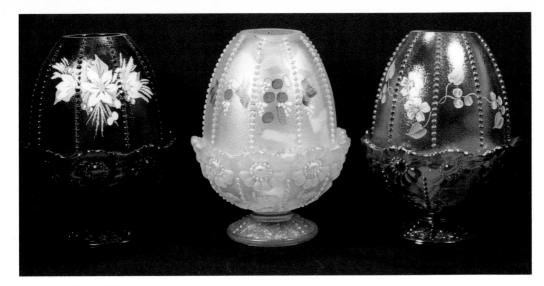

Fenton 5.75" #8405 'Beaded' two-piece fairy light. Dark green: $32-37 each; white iridescent: $35-40 each; red iridescent: $50-55 each. All hand decorated. (1990s).

Fenton 4.75" #7300 two-piece fairy light. Green with floral: $32-37 each; white opalescent with floral: $50-55 each. (1990s).

Fenton 4.75" #9304 two-piece fairy light. Blue with pink flowers, pink with pink flowers: $32-37 each. (1990s).

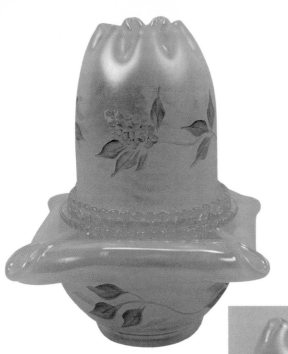

Fenton 5" #2040 three-piece fairy light. Yellow iridescent/floral with crystal insert: $125-135 each. (1990s).

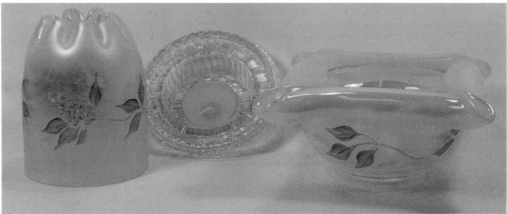

View of Fenton 5" #2040 three-piece fairy light unassembled.

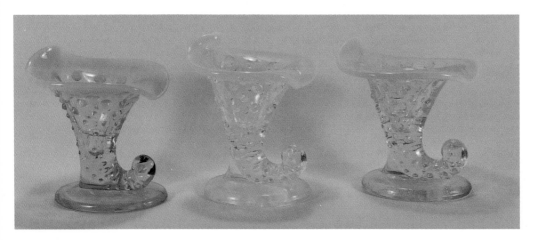

Fenton 3.625" #398 'Hobnail' mini cornucopia single light candle holder/vase. Blue opalescent: $26-31 each; topaz opalescent: $28-33 each; French opalescent: $21-26 each.

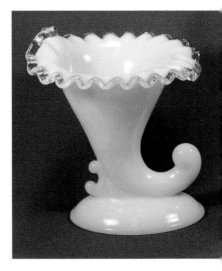

Fenton 5.25" #7274 'Silver Crest' cornucopia single light candle holder. White opalescent: $65-70 pair; gold crest: $65-70 pair.

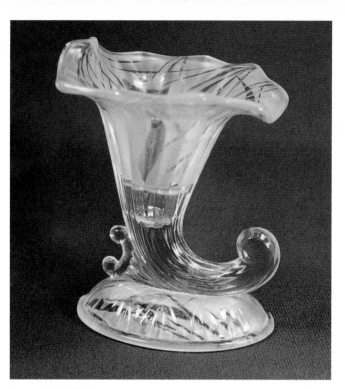

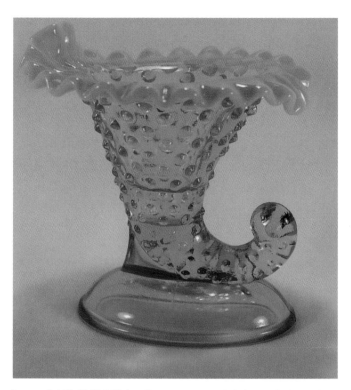

Fenton 5.5" #950 cornucopia single light candle holder/vase. Crystal with satin etched 'San Toy' pattern: $30-35 each. (c.1936).

Fenton 6.35" #3874 'Hobnail' cornucopia single light candle holder/vase. Blue opalescent: $60-65 pair; French opalescent: $55-60 pair; blue: $45-50 pair.

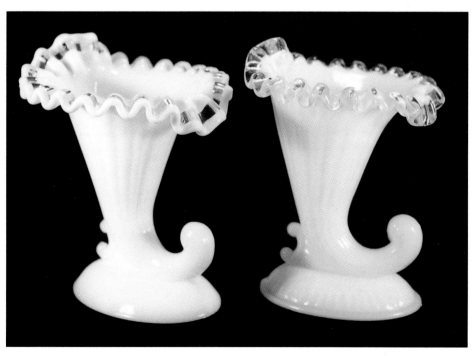

Fenton 6.25" #7274 cornucopia single light candle holder/vase. Silver crest (note that the crest is double), ivory crest: $80-85 pair; peach crest: $85-90 pair. (1940s).

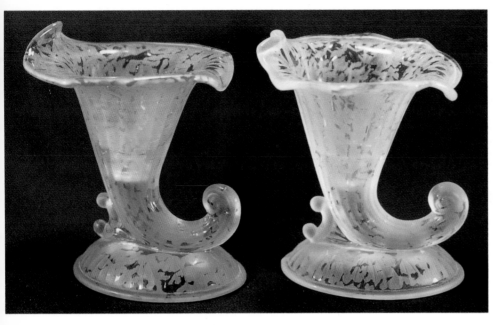

Fenton 5.25" #950 cornucopia single light candle holders/vases with
'Ming' etching. Green, rose: $40-45 each; crystal, amber: $30-35 each.
(c.1934-36).

Fenton 6" #8472 'Orange Tree' single light candlestick. Blue satin, blue
iridescent, lime sherbet, white satin, and Fenton carnival: $45-50 pair.
(1974-1975).

Fenton 5" #249 single light candlestick. Ruby red, crystal with etchings:
$30-35 each; jade green: $15-20 each; Venetian red: $47-52 each.
Also in stretch glass: Persian pearl: $35-40 each; Grecian gold: $40-45
each; Florentine green: $45-50 each; celeste blue: $65-70 each; ruby:
$165-185 each. (1920s-30s).

Fenton 4.875" #8374 'Valencia' single light candle holder. Colonial blue,
crystal, orange, colonial amber, colonial green: $15-20 each. (Late 1960s-
early 1970s). Also #8376 complete with globe: provincial blue opalescent,
dusty rose: $30-35 each; colonial amber, teal royale: $25-30 each; rose
corsage, holly berry: $37-42 each.

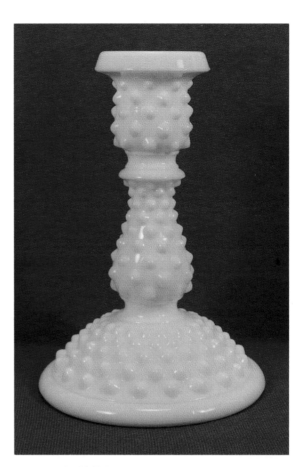

Fenton 5.75" #7474 'Silver Crest' single light candle holder. White milk glass with crystal edge: $35-40 each; gold crest: $35-40 each; with hand painted decoration, flame crest: $55-60 each. (1950s-1960s). **Note:** The glass here is more opaque than glass made in the 1940s.

Fenton 5.75" #3674 'Hobnail' single light candle holder. White milk glass: $30-35 pair.

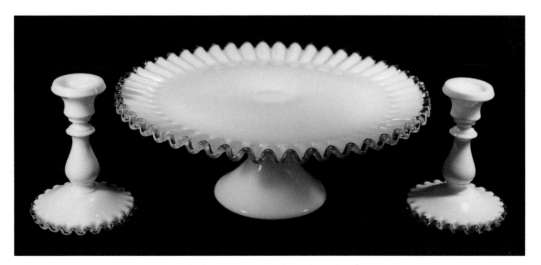

Fenton table center with gold crest #7213 cake stand and #7474 candle holders: $120-140.

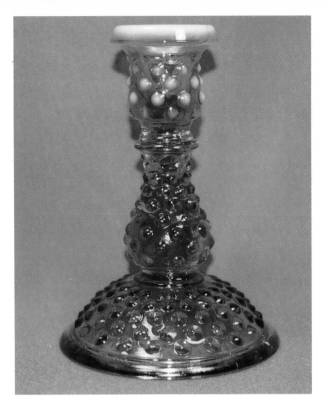

Fenton 5.625" #3674 'Hobnail' single light candlestick. Blue opalescent: $40-45 pair; blue slag: $50-55 pair.

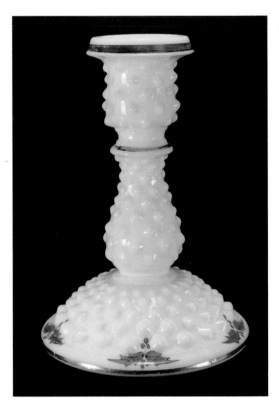

Fenton 5.75" #3674 'Hobnail' single light candlestick. White milk glass with holly: $35-40 pair.

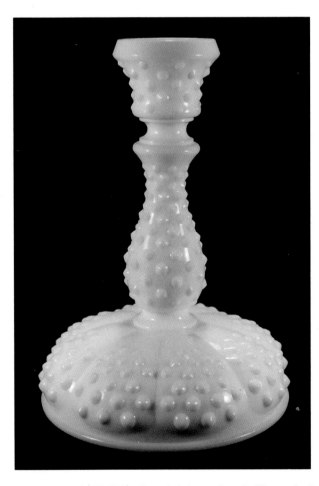

Fenton 7.5" #3745 'Hobnail' single light candlestick. White milk glass: $32-37 each.

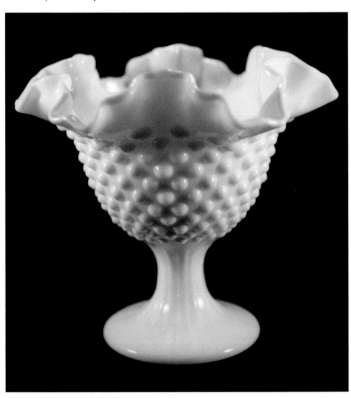

Fenton 6" 'Hobnail' single light pedestaled candle bowl. White milk glass: $22-27 each.

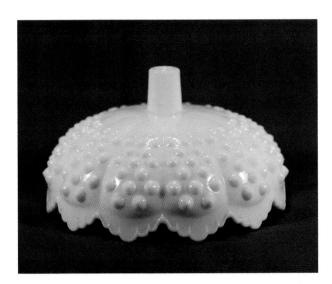

Fenton 3.25" #3746 'Hobnail' candle epergne. White milk glass: $60-65 each. Usually used with candlestick #3745 (7"). Also used for a three-piece centerpiece with #3748 candle bowl.

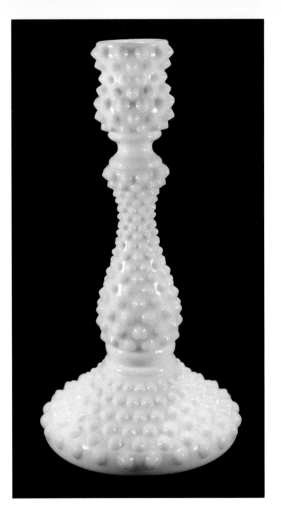

Fenton 10" #3774 'Hobnail' single light candlestick. White milk glass: $30-35 each; colonial amber: $20-25 each. Also 6" #3674.

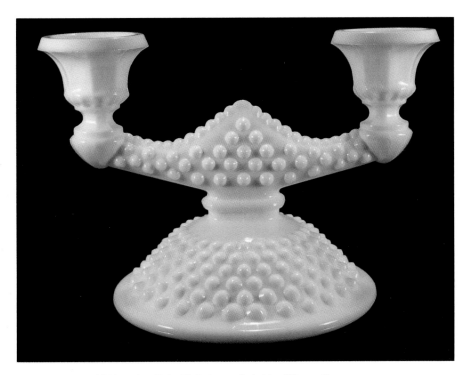

Fenton 5.375" #3672 'Hobnail' double light candle holder. White milk glass: $125-135 pair.

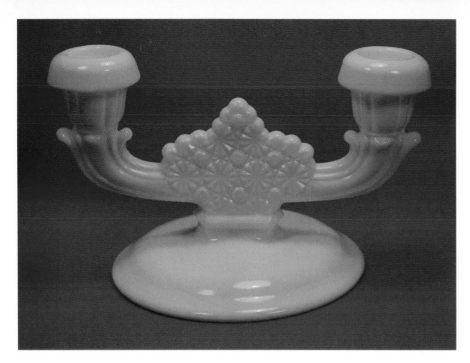

Fenton 4.25" #1974 'Daisy & Button' double light candle holder. White milk glass: $60-65 pair; French satin: $75-80 pair.

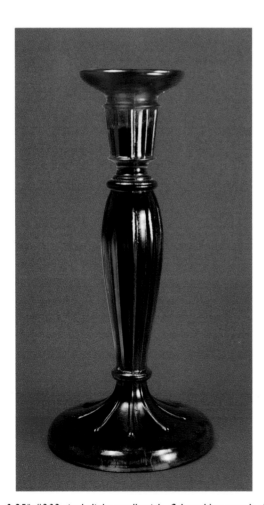

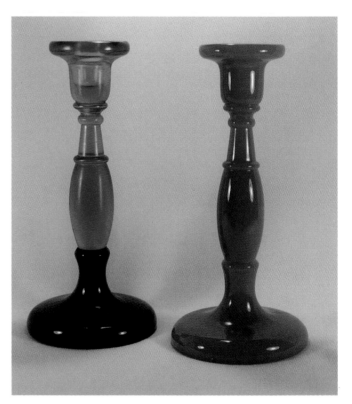

Fenton 7.875" #549 two-color single light candlesticks. Celeste blue iridescent/ebony base, flame/blue base, jade green/moonstone base: $120-130 each; moonstone/ebony base: $95-100 each. Also in stretch glass: topaz/celeste blue base, celeste blue/ebony base, wisteria/Persian pearl base: $120-130 each; Persian pearl/ebony base: $110-120 each. Also in single color stretch glass: topaz: $60-65 each; Grecian gold: $40-45 each; celeste blue: $75-80 each; Chinese yellow: $110-120 each. Also in single color non-iridescent: ruby, royal blue: $75-80 each; moonstone: $60-65 each; Pekin blue: $85-90 each; celeste blue: $45-50 each; flame: $120-130 each; jade green: $95-105 each. (1920s).

Fenton 8.25" #232 single light candlestick. Celeste blue stretch glass, Florentine green stretch glass: $75-80 each; Grecian gold stretch glass: $45-50 each; topaz stretch glass: $55-60 each.

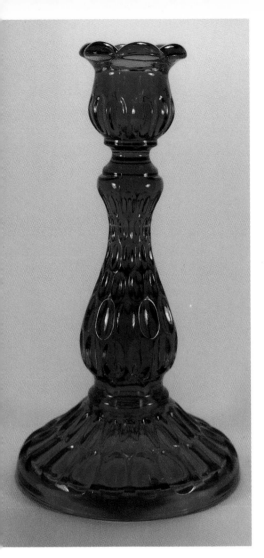

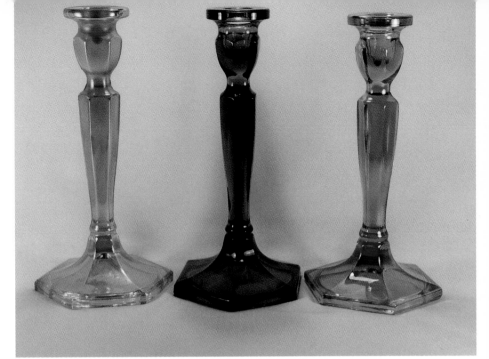

Fenton 8.5" #449 single light candlestick. Grecian gold: $35-40 each; celeste blue iridescent: $60-65 each; wisteria iridescent: $65-70 each. (Introduced in 1920s). Found in many color variations. Still in line today as #9071: candleglow: $15-20 each; royal blue with hand decoration: $40-45 each; Florentine green stretch glass, Persian pearl stretch glass: $50-55 each; ruby stretch glass: $175-185 each; topaz stretch glass: $60-65 each; wisteria stretch glass: $75-80 each.

Fenton 8.875" #4473 'Old Virginia Thumbprint' single light candlestick. Colonial blue, colonial amber, white milk glass: $40-45 pair.

Fostoria

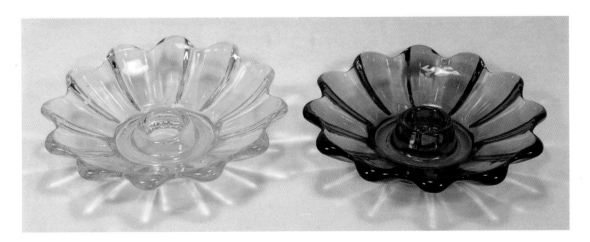

Fostoria 1" x 5.375" single light candle dish. Yellow, blue, green, crystal, multiple colors: $2-4 each.

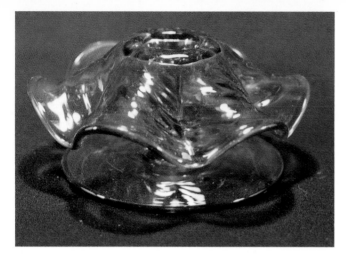

Fostoria 2.25" #2393 single light candle holder. Green, rose: $85-90 pair; amber: $70-75 pair; azure: $100-110 pair.

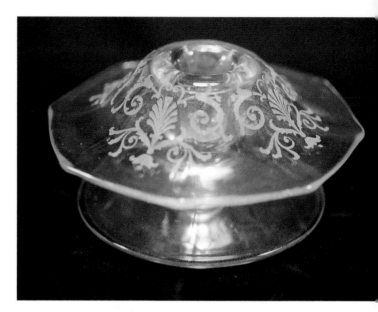

Fostoria 2.5" x 5" #2375-1/2 'Fairfax' line single light candle holder. Topaz with #278 'Versailles' etching, gold tint: $90-95 pair; azure: $105-115 pair. Without etching: crystal, amber: $35-40 pair; rose, green, topaz: $55-60 pair; orchid, azure: $75-85 pair. (1928-1944).

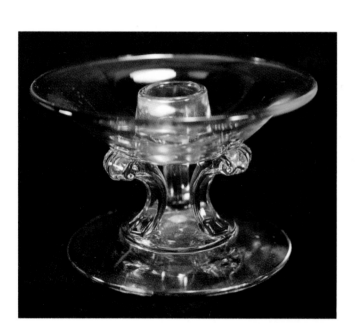

Fostoria 2.875" #243 pedestaled single light candle bowl. Topaz, rose, or azure with crystal base: $70-75 each; crystal with green, amber, or ebony base: $65-70 each.

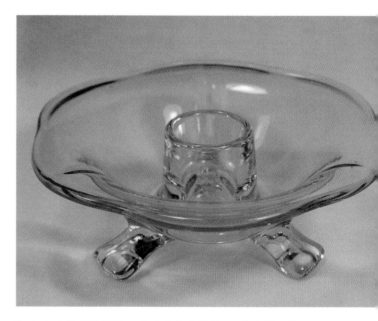

Fostoria 1.5" #2394 three-footed single light candle holder. Topaz, rose, green, amber: $10-15 each; crystal: $8-12 each; azure: $15-20 each.

Fostoria 2" #2324 single light low candle holder. Blue, azure, orchid, amber rose: $18-23 each; green, topaz: $15-20 each. (1927-1944).

Fostoria 2.25" #2324 'Short' single light candle holder. Blue: $35-40 pair; amber, green: $20-25 pair; black: $35-40 pair.

Fostoria 3" #2324 single light candle holder. Green, amber: $35-40 pair; green with #275 'Vesper' etching: $45-50 pair; blue: $75-80 pair. (1926-1934).

Fostoria 3" #2324 single light candle holder. Black: $35-40 pair.

Fostoria 3.125" #2424 single light candle holder. Amber with etching: $40-45 pair; crystal with #273 'Royal' etching: $50-55 pair.

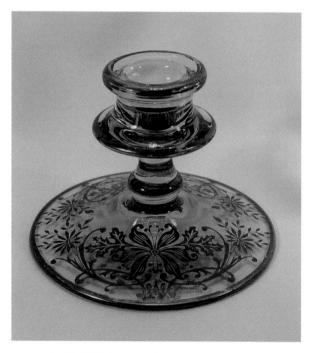

Fostoria 3.25" #2324 single light candle holder. Orchid with heavy sterling deposit: $35-40 each. (Late 1920s).

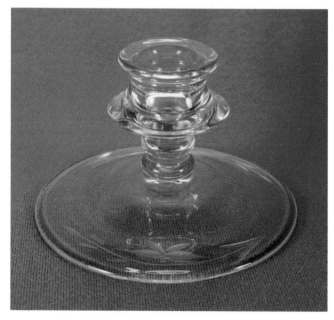

Fostoria 3" #2324 single light candle holder. Pink with cutting: $25-30 pair.

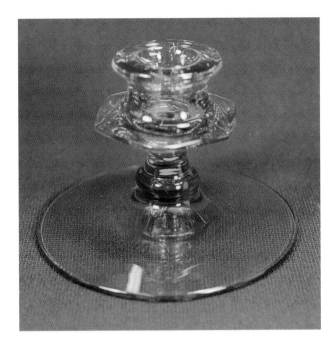

Fostoria 3.25" #2375 'Fairfax' line single light candle holder. Amber: $35-40 pair.

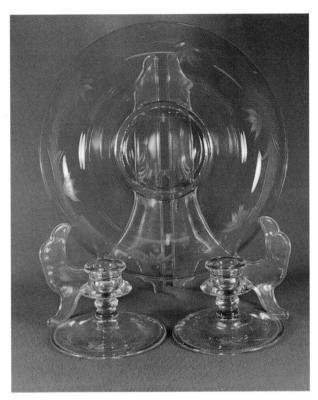

Fostoria console set: $55-65

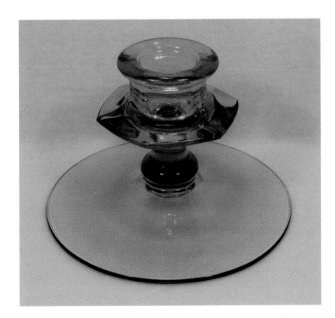

Fostoria 3" #2375 'Fairfax' line single light candle holder. Green, rose: $45-50 pair; crystal: $22-25 pair; topaz, gold tint, amber: $35-40 pair; azure, orchid: $65-70 pair. Made with a three-part mold. **Note:** The top edge of the light is round while the bottom edge is hexagonal.

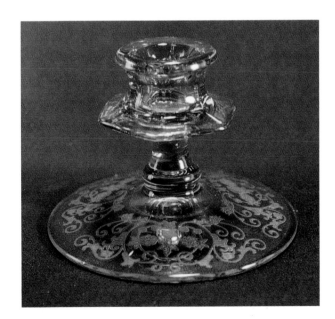

Fostoria 3.125" #2375 'Fairfax' line single light candle holder. Green with #285 'Minuet' etching: $50-55 pair.

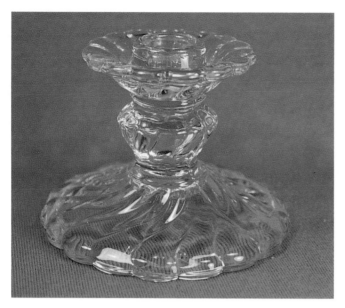

Fostoria 3" #2412 'Colony' single light #314 candle holder. Crystal: $10-14 each.

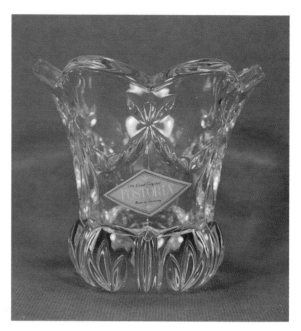

Fostoria 3" single light votive. Lead crystal: $19-22 each. Made in Germany.

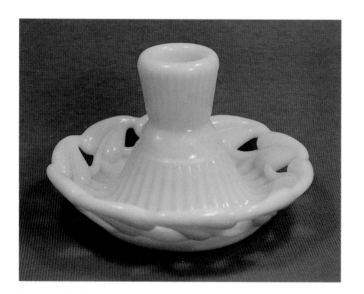

Fostoria 3" #314 'Betsy Ross' single light candle dish. Pink: $30-35 pair; white milk glass: $25-30 pair.

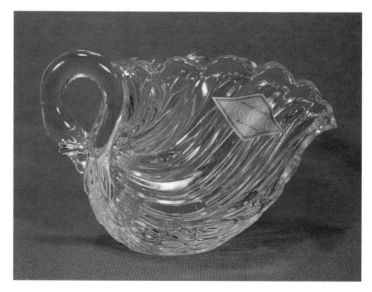

Fostoria 3" x 5" swan votive. Lead crystal: $23-26 each. Made in Germany.

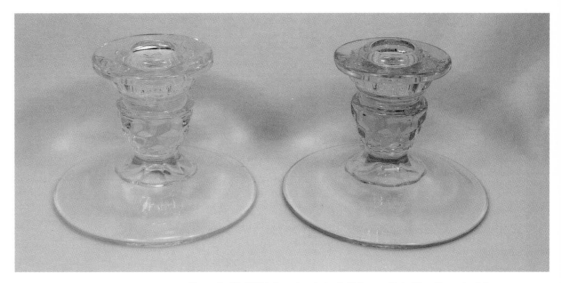

Fostoria 3" #314 'American' single light candle holder. Crystal, pink (1990s): $16-18 each.

Fostoria 3.75" x 7.25" #5056 'Heirloom Flora-candle' #2183/311 single light candle bowl. Yellow opalescent: $65-70 pair. (1959-1970).

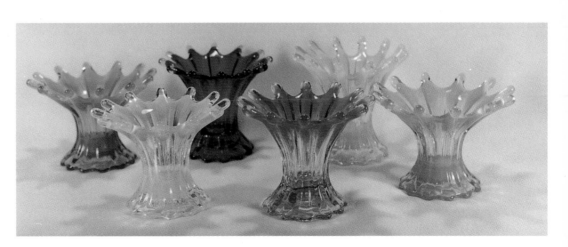

Fostoria 3" #5056 'Heirloom' #2726/311 single light candle holders. Multi-6, green, opalescent, ruby, bittersweet, yellow, blue, pink (not shown): $60-65 pair. (1959-1970).

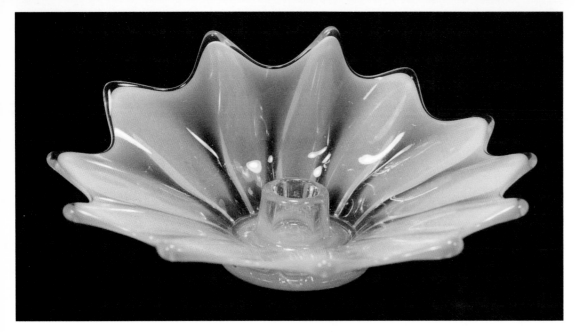

Fostoria 3.375" x 8.75" #5056 'Heirloom' single light candle bowl. Pink opalescent: $95-100 pair. (1959-1970).

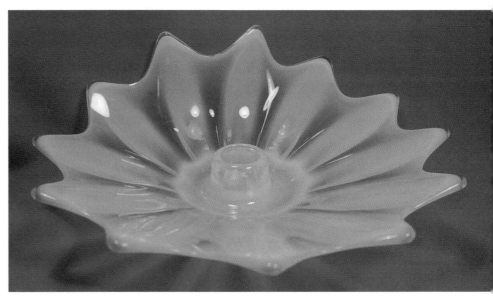

Fostoria 3.5" #5056 'Heirloom' single light candle bowl. White opalescent: $85-90 pair; colored opalescents: $95-100 pair. (1959-1970).

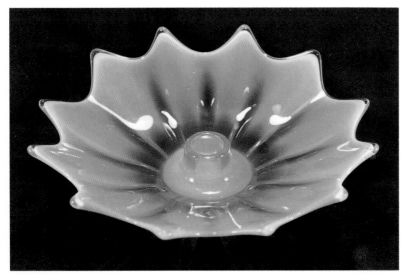

Fostoria 3.5" x 9.125" #5056 'Heirloom' single light candle bowl. Blue opalescent, green opalescent: $95-100 pair. (1959-1970).

Fostoria 3.5" x 9.125" #5056 'Heirloom' single light candle bowl. Amberina: $95-100 pair.

Fostoria 3.375" #2395 'Double Scroll' single light candle holder. Amber: $55-60 pair.

Fostoria 3.75" single light votive. Smoke: $19-22 each.

Fostoria 3.5" #2395 'Double Scroll' single light candle holder. Black, amber, green, rose: $55-60 pair; gold tint: $65-70 pair; azure: $80-85 pair.

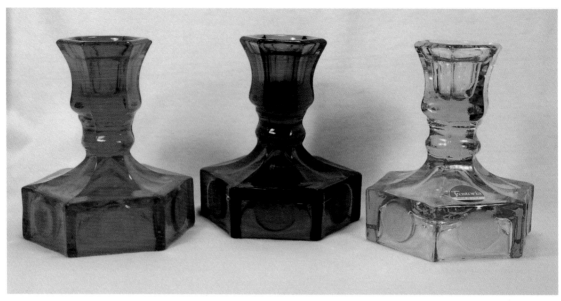

Fostoria 4.5" #1372 'Coin Glass' single light #316 candle holder. Ruby, empire green, blue: $60-65 pair.

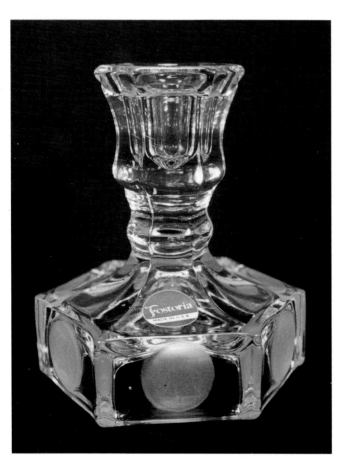

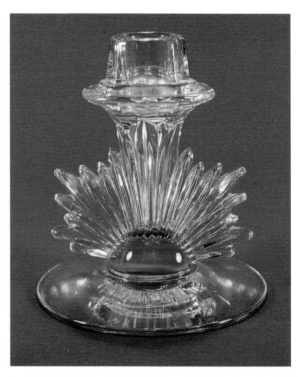

Fostoria 4.5" #1372 'Coin Glass' single light #316 candle holder. Crystal: $55-60 pair; ruby, empire green, blue: $60-65 pair; amber, olive: $50-55 pair.

Fostoria 4.5" #2545 'Flame' single light candle holder. Crystal: $90-95 pair; azure: $100-110 pair; gold tint: $95-100 pair. (1936-1944).

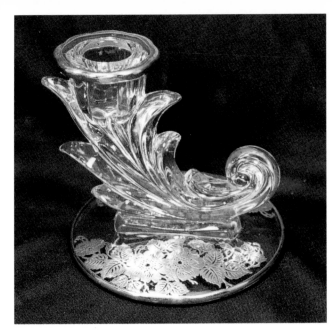

Fostoria 4" #315 'Baroque' single light #2496 candle holder. Crystal with silver deposit: $40-45 pair; topaz: $60-65 pair; azure: $70-75 pair; crystal without decoration: $30-35 pair. The blank of this candle holder is often used for with etchings, silver deposits, and gold deposits for other Fostoria patterns. (1936-1944).

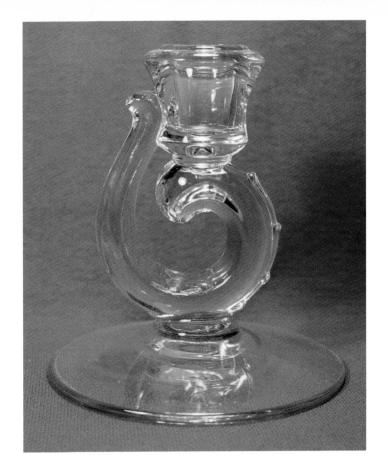

Fostoria 4.5" #316 'Century' single light candle holder. Crystal only: $35-40 pair. (1949-1985).

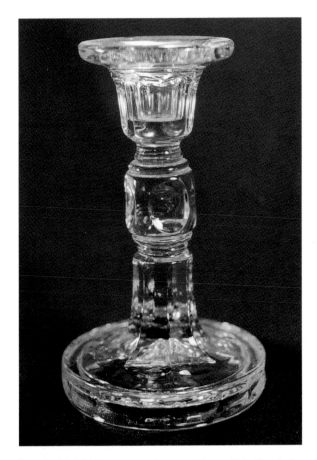

Fostoria 6" #2449 'Lexington' single light candle holder. Amber, olive green, brown: $20-25 pair. (1974-1979).

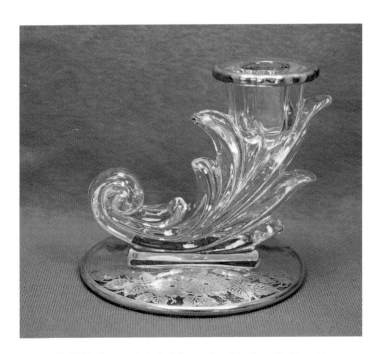

Fostoria 4" #315 'Baroque' single light candle stick. Crystal with gold deposit: $45-50 pair.

69

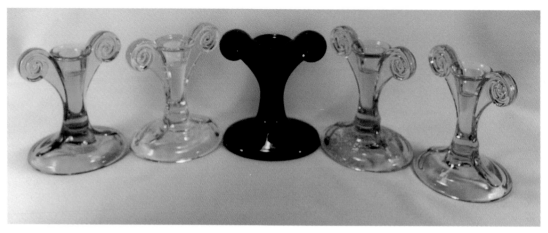

Fostoria 5" #2359-1/2 'Double Scroll' single light candle sticks. Amber, black, rose, green, crystal: $50-55 pair; topaz: $60-65 pair; azure: $80-85 pair.

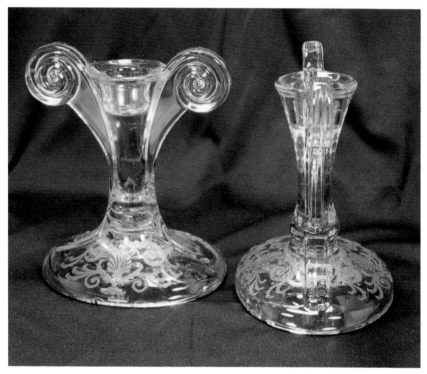

Fostoria 5" #2395-1/2 'Double Scroll' single light candle holders with 'Versailles' etching. Topaz: $80-85 pair; rose, green: $70-75 pair; azure: $100-110 pair.

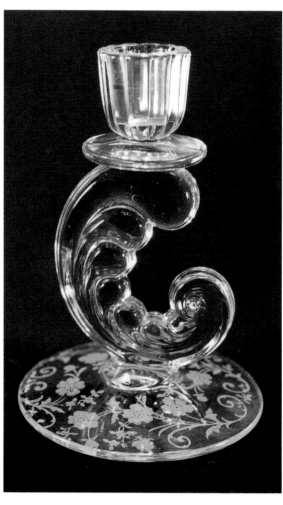

Fostoria 5.75" #2594 'Plume' single light candle holder. Crystal with #340 'Butter Cup' etching: $55-60 pair. (1941-1960).

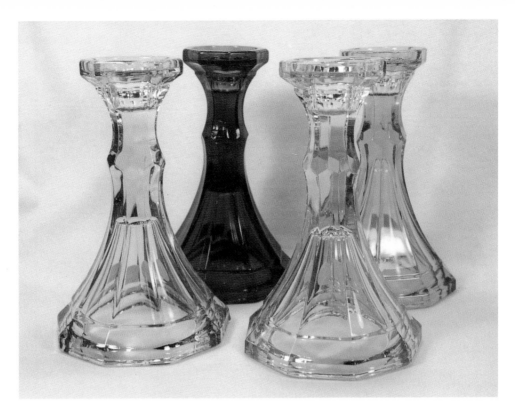

Fostoria 5.875" 'Virginia' single light candlesticks. Crystal, light blue, cobalt, peach, pink: $10-15 each.

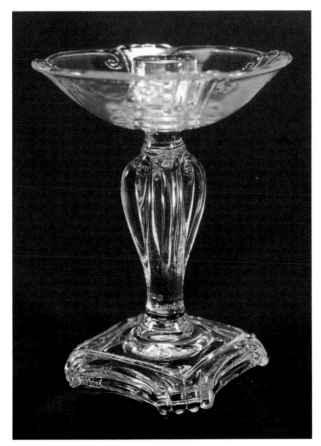

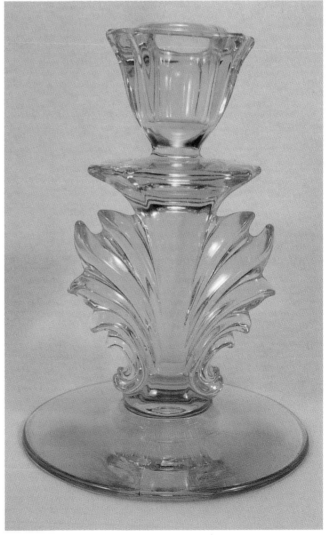

Above: **Fostoria** 5.75" #2470 single light candle holder. Topaz/crystal, rose/crystal, green/crystal: $45-50 pair ($75-80 pair with etching); wisteria/crystal: $95-100 pair ($115-125 pair with etching). (1933-1942).

Right: **Fostoria** 5.75" 'Baroque' single light candle holder. Topaz: $70-75 pair; crystal: $25-30 pair; azure: $75-80 pair.

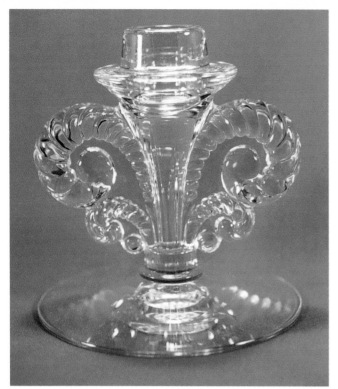

Fostoria 4.5" 'Coronet' line #2560 single light candle holder. Crystal: $35-40 pair; crystal with etching: $45-50 pair. (1938-1960).

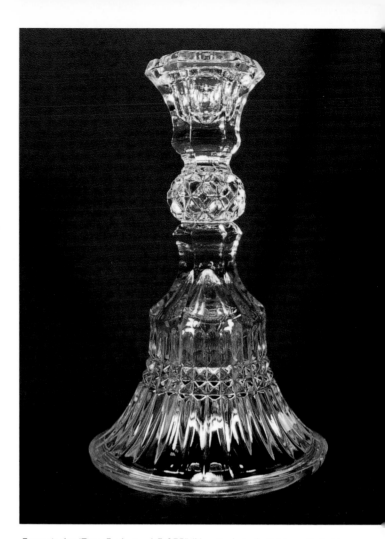

Fostoria for 'Tiara Exclusives' 7.375" 'Venetian' single light candle holder. Crystal: $12-16 each. Also in 5.5".

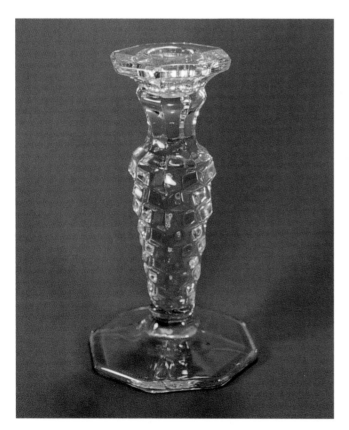

Fostoria 6.5" #2056 'American' single light #319 candle holder. Crystal: $60-65 pair.

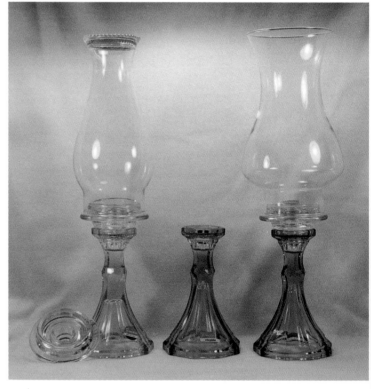

Fostoria 6" three-piece 'Virginia' hurricane bases, peg inserts, and Indiana 8.5" globes. Peach, pink, blue: $20-25 each.

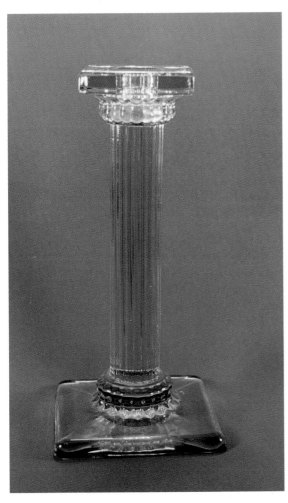

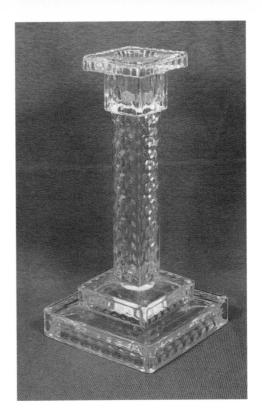

Fostoria 7" #2056-1/2 'American' single light candlestick. Crystal: $95-100 each. Part of an 'American' dresser set. (c.1925-1930). Crystal only now in outlets: $20-25 each.

Fostoria 8" #1064 'Ribbed Column' single light candle pillar. Crystal: $95-100 pair.

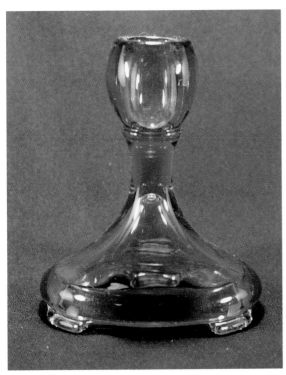

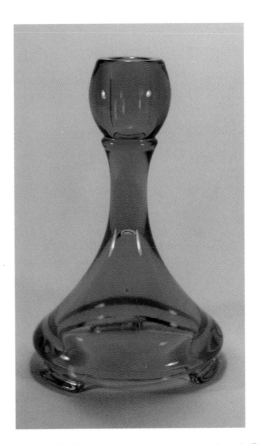

Fostoria 7" #2297 Art Deco single light candlestick. Blue, ebony: $60-65 pair; green, amber: $55-60 pair; canary: $90-95 pair.

Fostoria 5.125" #2299 Art Deco single light candle holder. Green, amber: $45-50 pair; blue, ebony: $50-55 pair; canary (vaseline): $80-85 pair.

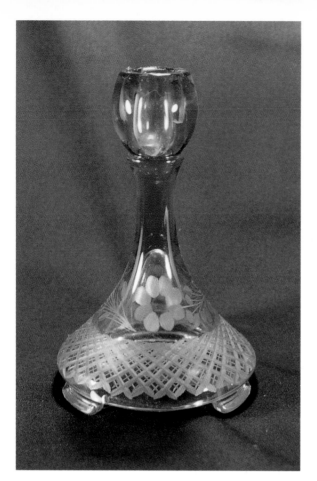

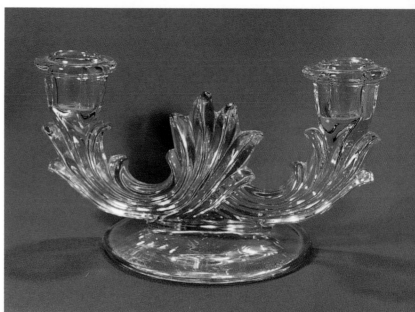

Fostoria 4.5" #2496 'Baroque' double light candle holder. Crystal: $30-35 pair; topaz: $100-110 pair; azure: $110-120 pair.

Fostoria 7" #1197 Art Deco single light candlestick. Green with cutting: $75-80 pair. (1924-1928).

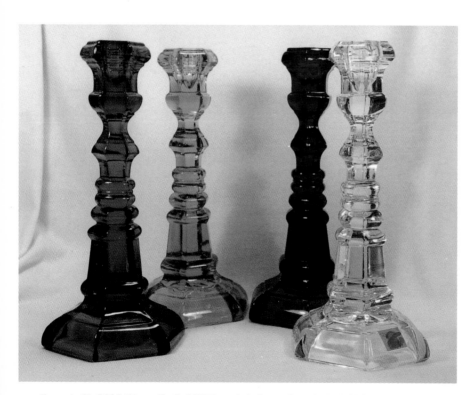

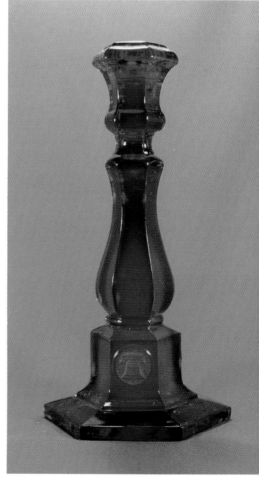

Fostoria 9" #327 'Henry Ford' #2776 single light candlestick. Red: $70-75 pair; crystal, teal (1997): $50-55 pair; cobalt: $55-60 pair; crystal, olive, blue: $90-95 pair. (1963-1970).

Fostoria 8" #326 'Coin Glass' single light candlestick. Ruby red: $115-125 pair; amber, olive, crystal: $60-65 pair. (1960s-1980s).

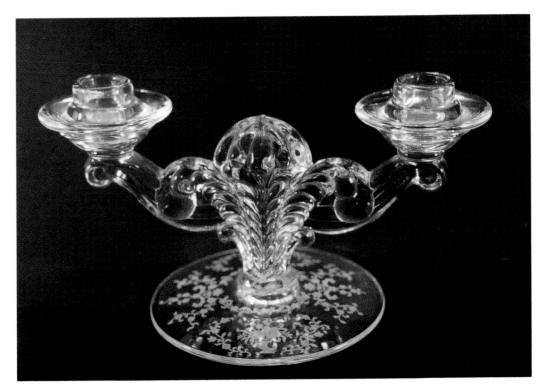

Fostoria 5" #2560 double light candle holder. Crystal with #332 'Mayflower' etching: $75-80 pair.

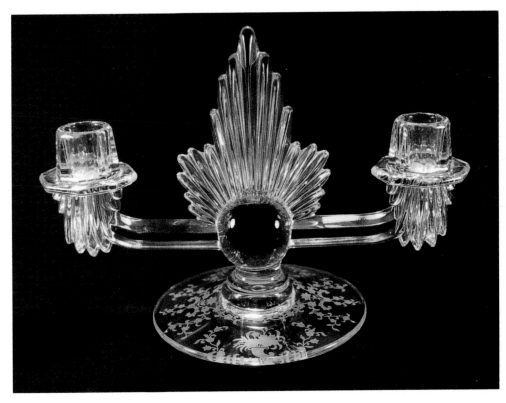

Fostoria 7.125" #2545 'Flame' double light candle holder. Crystal with #332 'Mayflower' etching: $85-90 pair; without etching: crystal: $70-75 pair; azure: $110-120 pair; gold tint: $95-100 pair; crystal candelabra: $185-195 pair. (1936-1944).

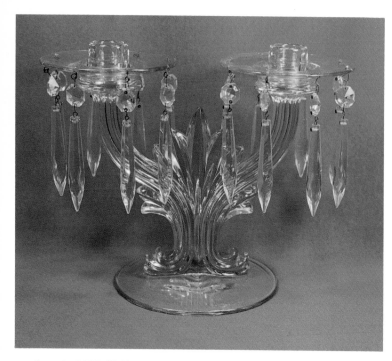

Fostoria 7.75" #2496 'Baroque' double light candelabra. Crystal: $80-85 each: topaz: $100-110 each; azure: $130-135 each.

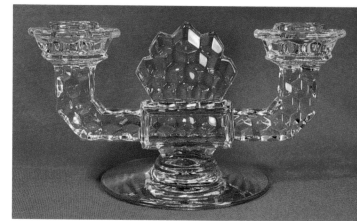

Fostoria 4.375" #331 (twin) 'American' double light candle holder. Crystal: $95-100 pair.

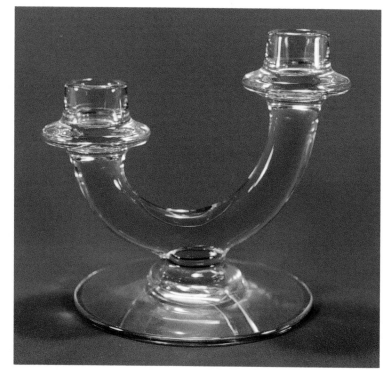

Fostoria 5.125" #6023 double light candle holder. Crystal: $55-60 pair; crystal with etching: $70-80 pair. (1940- mid 1980s).

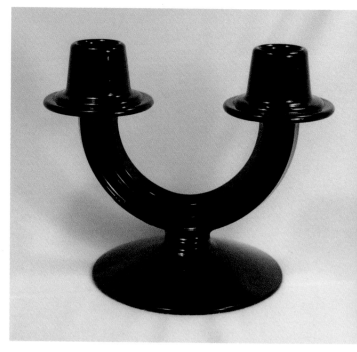

Fostoria 5.25" x 6.5" #2447 double light candle holder. Black: $65-70 pair; rose: $80-85 pair; green: $90-95 pair; topaz, gold tint: $110-120 pair. (1936-?).

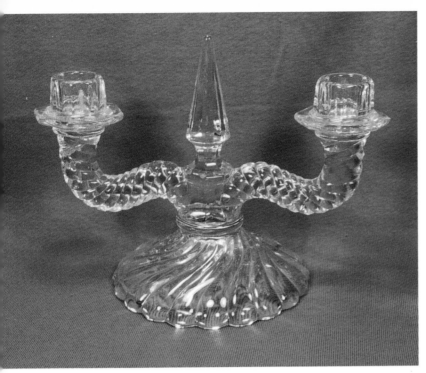

Fostoria 6.25" x 8.5" #2412 'Colony' #332 double light candle holder. Crystal: $60-65 pair. (1938-1979).

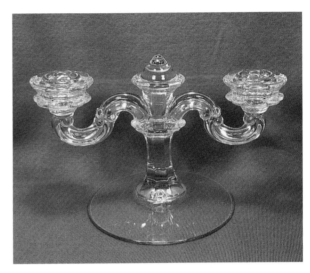

Fostoria 5" x 8" #2472 double light candle stick. Crystal: $75-80 pair. (1934-1980). The blank of this candle holder was used in many additional table service patterns.

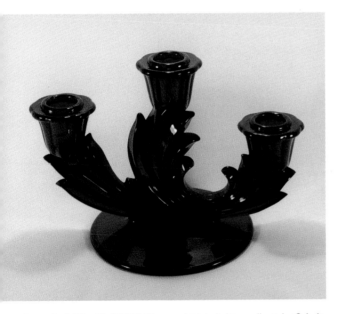

Fostoria 5.5" x 8" #2496 'Baroque' triple light candlestick. Cobalt: $130-140 pair; ruby: $140-150 pair; empire green: $120-130 pair; black amethyst: $125-135 pair. (1933-1966).

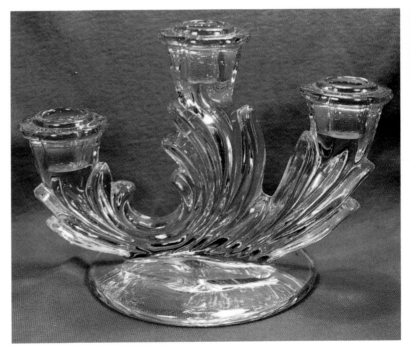

Fostoria 5.5" x 8.25" #2496 'Baroque' triple light candle holder. Crystal: $55-60 pair; topaz: $100-110 pair; azure: $120-130 pair.

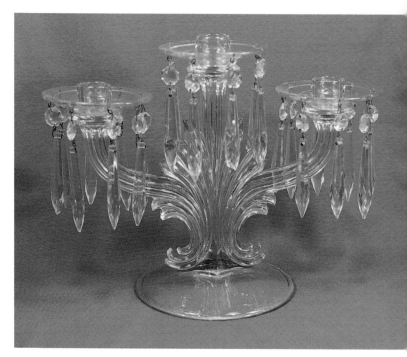

Fostoria 9" #2484 'Baroque' triple light candelabra. Crystal: $120-130 each; topaz: $160-170 each; azure: $185-195 each.

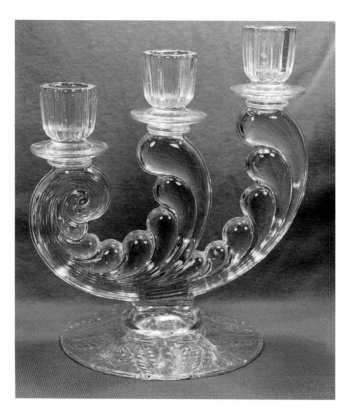

Fostoria 7.75" x 6.5" #2594 'Plume' triple light (trindle) candle holder. Crystal: $100-110 pair. (1941-1960). The blank of this candle holder was used for many additional cuttings and etchings.

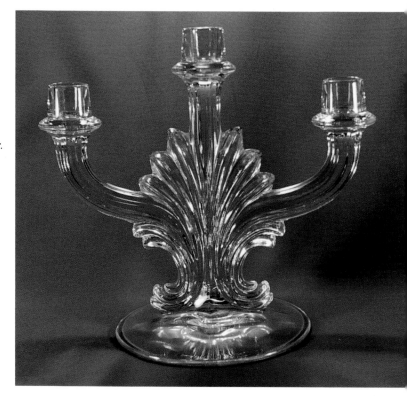

Fostoria 9.25" x 8.25" #2484 'Baroque' triple light candle holder. Crystal: $50-55 each; topaz: $85-90 each; azure: $100-110 each. (1933-1966).

France

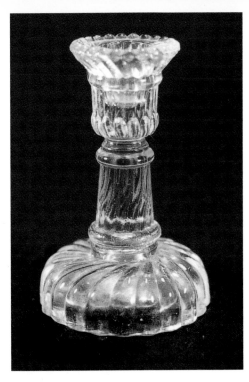

France 2" #62510 single light candle holder. Lead crystal: $15-18 pair. Made by Durand.

France 3" child's swirl single light candlestick. Crystal: $10-12 pair; white milk glass: $25-30 pair; green or blue milk glass: $42-47 pair; amber: $30-35 pair. Crystal has been reproduced.

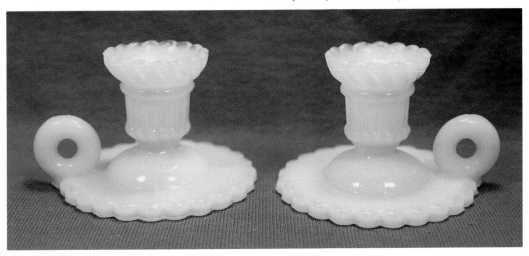

France 1.75" child's swirl single light chamberstick. Crystal: $15-20 pair; white milk glass: $25-30 pair; amber: $30-35 pair; blue or green milk glass: $35-40 pair.

Hazel Atlas

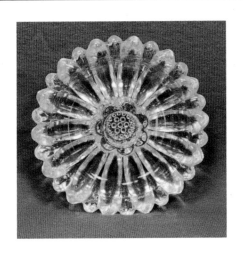

Hazel Atlas 1" 'Capri Swirl' single light candle holder. Crystal, white milk glass: $8-10 pair.

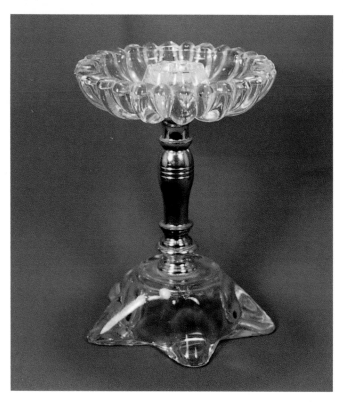

Hazel Atlas 6" 'Daisy' single light candle holder. Crystal with metal pillar: $12-17 pair.

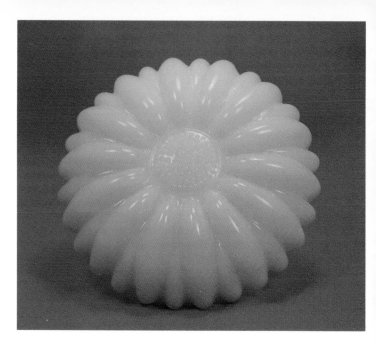

Hazel Atlas 1" 'Capri Swirl' single light candle holder. White milk glass: $8-10 pair.

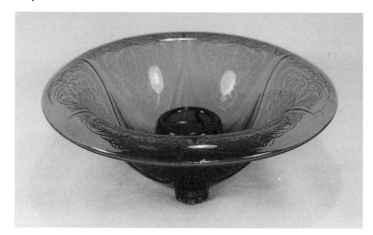

Hazel Atlas 1.875" 'Royal Lace' rolled edge single light candle bowl. Deep blue: $210-225 pair; pink, green: $100-110 pair; crystal: $55-60 pair; amethyst: cannot price. (1934-1941).

Hazel Atlas 1.375" x 4.5" single light candle dish. Crystal: $10-12 pair; amethyst: $15-20 pair. Same pattern as in 'Moroccan'. (1960s).

Hazel Atlas 2.5" 'Poppy #2' or 'Florentine #2' single light candle holder. Yellow: $75-80 pair; crystal: $45-50 pair; green: $55-60 pair. (1932-1937).

Heisey 1.5" x 4.25" #1540 'Lariat' single light candle holder. Crystal only: $20-25 each. (1942-1953).

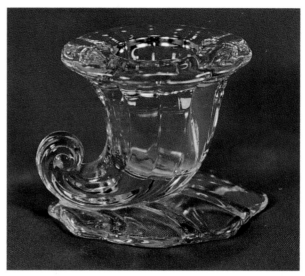

Heisey 2.375" #1428 'Warwick' single light candle holder. Crystal: $25-30 each; sahara: $60-65 each; cobalt: $120-130 each; moongleam: $125-135 each; flamingo: $150-160 each. (1935-1944). Usually marked. Reissued by Imperial. Note: Compare to U.S. Glass' cornucopia.

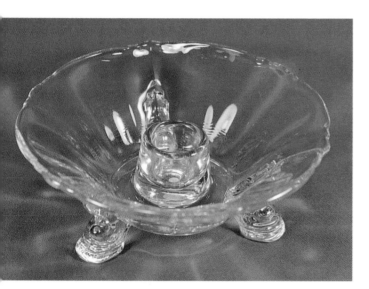

Heisey 2.125" x 5.75" #1509 'Queen Ann' three-footed single light candle holder. Crystal only: $90-95 pair. Usually marked. (1939-1941).

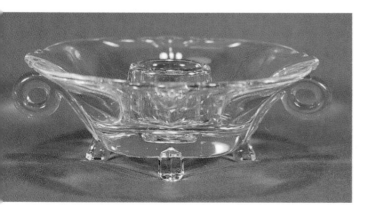

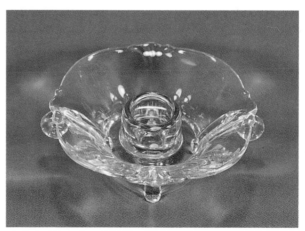

Heisey 1.5" x 4.375" #1401 'Empress' four-footed, two-handled single light candle dish. Crystal: $60-65 pair; flamingo, moongleam: $90-95 pair; sahara: $80-85 pair. (1932-1936). Usually marked.

Heisey 1.5" 'Empress' four-footed, two-handled single light candle dish. Crystal: $60-65 pair. (1932-1936).

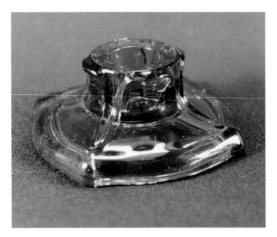

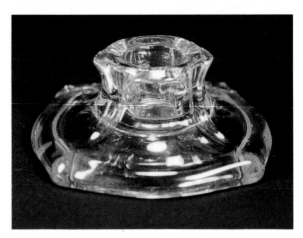

Heisey 1.5" x 3.75" #99 'Little Squatter' single light candle block. Moongleam: $60-65 pair; crystal: $20-25 pair; flamingo: $40-45 pair; marigold: $85-90 pair. Some marked. (1922-1944).

Heisey 1.5" x 3.75" #99 'Little Squatter' single light candle block. Marigold: $85-90 pair.

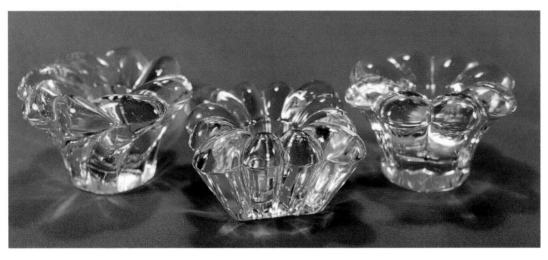

Heisey 1.75" #1502 'Swirl,' 1.5" #1503-1/4 'Square,' and 1.875" #1503 'Rosette' single light candle blocks. Crystal only. 'Swirl:' $25-30 pair (not reissued); 'Square' and 'Rosette:' $20-25 pair (both reissued by Imperial). Usually not marked.

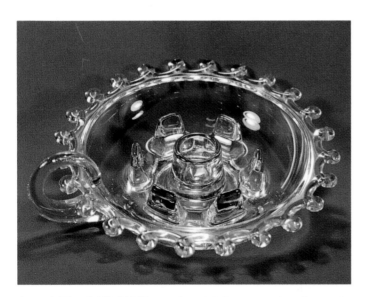

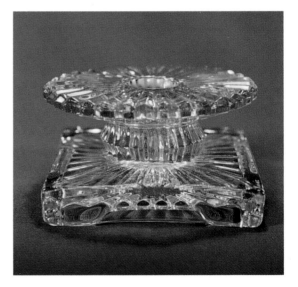

Heisey 1.75" x 7.25" #1540 'Lariat' single light hurricane lamp base with handle. Crystal only: $125-140 pair. (1942-1950). Found with and without a handle. Complete with 7" or 8" #1540 globe: $275-300 pair.

Heisey 2.125" x 3.75" #1469 'Ridgeleigh' single light candlestick. Crystal: $40-45 pair; zircon: cannot price. (1936-1942).

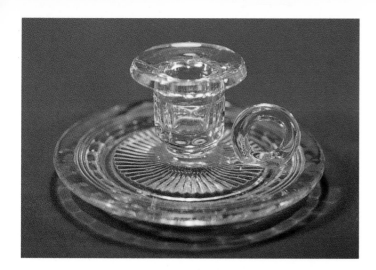

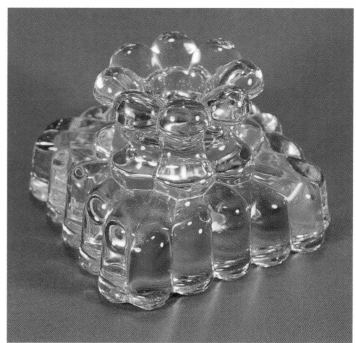

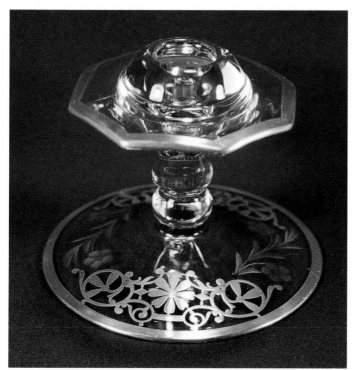

Top left: **Heisey** 2.5" #150 'Banded Flute' single light candle holder. Crystal only: $90-95 pair. (1908-1933). Usually marked.

Left: **Heisey** 3.75" #114 'Pluto' single light candle holder. Crystal with silver deposit (decorated by an unidentified company): $40-45 pair; moongleam, flamingo: $75-80 pair; hawthorne: $95-100 pair; marigold: $120-130 pair. (1926-1931). Some marked.

Above: **Heisey** 2.75" x 4" #1503 'Crystolite' single light hurricane block. Crystal only: $60-65 pair. Complete with 10" #4061 globe: $190-210 pair. (1938-1953).

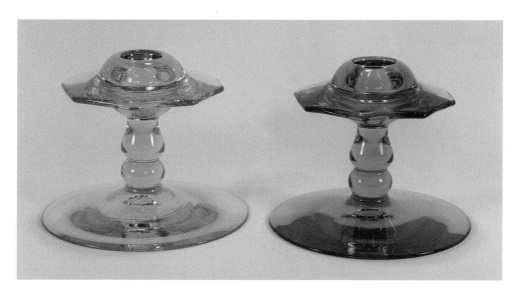

Heisey 3.75" #114 'Pluto' single light candle holders. Flamingo, moongleam: $75-80 pair. **Note:** Compare to Indiana's #603 candle holder.

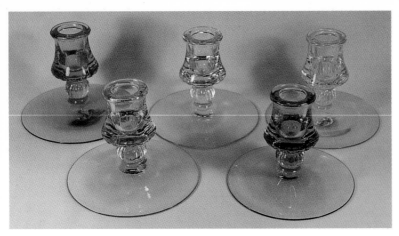

Heisey 3.625" #112 'Mercury' single light candle holder. Crystal: $30-35 pair; flamingo, moongleam: $45-50 pair; sahara: $55-60 pair; hawthorne: $80-85 pair. (1926-1957). Also made in 9" (1927-1930). Some marked. Reissued by Imperial.

Heisey 6.325" #112 'Mercury' single light candle holder. Crystal with 'Orchid' etching: $70-75 pair. (1940-1957).

Heisey 4.25" #1503 'Crystolite' single light footed candlestick. Crystal only: $50-55 pair. (1937-1953).

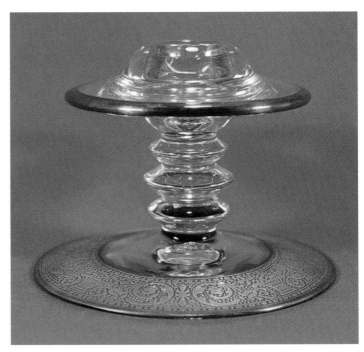

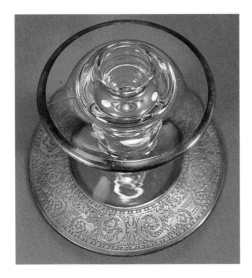

Above: Heisey 3.5" #113 'Mars' single light candle holder. Crystal with gold (decorated by an unidentified company): $35-40 pair; moongleam, flamingo: $50-55 pair; hawthorne: $95-100 pair; marigold: $120-130 pair; sahara: $95-100 pair. (1926-1933).

Left: Alternative view of Heisey 3.5" #113 'Mars" single light candle holder. Crystal with gold (decorated by an unidentified company): $35-40 pair.

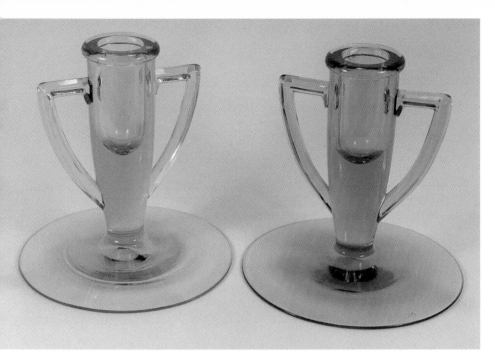

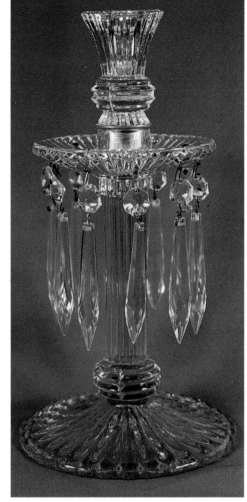

Heisey 5.125" #126 'Trophy' single light candle holder. Flamingo, moongleam: $100-110 pair; crystal: $70-75 pair. (1928-1929). Usually marked.

Above: **Heisey** 9.5" #1469-1/2 'Ridgeleigh' single light candlestick with bobeche and 10 'A' prisms. Crystal only: $190-200 pair. (1936-1943). Usually marked.

Below: **Heisey** 9.5" #1469-1/2 'Ridgeleigh' single light candlestick. Crystal only: $190-200 pair.

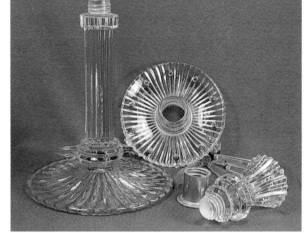

Heisey 5.375" #33 'Skirted Panel' and 3.5" #33 'Toy Skirted Panel' single light candle holders. Crystal only: 'Skirted Panel': $90-95 pair; 'Toy': $75-80 pair. (1910-1929). 'Skirted Panel' also made in 7", 9", and 11". All usually marked. 'Toy' reissued by Imperial.

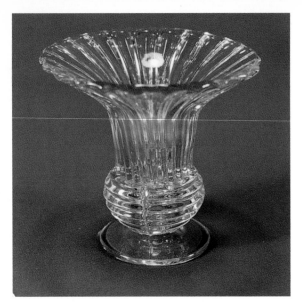

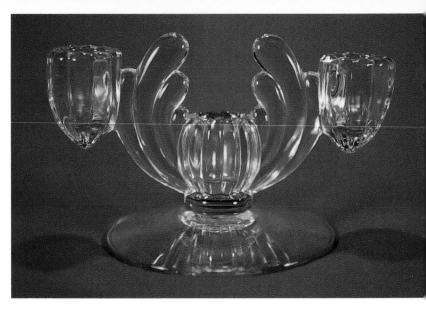

Heisey 4.5" #1469 'Ridgeleigh" single light candle vase.
Crystal: $55-60 pair; sahara: $160-170 pair; zircon:
$350-375 pair. (1936-1940). Made by flaring a 6" vase.
Some marked.

Heisey 4.5" #1503 'Crystolite' triple light candle holder. Crystal only:
$85-90 pair. (1937-1957).

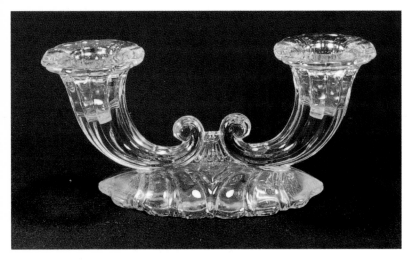

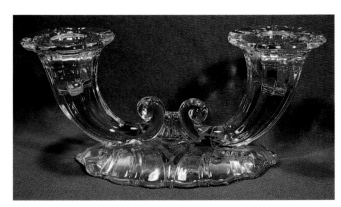

Heisey 3.25" #1428 'Warwick' double light candle holder. Sahara: $135-145 pair.

Heisey 3.25" #1428 'Warwick' double light candle holder. Crystal: $70-75 pair; sahara: $135-145 pair (1933-1950); flamingo, moongleam: $190-200 pair; cobalt: $200-220 pair. Some marked. Reissued by Imperial.

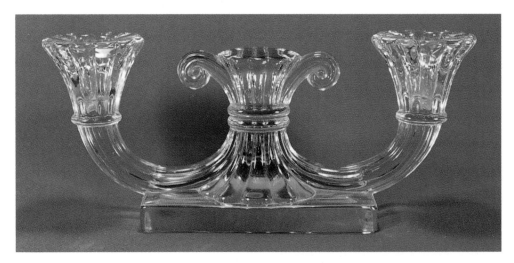

Heisey 3.5" #1504 'Regency' double light candle holder. Crystal only:
$75-80 pair. (1941-1957). Reissued by Imperial.

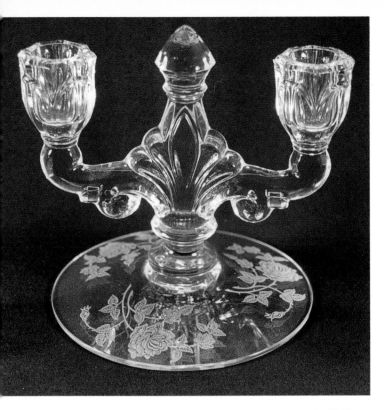

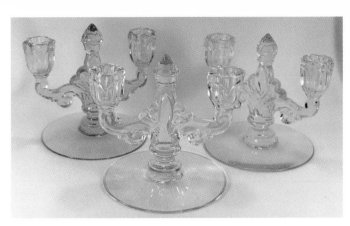

Heisey 5.5" #134 'Trident' double light candle holders. Flamingo, Sahara: $100-110 pair; crystal: $55-60 pair.

Heisey 5.5" #134 'Trident' double light candle holder. Crystal with #515 'Heisey Rose' etching, moongleam: $120-130 pair; crystal: $55-60 pair; flamingo: $100-110 pair; tangerine/crystal, sahara/moongleam, alexandrite/sahara: $200-220 pair; moongleam/crystal: $110-120 pair; marigold, alexandrite: cannot price. (1929-1957). Reissued by Imperial.

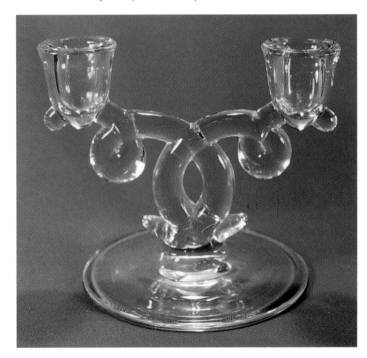

Heisey 5.25" #1540 'Lariat' double light candle holder. Crystal only: $65-70 pair. (1941-1957). Reissued by Imperial.

Heisey 5.975" #1503 'Crystolite' double light candelabra. Crystal only: $140-150 pair. (1937-1953).

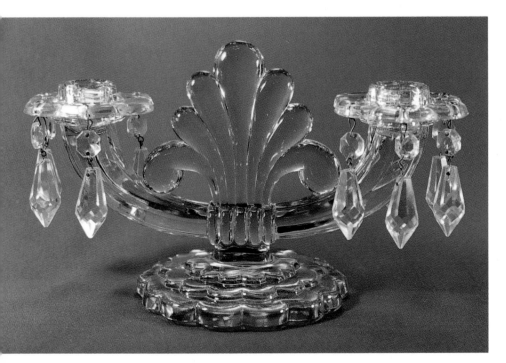

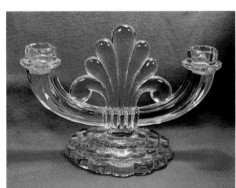

Heisey 5.875" #1503 'Crystolite' double light candle holder. Crystal only: $95-100 pair. (1937-1953).

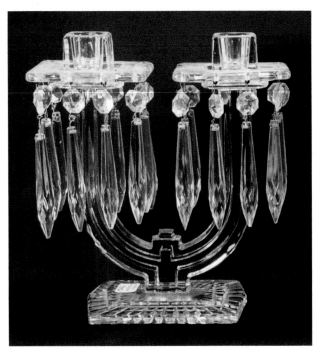

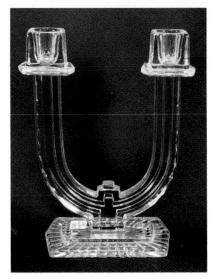

Heisey 8" #4404 'New Era' double light candle holder. Crystal: $130-140 pair. Notice the different base here. Source of cutting unknown.

Heisey 8" #4404 'New Era' double light candelabra with 'A' prisms. Crystal: $190-200 pair.

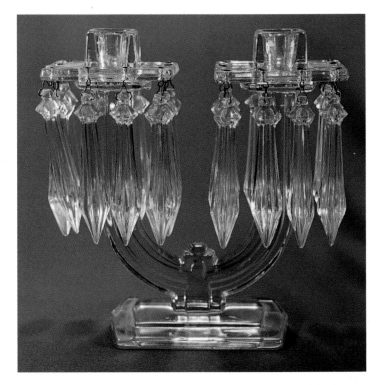

Heisey 6.125" #1469 'Ridgeleigh' double light candlestick with center bobeche and 6 'A' prisms. Crystal only: $225-250 pair.

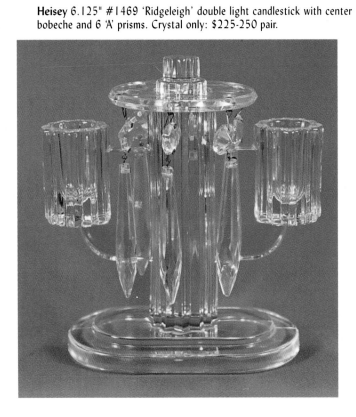

Heisey 7.5" #4404 'New Era' double light candelabra with 20 'H' prisms. Crystal: $275-300 pair; alexandrite (rare): cannot price. (1934-1957). Unmarked. Reissued by Imperial in crystal.

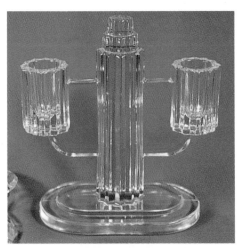

Heisey 6.125" x 6" #1469 'Ridgeleigh' double light candlestick . Crystal only: $140-150 pair. (1936-1944). Rarely marked.

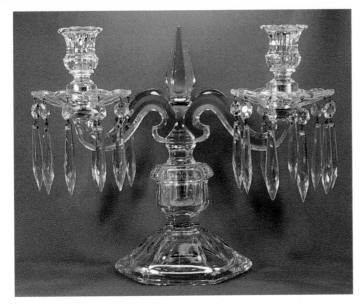

Heisey 10.5" #301 'Old Williamsburg' short base double light candelabra with 16 'A' prisms. Crystal: $115-125 each; sahara: $325-350 each; alexandrite and cobalt: cannot price. (1924-1957). Some marked. Reissued by Imperial.

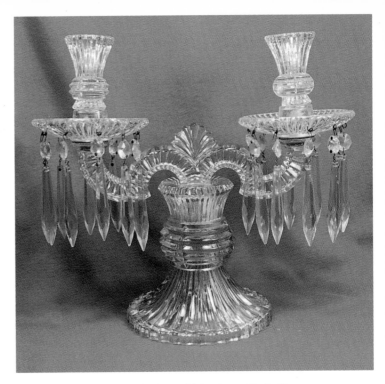

Heisey 10.5" #1469 'Ridgeleigh' candelabra base with double arms. Crystal only: $275-300 each. (1935-1936). Usually marked.

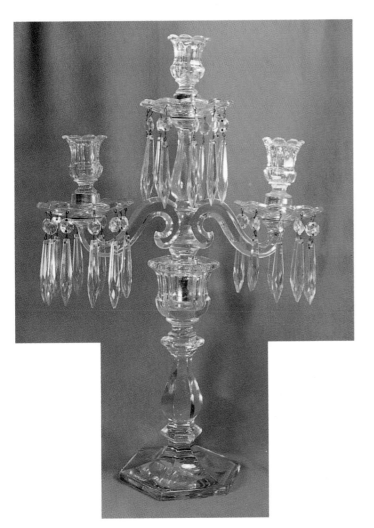

Heisey 20.5" #300-3 'Old Williamsburg' triple light candlestick with #300 arms and #300 bobeches. Crystal: $330-350 each. Candlestick made in 7" and 9". Some marked.

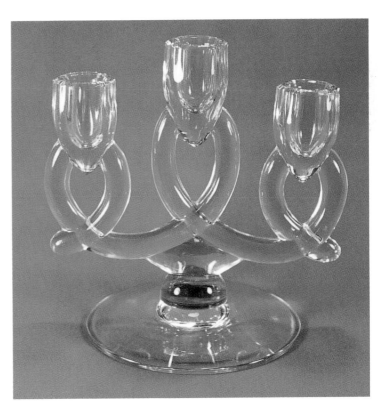

Heisey 6.75" #1540 'Lariat' triple light candle holder. Crystal only: $95-100 pair. (1942-1953).

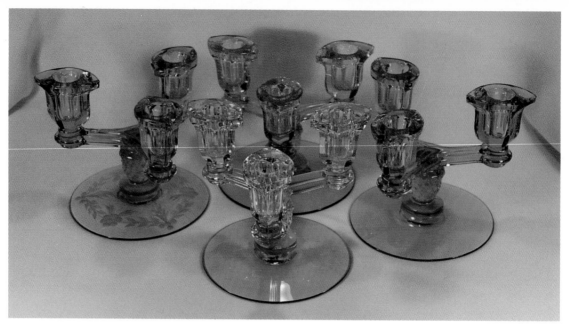

Heisey 5" #129 'Tricorn' triple light candle holders. Moongleam with etching, moongleam/crystal: $250-265 pair; flamingo: $195-210 pair; moongleam: $225-250 pair; marigold: $400-450 pair. (1929-1936). Usually marked.

Hocking

Above: **Hocking** 1.875" 'Block Optic' single light candle holder. Green: $100-110 pair; pink $90-100 pair. (1929-1933).

Top right: **Hocking** 1.5" 'Oyster & Pearl' variation single light candle holder/ hurricane base. White with fired on green, white: $10-12 pair; crystal: $8-10 pair; complete with globe: $15-20 pair.

Right: **Hocking** 2.125" 'Moonstone' single light candle holder. Crystal opalescent: $20-25 pair. (1942-1946).

Hocking 0.875" 'Manhattan' single light candle dish. Crystal only: $20-25 pair. (1938-1941).

Hocking 1.75" single light candle holder/lamp base. Crystal, white milk glass: $8-10 pair.

Hocking 2.625" 'Ball Edge' single light candle holder. White milk glass, crystal: $12-17 pair.

Hocking 3.125" 'Thumbprint' single light candle holder. White milk glass: $12-14 pair. This base has no pattern underneath.

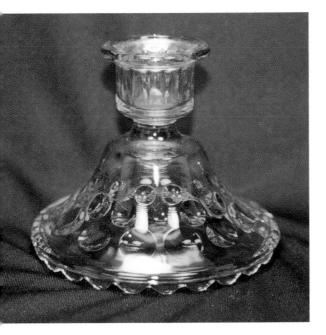

Hocking 2.25" 'Thumbprint' single light candle holder. Green, amber: $12-14 pair. The pattern is on the underside of the base.

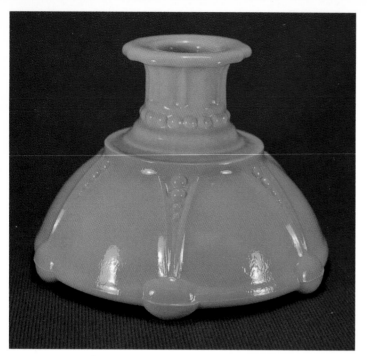

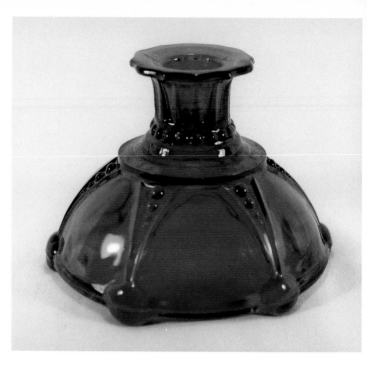

Hocking 3" 'Oyster & Pearl' single light candle holder. White with fired on pink or green, white: $18-20 pair; crystal: $40-45 pair; pink: $50-55 pair; ruby: $60-65 pair.

Alternative view of **Hocking** 3.375" 'Oyster & Pearl' single light candle holder. Ruby: $60-65 pair.

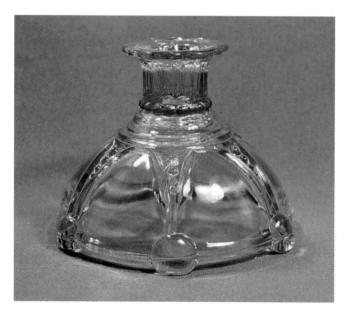

Alternative view of **Hocking** 3.25" 'Oyster & Pearl' single light candle holder. Pink: $50-55 pair.

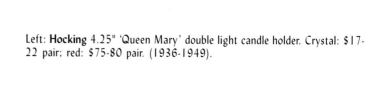

Hocking 5.5" #784 'Early American Prescut' double light candle holder. Crystal: $20-25 each.

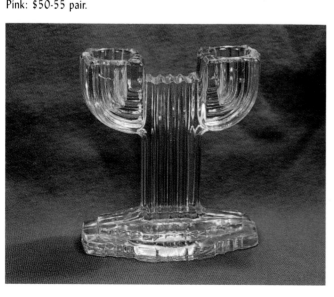

Left: **Hocking** 4.25" 'Queen Mary' double light candle holder. Crystal: $17-22 pair; red: $75-80 pair. (1936-1949).

Home Interior

Home Interior 7.5" single light candlestick with globe. Crystal: $25-30 pair. Marked 'Homeco.'

Home Interior 6" single light candlestick. Crystal: $15-20 pair. Marked 'Homeco.'

Hong Kong

Hong Kong 2.25" single light petal votive. Cobalt: $4-6 each.

Houze

Houze 3.125" electrified single light candle holder/lamp base. White milk glass: $5-7 each; pink, blue, blue opalescent, moonstone, Nile green, jade, canary, veined onyx: $10-12 each. (1920s-1930s). Many were made for F. W. Woolworth.

Imperial

Imperial 1.75" single light candle holder with flower frog. Crystal: $10-12 each.

Imperial 1.75" #1506 'Provincial' single light candle holder. Amber, green, crystal, heather: $18-22 each.

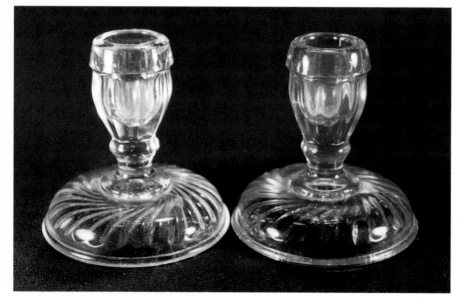

Imperial 3.375" #708 'Twisted Optic' single light candle holder. Crystal, green, pink, amber: $25-30 pair; blue, canary yellow: $50-55 pair.

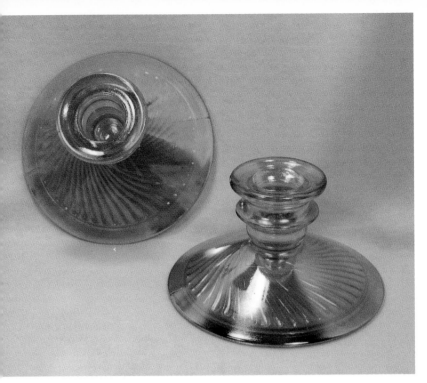

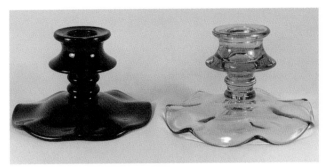

Imperial 2.75" single light ruffled candle sticks. Black, green, pink: $45-50 pair. (1920s-1930s).

Imperial 2.375" 'Swirl' single light candle holder. Marigold iridescent: $35-40 each.

Imperial 1.375" x 6" #40F 'Candlewick' line #400 single light flower round candle holder. Crystal: $25-30 each. (1947-1960).

Imperial 2.125" x 5" #40C 'Candlewick' line #400 single light crimped flower candle holder. Crystal: $30-35 each; ruby: $190-210 each.

Imperial 1.875" #86 'Candlewick' line #400 single light mushroom candle holder. Crystal: $35-40 each; crystal with gold beads: $37-42 each; Viennese blue: $70-75 each; crystal with wheat cutting: $40-45 each; crystal with etching: $70-75 each. (1937-1941).

Imperial 3" #79R 'Candlewick' line #400 single light rolled edge candle holder. Crystal: $12-15 each; crystal with ruby stain: $55-60 each; crystal with floral decoration or floral cutting #18-22: $65-75 each; crystal with frosted base: $40-45 each. (1943-1961). Reissued: 1978-1984.

Imperial 3.5" #80 'Candlewick' line #400 single light candle holder. Crystal: $12-15 each; crystal with gold beads, blue stain with silver decoration: $40-45 each.

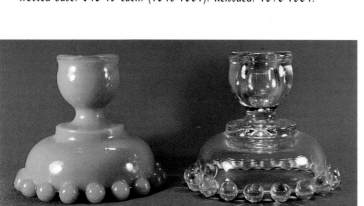

Imperial 3.625" #170 'Candlewick' line #400 single light candle holder. Pink milk glass (1950-1960), crystal (1943-1961; reissued 1978-1984): $15-20 each.

Imperial 3.75" #90 'Candlewick' line #400 single light handled chamber stick. Crystal: $45-50 each. (1947-1967). **Note:** Earlier molds have a deep cupped base.

Imperial 2.5" #39 single light candle holder. Pink, green: $15-20 pair; crystal: $12-16 pair.

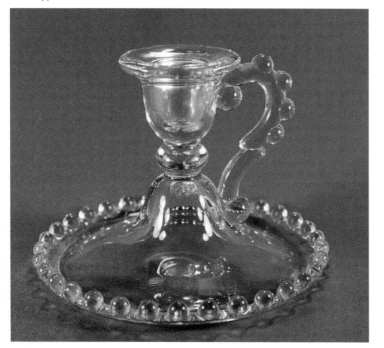

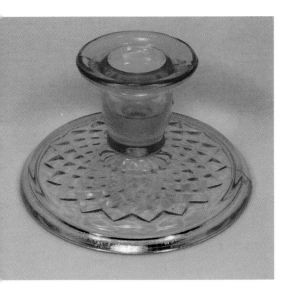

Imperial 2.75" 'Diamond Quilted' single light candle holder. Green: $27-32 pair; blue, black: $50-55 pair.

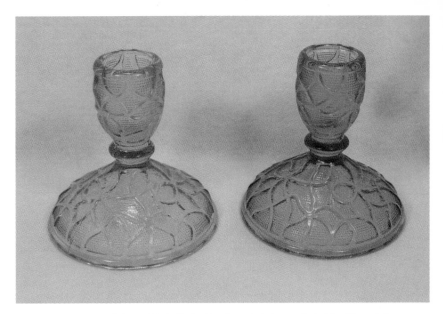

Imperial 3.375" #675 'Soda Glass' single light candle holder. Blue, pink, green, amber: $25-30 pair; marigold: $50-55 pair; smoke: $70-75 pair. (1929-1930).

Imperial 2.5" #7796 'Empire' single light candle holder. Crystal: $22-25 each; pink, blue, green: $25-30 each.

Imperial 4"x 6" 'Linear' two-way candle holder. Crystal only: $8-10 each. (Late 1970s).

Imperial 2.5" 'Old English' single light thumbprint candle holder. Blue: $12-15 each; crystal: $7-10 each; ruby: $18-20 each. (1939).

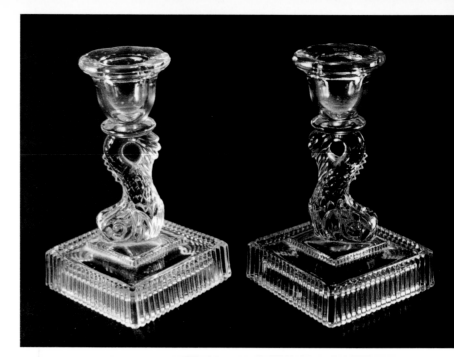

Imperial 5" #779 'Empire Dolphin' single light candle holder. White milk glass: $35-40 each. (1953-1960).

Imperial 5" #779 'Empire Dolphin' single light candle holder. Crystal: $16-18 each; blue: $22-27 each; carmel slag, white milk glass: $35-40 each. (Mid 1930s).

Below Left: **Imperial** 6.875" #41 single light candlestick. Crystal, amber, marigold iridescent: $25-30 each; mulberry, peacock iridescent, nuruby iridescent: $30-35 each. (1904-1938).

Below Center: **Imperial** 6.75" #41 'Special Lot' single light candle holder. Amber, crystal: $25-30 each. (1920-1930). A 9" version #419 was also made.

Below Right: **Imperial** 7.375" six-sided single light candlestick. Crystal: $35-45 pair; crystal with gold decoration: $55-60 pair; iridescents: cannot price. Crystal was reissued by Imperial in the 1960s.
Note: Compare to Westmoreland's #240 candlestick.

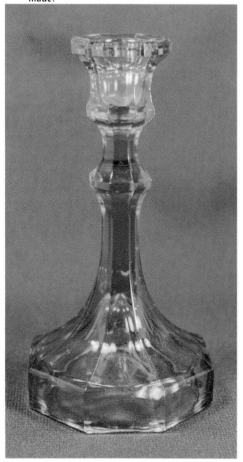

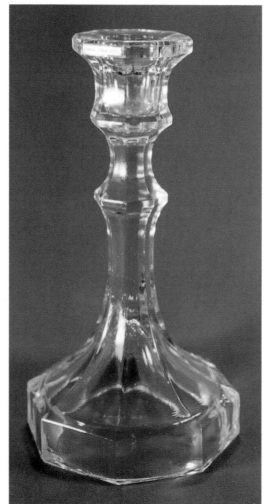

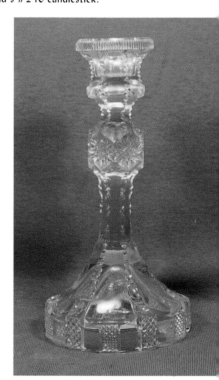

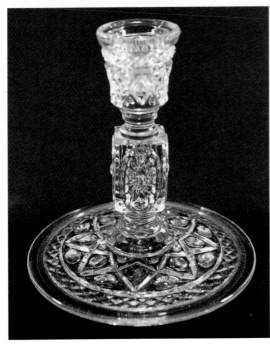

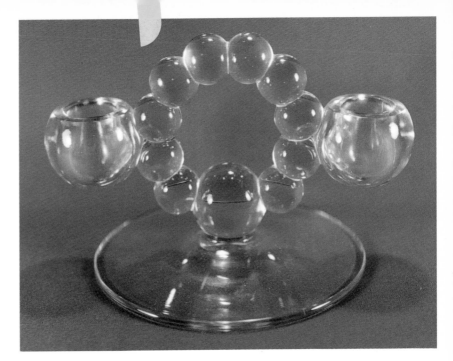

Imperial 4.875" #80 'Cape Cod' single light candle holder. Crystal: $20-25 each. (1930s-mid 1980s).

Below Left: **Imperial** 8.375" #635 single light candlestick. Teal: $30-35 each.

Below Center: **Imperial** 8.25" #635 single light candlestick. Amber: $28-32 each; crystal: $25-30 each; mulberry, peacock, nuruby, peacock iridescent, marigold iridescent: $35-40 each; nuruby iridescent: $40-45 each.

Imperial 4.25" #100 'Candlewick' line #400 double light candle holder. Crystal: $25-30 each. **Note:** This candle holder has the earlier domed base. (1939-1968).

Below Right: **Imperial** 6.875" #671 'Amelia' single light candlestick. Crystal: $30-35 each. (c.1925-1935).

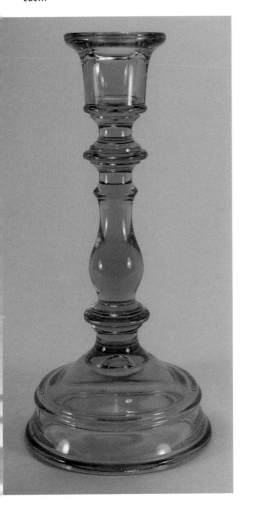

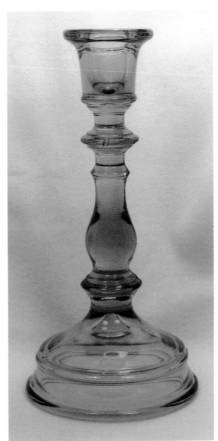

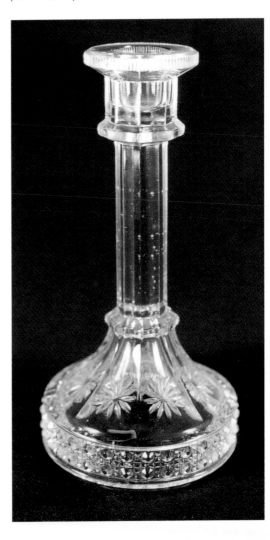

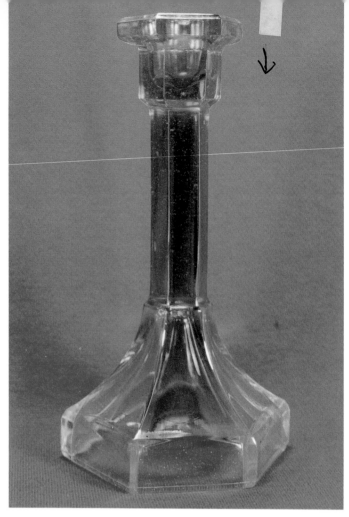

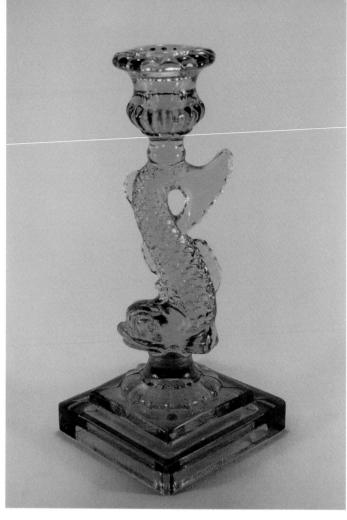

Imperial 7" #6007 hexagonal based single light candlestick. Marigold iridescent: $25-30 each; nuruby iridescent, peacock iridescent, sapphire iridescent: $30-35 each. **Note:** The candlestick shown has worn iridescence and will not command a mint condition price.

Imperial 8.875" #51792 'Dolphin' single light candlestick. Green, amber: $35-40 each.

Imperial 8.5" #320 'Double Scroll' single light candlestick. Marigold iridescent: $35-40 each.

Imperial 8.5" #320 'Double Scroll' single light candlestick. Amber: $25-30 each.

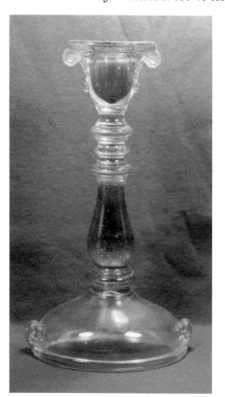

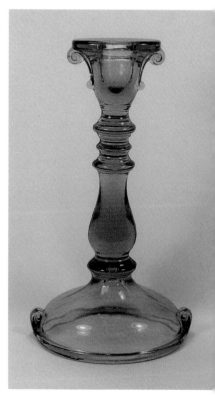

Imperial 8.5" #320 'Double Scroll' single light candlesticks. Marigold iridescent: $35-40 each; teal iridescent: $75-80 each; red: $40-45 each; smoke: $50-55 each; clambroth, amber: $25-30 each; green, Rose Marie: $30-35 each. May have cuttings.

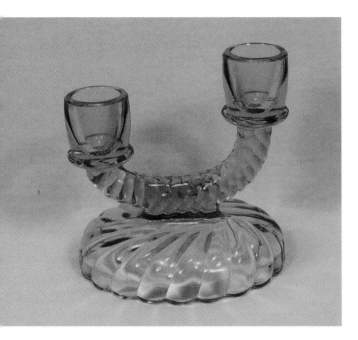

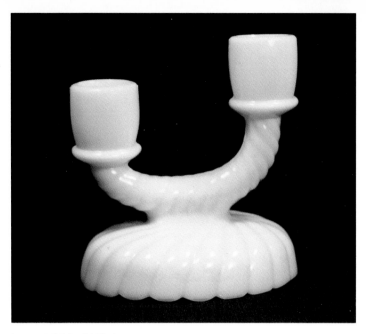

Imperial 4.25" #153 'Newbound' double light candle holder. White milk glass: $15-20 each.

Imperial 4.375" #153 'Newbound' double light candle holder. Light blue, rose pink, Imperial green: $25-30 each; black: $20-25 each; white milk glass, amber, crystal: $15-20 each.

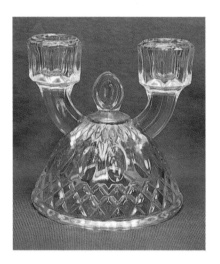

Imperial 4.5" 'Tradition' double light candle holder. Crystal: $30-35 pair.

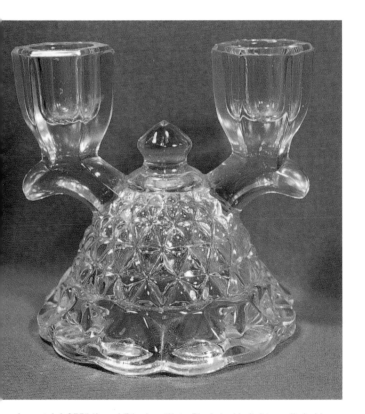

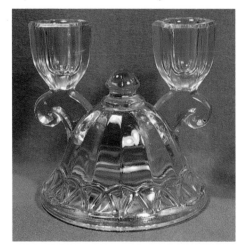

Imperial 4.375" 'Laced Edge' or 'Katy Blue' double light candle holder. Crystal: $18-22 pair; white milk glass: $16-20 pair; blue opalescent, green opalescent: $160-170 pair.

Imperial 4.375" 'Crocheted Crystal' double light candle holder. Crystal: $35-40 pair; white milk glass: $16-20 pair.

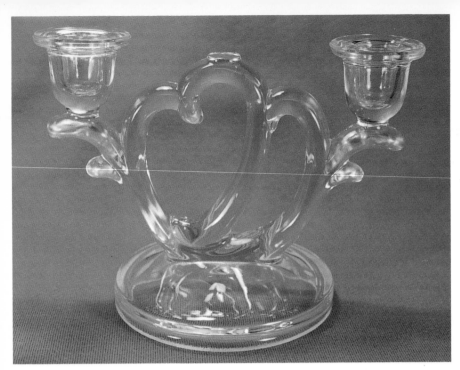

Imperial 5.5" #752 double light candle holder. Crystal: $20-25 each.
The blank of this candle holder was used as a blank for other etchings.

Imperial 5.875" #100 'Cape Cod' line #160 double light candle holder.
Crystal: $55-60 each. (Mid 1930s-mid 1980s).

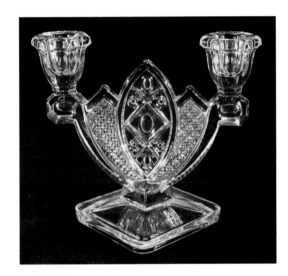

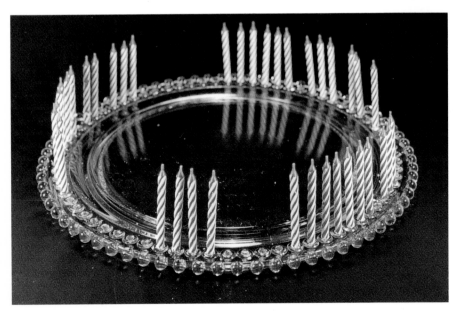

Imperial 0.75" x 13.25" #160 'Candlewick' line #400 72-light 'Birthday
Plate.' Crystal: $430-460 each.

Indiana 2" #2543 'Starburst' votives. Crystal, cobalt, teal: $3-4 each. (1990s).

Indiana 1.75" #1612 single light candle holders. Black, crystal: $2-4 each. (1990s).

Indiana 1.625" 'Diamond Sawtooth' candle pillar. Crystal: $10-12 pair.
Note: This style reflects an increase in pillar platforms for larger candles.

Indiana 1.625" 'Diamond Sawtooth' single light candle saucer. Amber: $10-12 pair.

Indiana 1.125" x 4.25" #2535 single light star candle holders. Crystal: $2-3 each; red, green: $3-4 each. (1990s).

Indiana 2.125"#2538 'Prism' votive. Crystal: $3-4 each. (1990s).

Indiana 2.875 #6373 'Whitehall' votive. Crystal: $2-3 each.

Indiana 2.5" #0775130 'Elegance' votive. Crystal: $1-2 each; cranberry: $2-3 each. (1990s).

Indiana 2" #7512 single light candle holders. Crystal, teal: $2-3 each; red, cranberry: $3-4 each. (1990s).

Indiana 2.25" #0853 'Whitehall' votive. Crystal: $2-3 each. (1990s).

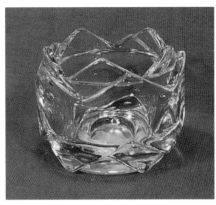

Indiana 2.5" ribbed votive. Red, cranberry, light green, green, light blue, blue, black: $2-3 each. (1990s).

Indiana 2.25" #6752 stackable votive. Crystal: $3-4 each. (1990s).

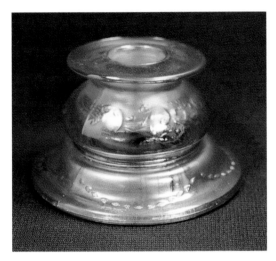

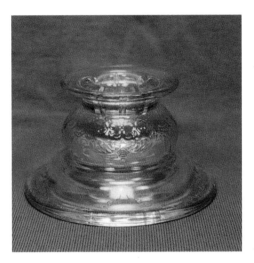

Shown here for comparision to Indiana's 'Recollections' candle holder, **Federal** 2.25" 'Madrid' single light candle holder. Marigold carnival, amber (1932-1939): $24-28 pair. Reissued by Federal in amber in 1976 for the Bicentennial; marked '1976' and called 'Recollection:' $16-18 pair. Shown here for comparison with Indiana's 'Recollections' candle holder.

Indiana 2.25" #378 'Recollections' ('Madrid' mold) single light candle holder. Pink, iridescent, amber, blue, crystal: $8-10 pair. The 1976 date has been removed from the mold, and a vertical grip variation in the candle port has been added. (1990s).

Indiana 2.5" votives with Christmas decorations. Crystal: $2-3 each.

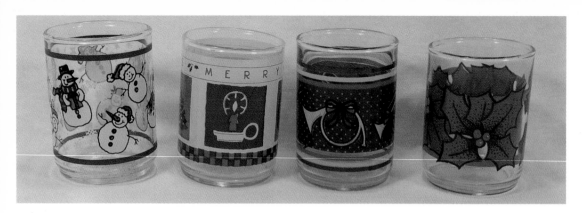

Indiana 2.5" votives with Christmas decorations. Crystal: $3-4 each.

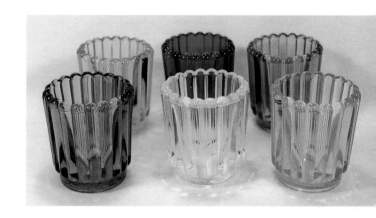

Indiana 2.625" round rib votives. Dark amber, light blue, crystal, green, light green: $2-3 each; red: $3-4 each.

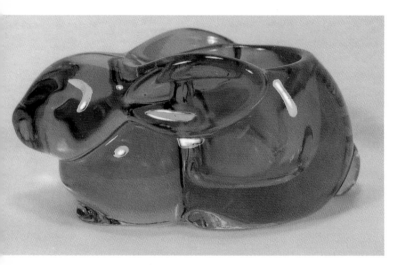

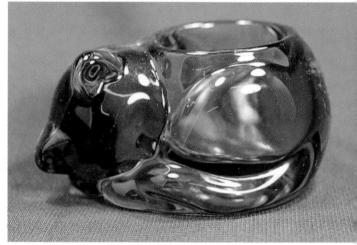

Indiana 2.5" rabbit votive. Cranberry: $5-6 each.

Indiana 2.5" cat votive. Green: $5-6 each.

Indiana 2.5" polar bear, cat, and rabbit votives. Crystal: $5-6 each. (1990s).

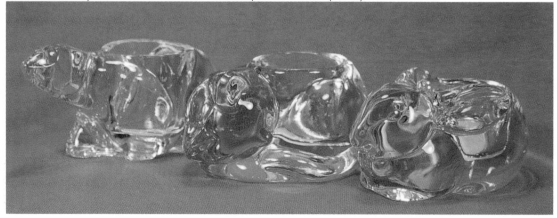

Indiana 3.25" 'Diamond Point' footed votive. Crystal: $3-4 each.

Indiana 3.5" 'Sawtooth Diamond' single light candle holder. Crystal with fired on cranberry: $12-14 pair

Indiana 3.375" 'Diamond Point' votive. Crystal: $3-4 each.

Indiana 3" child's single light candlestick. Blue: $28-32 each; crystal: $22-25 each.

Indiana (for Tiara) 2.875" child's single light candlesticks. Frosted crystal, white milk glass: $12-15 pair.

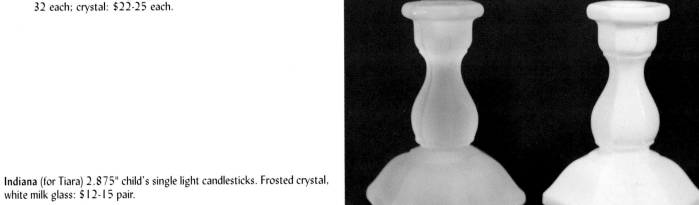

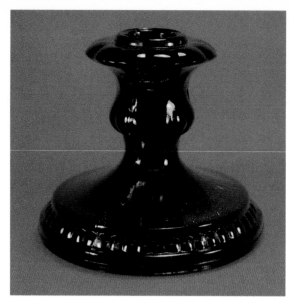

Indiana 3.5" 'Sandwich Glass' single light candle holder. Teal: $16-18 pair.

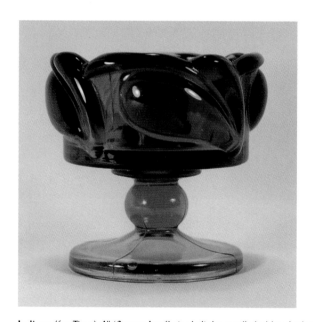

Indiana 3.5" 'Sandwich Glass' single light candle holder. Crystal, amber, teal: $16-18 pair.

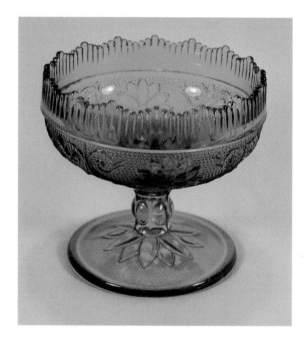

Indiana (for Tiara) 3.375" single light footed candle bowl. Amber, crystal: $16-18 pair.

Indiana (for Tiara) 4" 'Sunset Leaf' single light candle holder. Amberina only: $30-35 pair. (1978).

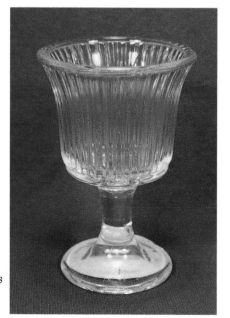

Far left: **Indiana** 4.125" #0935 pedestaled votive. Crystal: $3-4 each.

Left: **Indiana** 3.875" votive. Crystal: $4-6 each. Some made for Avon and marked. Unmarked votives are currently in supermarkets filled with air freshener gel.

Indiana 3.5" #603 single light candle holder. Crystal with fired on red and white decorations: $30-35 pair.

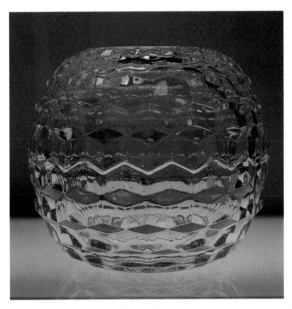

Indiana 3.5" #603 single light candle holder. Pink, crystal: $25-30 pair; crystal with fired on colors and hand decorations: $30-35 pair. (1928-1941). **Note:** Compare to Heisey's #114 'Pluto.'

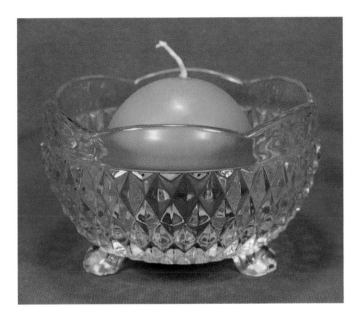

Indiana 3" x 4.875" 'Diamond Point' three-footed candle bowl. Crystal, frosted crystal: $6-7 each; frosted pink: $8-10 each.

Indiana 4.75" 'American Whitehall' two-piece single light candle lamp. Crystal: $14-16 each. Bases for this lamp are also found with the 'Homeco' mark.

Indiana 2.25" x 4.375" #1608 single light candle holder. Crystal: $2-3 each. (1990s).

Above: **Indiana** 3.75" 'Grape & Leaf' single light pedestaled candle holder. Teal, teal iridescent, white milk glass: $12-16 pair.

Center: **Indiana** 5.375" 'Diamond Point' two-piece candle lamp. Crystal: $6-7 each.

Indiana (Duncan Miller mold) 4.125" 'Sandwich Glass' single light candle holder. Amberina, bright blue, green: $7-10 each.

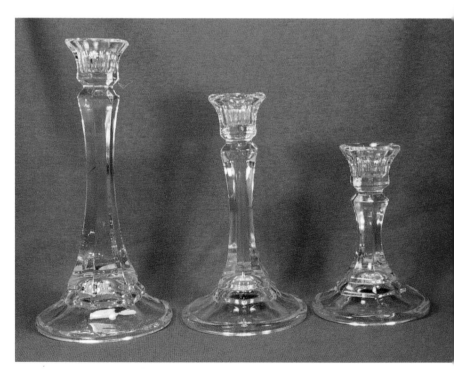

Shown here for comparision to Indiana's #2245, #2246, and #2247 candle holders, **Libby** 4.5" single light candle holder. Lead crystal, amber: $3-6 pair; amethyst: $10-15 pair; black amethyst: $15-20 pair. **Note:** The lead crystal version, which has been discontinued, is probably the most commonly seen candle holder in antique malls where prices vary from $6 a pair to an amazing $28 a pair!

Indiana 7.375" #2247, 6" #2246, and 5" #2245 single light candle holders. Crystal: $3-4 each; colors: $4-6 each. (1990s). **Note:** Compare carefully to Libby's older, discontinued candle holder.

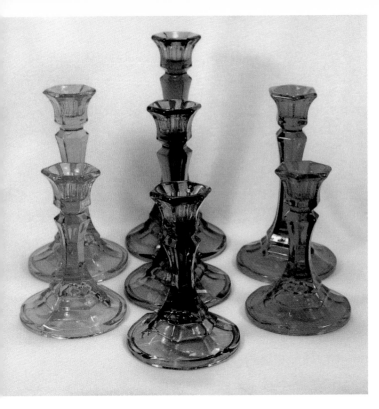

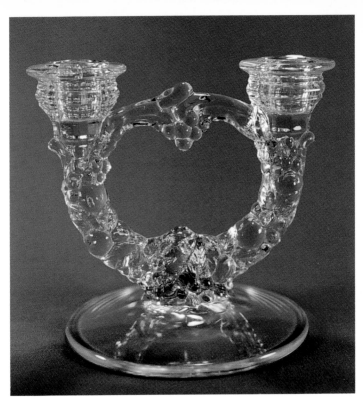

Indiana 7" #2247, 6" #2246, and 5" #2245 single light candlesticks. Colors: $4-6 each. (1990s).

Indiana 5.375" #301 'Garland' double light candle holder. Crystal, crystal/frosted crystal, milk glass: $60-65 pair; crystal with fired on colors: $75-80 pair.

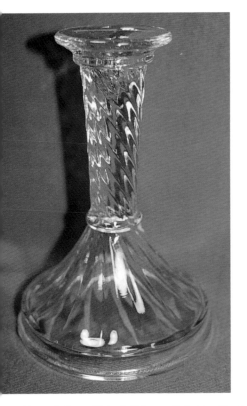

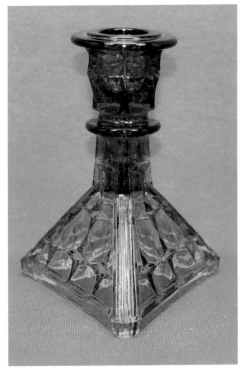

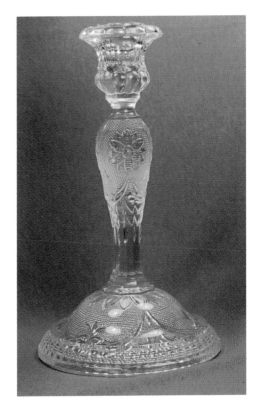

Above: Indiana 6" single light candle holder. Crystal, black: $6-9 each.

Center: Indiana (for Tiara) 5" single light candle holder. Amberina, amber: $7-10 each; teal, yellow, green: $6-9 each.

Indiana 8.25" 'Sandwich Glass' single light candle holder. Crystal, frosted crystal: $28-32 pair; amber: $22-26 pair.

Jeannette

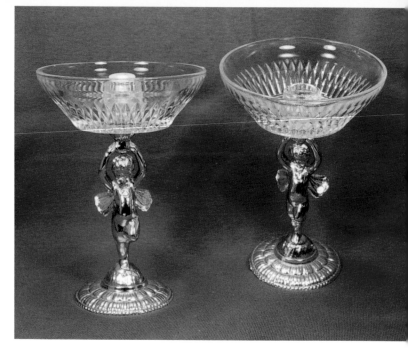

Jeannette 1.75" x 4.875" 'Anniversary' single light candle holder. Crystal: $18-23 pair; marigold iridescent: $23-28 pair.

Jeannette 6.75" 'Anniversary' single light candle holder. Crystal on 5" pedestal: $20-25 pair. The maker of this variation is unknown.

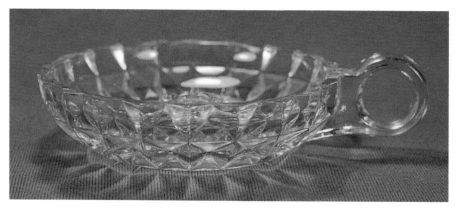

Jeannette 1.25" x 5.25" 'Windsor Diamond' single light handled candle dish. Crystal: $15-20 each. (1947-1972).

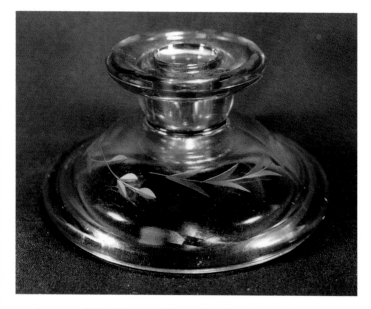

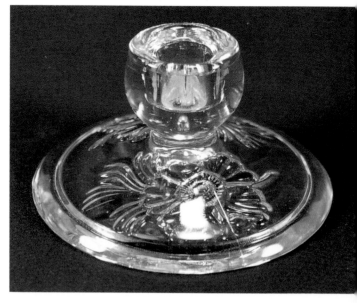

Jeannette 2.5" #69 single light candle holder. Green with cutting, amber: $35-40 pair. (1920s). Used in console sets.

Jeannette 2.625" 'Camelia' single light candle holder. Crystal: $20-25 pair. (1947-1951).

Jeannette 2.625" single light candle holder. Crystal with gold decoration: $20-25 pair.

Jeannette 3" 'Windsor Diamond' single light candle holder. Crystal: $20-25 pair; pink: $85-90 pair.

Jeannette 3" 'Eagle' single light footed candle holder. Shell pink: $85-90 pair.

Jeannette 2.75" 'Bird' or 'Pheasant' single light candle holder. Crystal with gold: $28-32 each; shell pink: cannot price.

Jeannette 3.875" 'Floral' or 'Poinsettia' single light candle holder. Pink: $75-80 pair; green: $85-90 pair. (1931-1935).

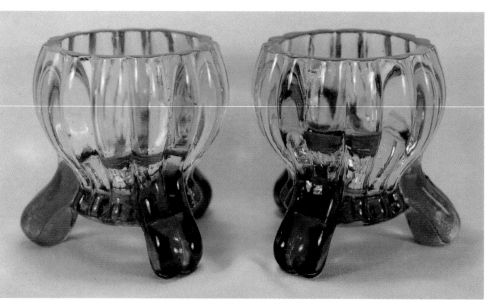

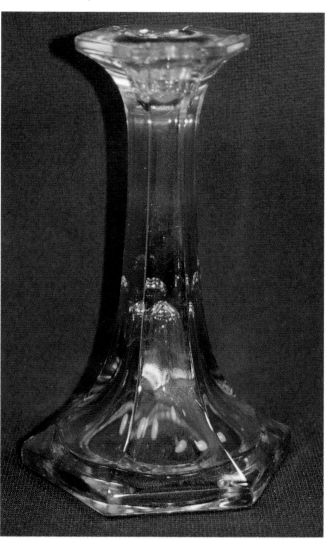

Jeannette 3" 'National' three-footed single light candle holder. Crystal with fired on cranberry, crystal with fired on ruby: $20-25 pair; crystal: $15-20 pair.

Jeannette 7" #5132 single light candle holder. Crystal painted with orange and black: $30-35 pair.

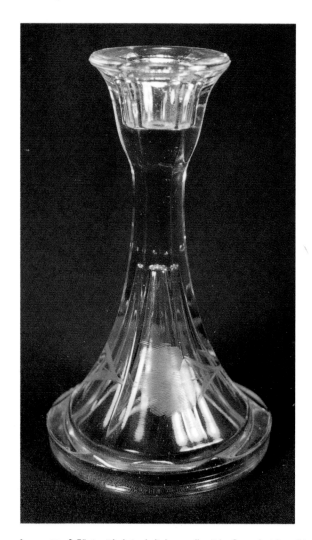

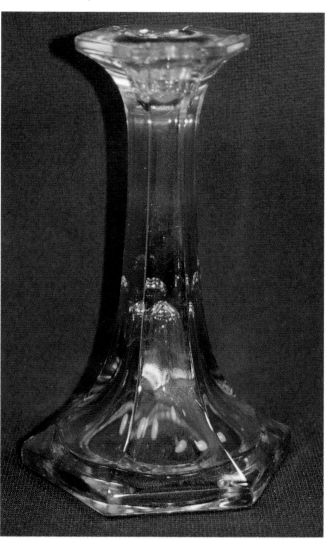

Jeannette 6.5" six-sided single light candlestick. Crystal with etching, crystal, amber, green, marigold iridescent: $35-40 pair. Used in console sets.

Jeannette 7" single light candle pillar. Marigold iridescent: $35-40 pair.

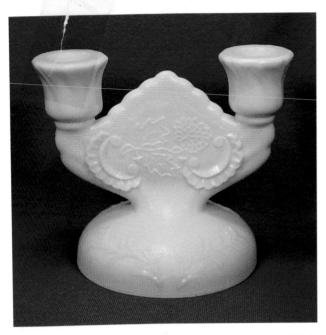

Jeannette 5.25" 'Shell Pink' double light candle holder. Pink milk glass: $55-60 pair. (Late 1950s).

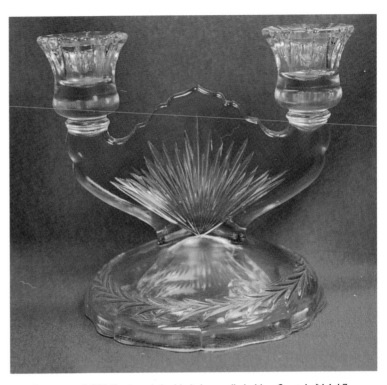

Jeannette 5.25" 'Sunburst' double light candle holder. Crystal: $14-17 each; crystal blank: $10-14 each.

my blue
very similar: ~~mine does not have scallops~~ ↓
~~or base~~
+ top is
~~slightly~~
roundly
hexagonal

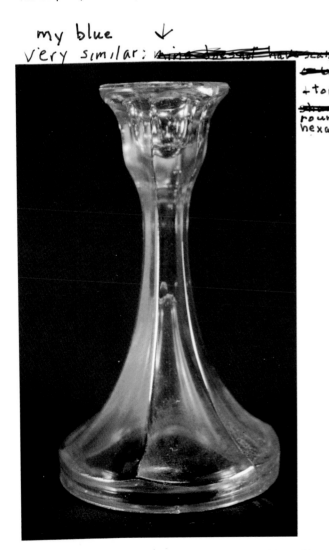

Jeannette 6.5" #5201 six-sided single light candlestick. Marigold iridescent: $35-40 pair. Used in console sets.

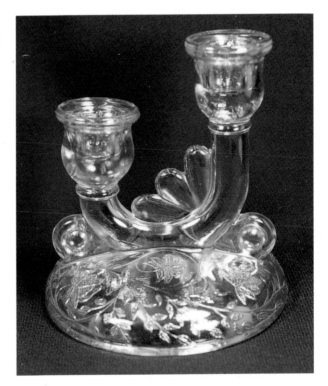

Jeannette 5.25" 'Floragold' or 'Louisa' double light candle holder. Marigold iridescent: $60-65 pair; crystal blank: $50-55 pair.

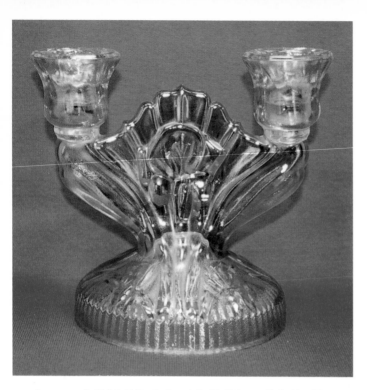

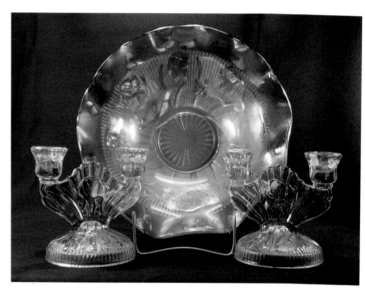

Jeannette 5.25" 'Iris & Herringbone' double light candle holder. Crystal: $40-45 pair (1928-1932; 1950s-1970s); marigold iridescent: $50-55 pair (1950s); frosted crystal with blue and green or red and yellow: $35-40 pair.

Jeannette 5.5" 'Iris & Herringbone' double light candle holder. Marigold iridescent: $50-55 pair.

Jeannette 5.5" 'Swirl' double light candle holder. Green variation: $60-65 pair; pink: $50-55 pair. (1937-1938). Note: This candle holder is usually listed as ultramarine, but considerable variation in color can be found.

Jeannette table center: $70-8

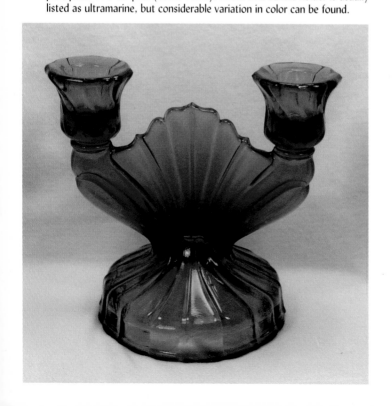

Jeannette table center with 9" bowl, 9.25" plate, and candle holders. Ultramarine: $115-125.

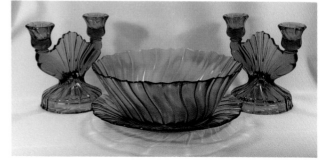

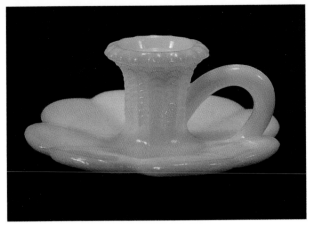

Kemple 2.5" #94 'Narcissus' single light chamber stick. White milk glass, blue, green, amber: $20-25 each; amberina: $25-30 each. Bottom marked 'K.'

Kemple

Kemple 5.25" #304 'Moon & Star Variant' single light candlestick. White milk glass, amber, blue, green: $35-40 each.

Kemple 6.5" #40 'Sawtooth' single light candlestick. Blue, white milk glass, crystal, light amethyst, green, teal amber: $25-30 each; amberina, slag, dark amethyst: $30-35 each.

Kemple 3.25" #70 'Toltec' single light candle dish. Amber, blue, green, white milk glass: $20-25 each; amberina: $25-30 each. Bottom marked 'K.'

Kemple 3" 'Hobnail' single light three-footed candlestick. White milk glass, blue, green, amber, black: $20-25 each. Marked on bottom.

Kemple table center with #87 bowl and #70 candle holders: $95-110.

L. E. Smith

L.E. Smith 2.625" x 5.5" #5217 'Moon & Stars' candle nappy. Amber, crystal, blue, green: $35-50 each; amberina: $35-40 each. (1979).

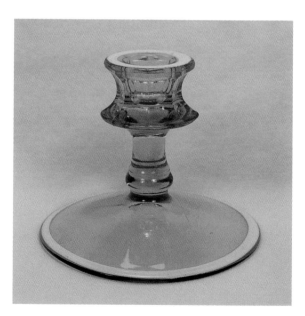

L.E. Smith 3.5" single light candle holder. Pink with white trim, crystal, amber, pink, green, blue: $15-20 pair; black: $20-25 pair. From the Greenburg #1002 mold. Note: Both the top and bottom edges of the light are octagonal.

L.E. Smith 2.75" x 4.75" 'Vintage Grape' single light candle holder. White milk glass: $35-40 pair.

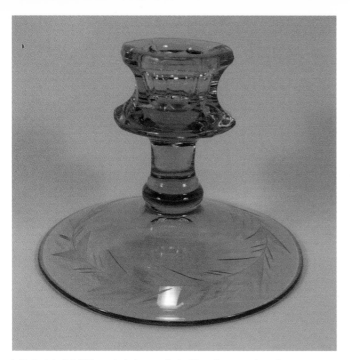

L.E. Smith 3.375" single light candle holder. Green with etching: $18-22 pair.

L.E. Smith 2.25" 'Mt. Pleasant' or 'Double Shield' single light candle holder. Black amethyst, cobalt: $30-35 pair; pink, green, crystal: $22-27 pair.

L.E. Smith 2.5" #133 'Romanesque' single light candle holder. Green, canary, pink, amber, crystal: $25-30 pair; black: $35-40 pair. (1925-1930).

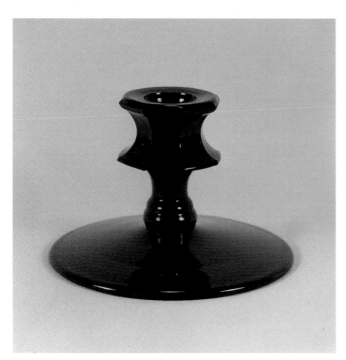

L.E. Smith 3.375" single light candle holder. Black: $20-25 pair.

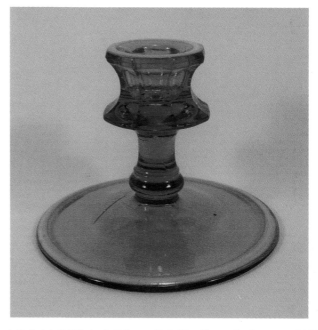

L.E. Smith 3.25" single light candle holder. Blue with white trim: $15-20 pair.

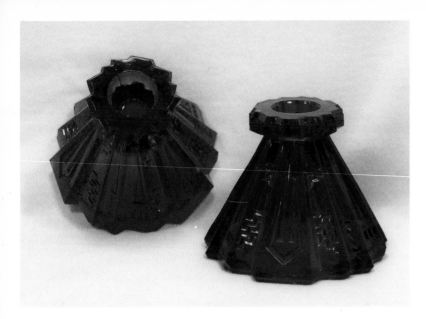

L.E. Smith 2.875" 'Wig-Wam' single light candle holder. Cobalt: $30-35 pair; crystal, amber, pink, green, blue: $25-30 pair.

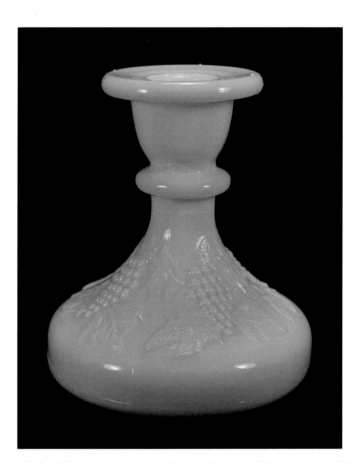

L.E. Smith 4.375" single light candle holder. White milk glass: $25-30 pair.

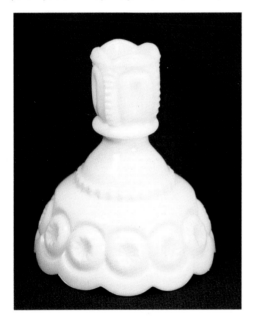

L.E. Smith 4.5" #5231 'Moon & Stars' single light candle holder. White milk glass, crystal: $20-25 pair; cobalt, cobalt carnival, colonial blue: $25-30 pair; all opalescents: $30-35 pair.

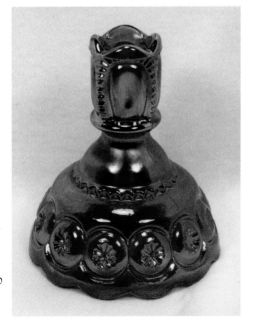

L.E. Smith 5" grape pattern single light candle holder. White milk glass: $25-30 pair.

L.E. Smith 4.5" #5231 'Moon & Stars' single light candle holder. Cobalt carnival: $25-30 pair.

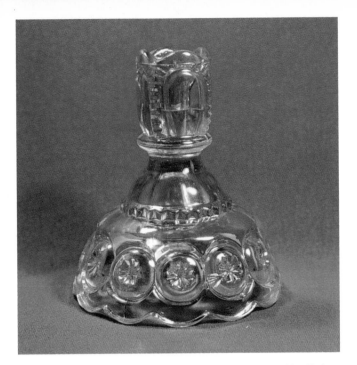

L.E. Smith 4.5" #5231 'Moon & Stars' single light candle holder. Pink iridescent: $25-30 pair. (1990s).

L.E. Smith 3.5" x 4.5" #5281 'Moon & Stars' single light candle holder. Golden amber, white milk glass, blue, green: $15-20 pair; amberina: $20-25 pair.

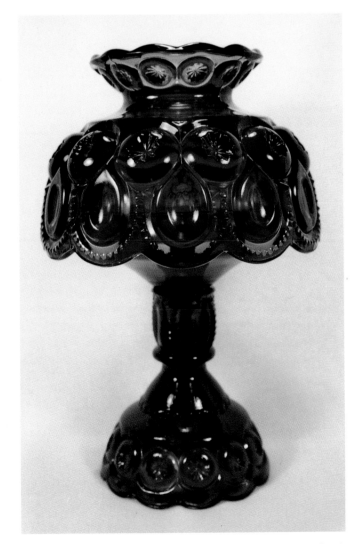

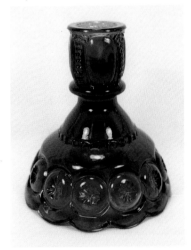

L.E. Smith 4.5" #5231 'Moon & Stars' single light candle holder. Cobalt: $25-30 pair.

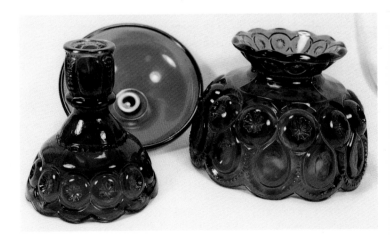

L.E. Smith 7.75" #5275 'Moon & Stars' three-piece candle lamp. Cobalt, amberina: $75-80 each; crystal, brown: $50-55 each; amber, green, blue: $60-65 each.

L.E. Smith 7.75" #5276 'Moon & Stars' three-piece candle lamp. Cobalt: $75-80 each.

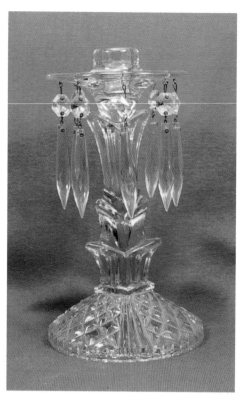

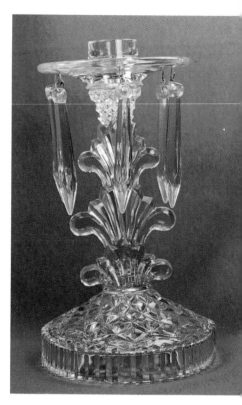

Above: **L.E. Smith** 7.5" single light lustre candle holder with prisms. Crystal: $40-45 each. **Note:** Compare to Duncan Miller's #14 lustre.

Center: **L.E. Smith** 8.5" #1/18 single light lustre candle holder with prisms. Crystal: $40-45 each. (c.1930s).

L.E. Smith 7.5" single light lustre candle holder with prisms. Crystal: $40-45 each.

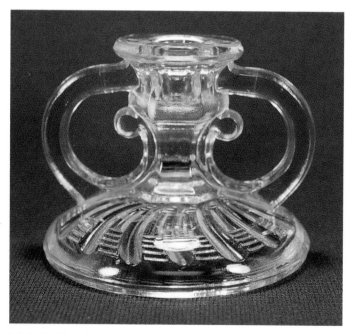

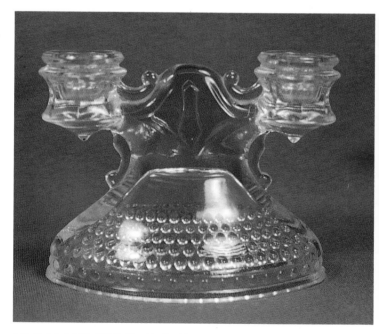

L.E. Smith 3" single light candle holder. Yellow, black, teal, white milk glass, pink iridescent, dark green: $25-30 pair.

L.E. Smith 4.25" #600 'Double Shield' with 'Tear Drop' variation double light candle holder. Crystal: $25-30 pair.

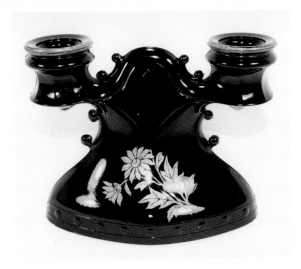

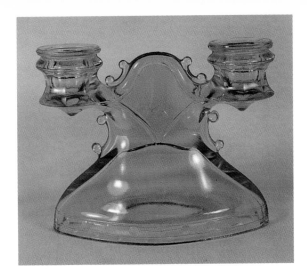

L.E. Smith 4.5" #600 'Double Shield' double light candle holder. Black amethyst with silver decoration: $45-50 pair.

L.E. Smith 4.5" #600 'Double Shield' double light candle holder. Green, pink: $30-35 pair; black amethyst, cobalt: $45-50 pair; crystal: $25-30 pair.

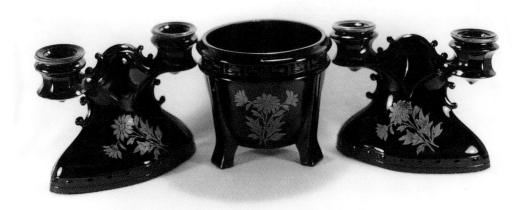

L.E. Smith table center with silver decorated #2 jardiniere and #600 candle holders: $75-80.

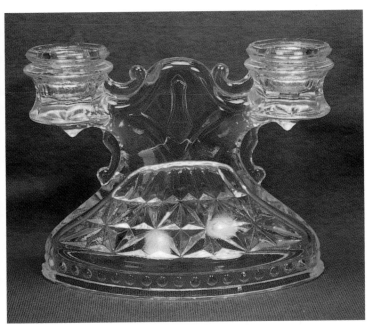

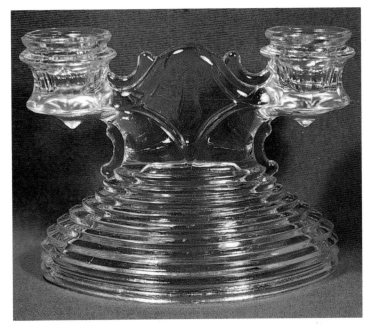

L.E. Smith 4.5" #600 'Double Shield' with 'American Prescut' variation double light candle holder. Crystal: $25-30 pair.

L.E. Smith 4.5" #600 'Double Shield' with 'Manhattan' variation double light candle holder: Crystal: $25-30 pair. This variation was part of the #309/38 console set.

L. G. Wright

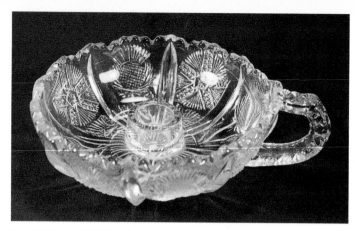

L.G. Wright 1.75" 'Thistle' single light nappy candle holder. Crystal: $25-30 each. (1972-1973 catalog).

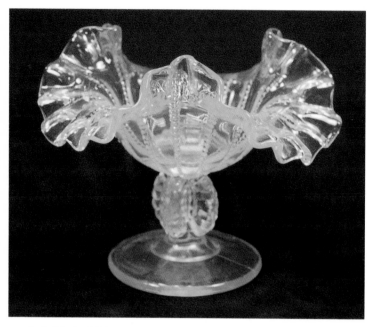

L.G. Wright 4.75" single light candle holder. Vaseline: $50-55 each; crystal: $40-45 each; stormy blue, sparkling ruby: $45-50 each. From an old Northwood mold.

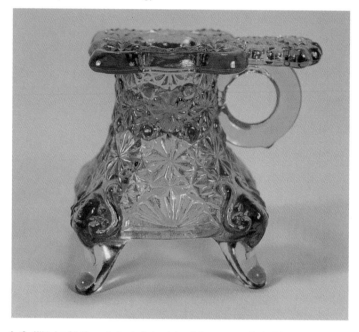

L.G. Wright 3" 'Stove' single light daisy & button candle holder. Amber, green, blue, amethyst: $18-22 each. (1950s-1960s).

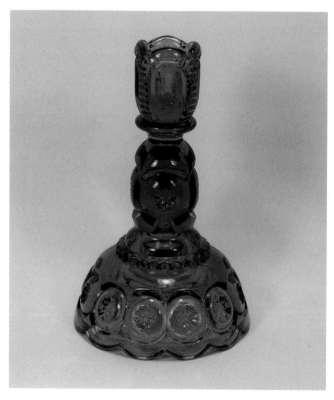

L.G. Wright 6.125" #44-4 'Moon & Stars' single light candle holder. Blue: $35-40 pair; green, amber: $25-30 pair; amberina: $40-45 pair.

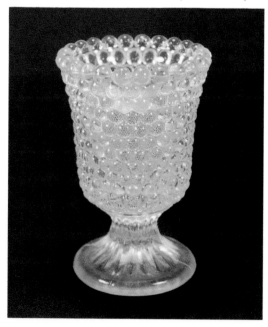

L.G. Wright 4" pedestaled single light votive. Vaseline: $10-13 each; red, blue, green: $6-8 each.

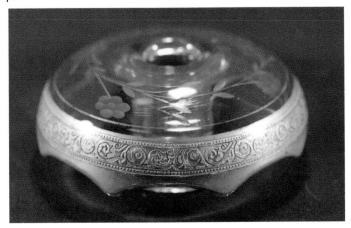

McKee 2" 'Brocade' single light candle holder. Pink with etching: $40-45 pair.

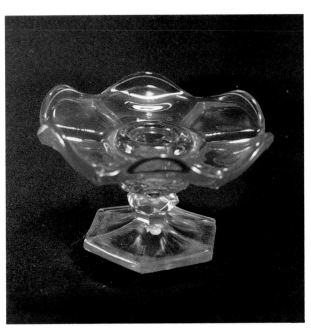

McKee 2" #156 'Optic' or 'Octagon' single light candle holder. Green with cutting and heavy gold decoration: $45-50 pair.

McKee 3" #1776 'Colonial' single light footed candle holder. Green: $25-30 pair.

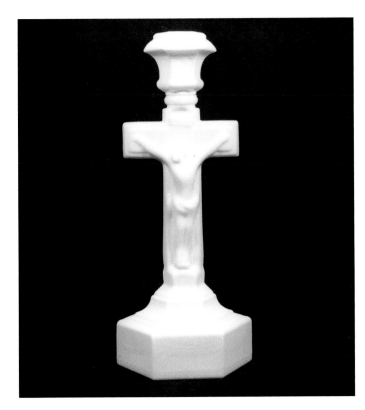

McKee 7.875" single light crucifix candle holder. White milk glass: $65-70 each.

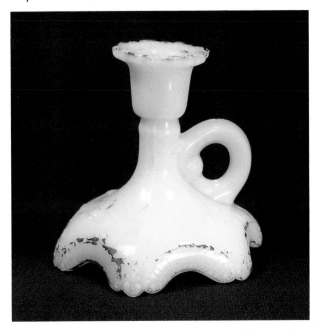

McKee 3.75" 'Cinderella' single light chamber stick. White milk glass with fired on gold: $20-25 each. (c.1899).

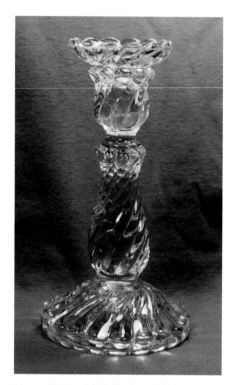

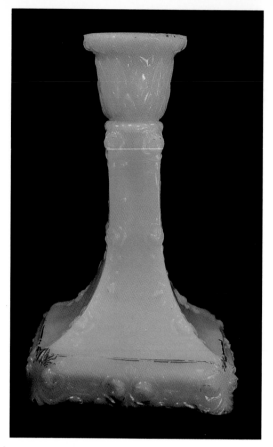

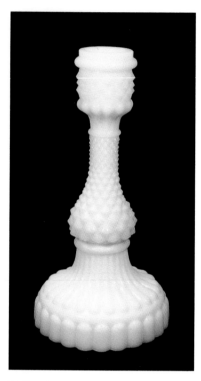

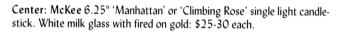

Above: McKee 7.75" 'Ray' single light candle holder. Crystal: $70-75 pair. (1910-1930). **Note:** The flared piece at the top of the light is absent from Fostoria's 'Cascade' and 'Colony.'

Center: McKee 6.25" 'Manhattan' or 'Climbing Rose' single light candlestick. White milk glass with fired on gold: $25-30 each.

McKee 6.5" 'Sawtooth' single light candlestick. White milk glass, crystal: $50-55 pair. (1859-1865). Reissued by Kemple.

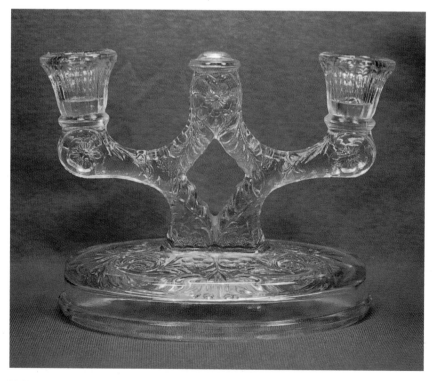

McKee 5.125" 'Rock Crystal' double light candle holder. Crystal: $45-50 pair; red, cobalt: $250-275 pair; green, aquamarine, yellow, pink, amber, frosted crystal, decorated crystal, white milk glass: $100-110 pair.

Metropolitian Museum of Art

Metropolitan Museum of Art 10.75" dolphin single light candle holder.
Blue: $25-30 each.

New Martinsville

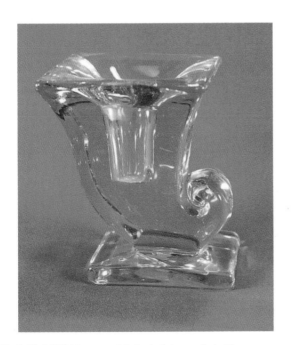

New Martinsville 3.5" #653 'Cornucopia' single light candle holder.
Crystal: $20-25 pair. (c.1930s).

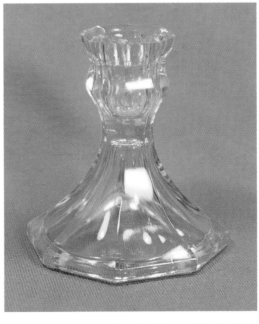

New Martinsville 4" #10 single light candle holder. Pink, black: $15-20
pair.

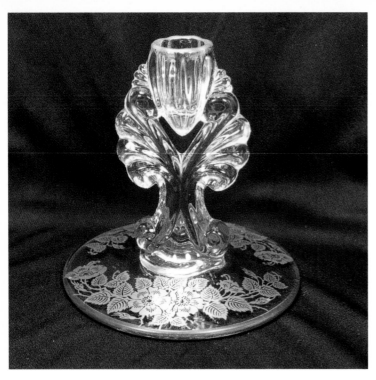

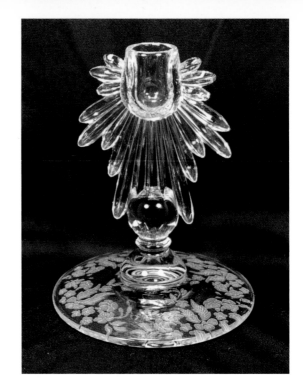

New Martinsville 5.5" #4554 'Vogue' single light candle holder with heavy gold deposit. Crystal: $25-28 each.

New Martinsville/Viking 5.75" #4453 'Sunburst' single light candle holder. Crystal with #26 'Meadow Wreath' etching: $40-45 pair; red, cobalt: $60-65 pair.

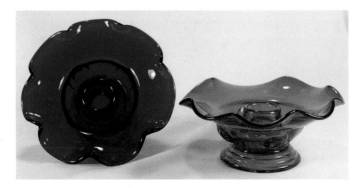

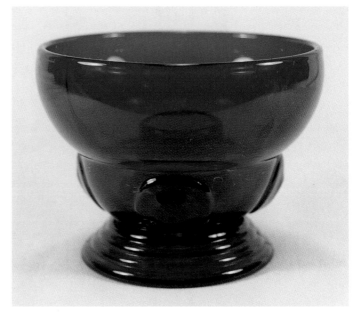

Above: New Martinsville 2" #37 'Moondrops' single light candle holders. Cobalt, red: $50-55 pair; colors: $30-35 pair.

Right: New Martinsville 2.625" 'Moondrops' single light candle bowl. Cobalt, red: $30-35 pair; amber, pink, green, ice blue, amethyst, jadeite, smoke, black, crystal: $25-30 pair.

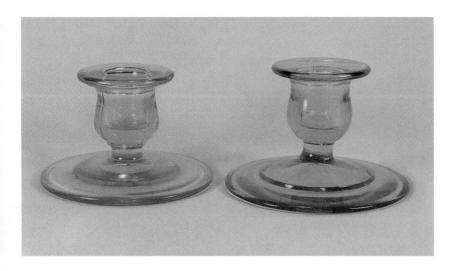

New Martinsville 2.5" #10/4 single light candle holder. Green, amber, pink: $14-16 each; blue: $18-20 each; jade green: $30-35 each.

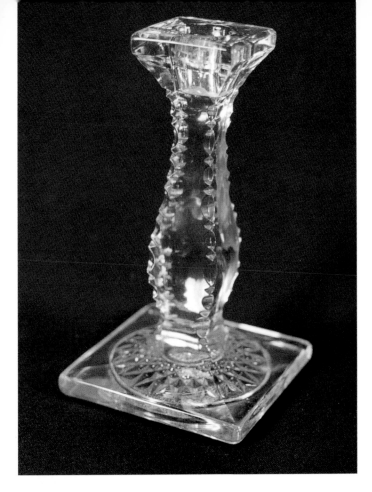

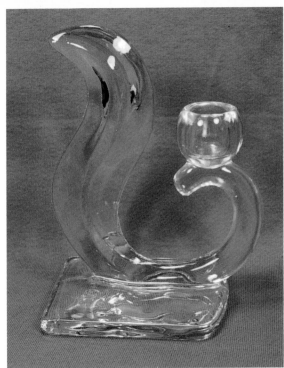

Left: New Martinsville 5.5" #15 single light candlestick. Crystal with wheel engraving: $25-30 each. (1901-1920). Also in 5", 7", and 8.5".

Above: New Martinsville 6.5" #415 'Squirrel Tail' single light candle holder. Crystal only: $10-15 each. (1937-1944). Reissued by Dalzell as #8566.

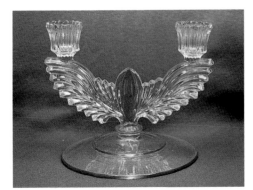

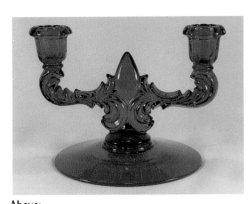

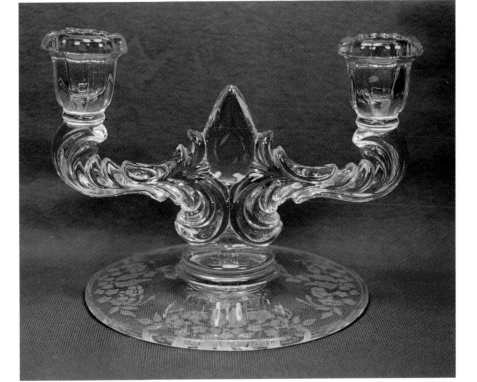

Above:
Top: New Martinsville/Viking 6" #18 'Crystal Eagle' double light candle holder. Crystal: $40-45 each; ruby: $60-65 each. (1936-1944).

Bottom: New Martinsville 5.125" #4457 double light line #4400 candle holder. Red: $40-45 each; pale blue: $35-40 each; crystal with etching: $20-25 each. (Early 1940s). Mold used by Viking 1945-1986.

New Martinsville 5" #4457 double light line #4400 candle holder. Crystal with etching: $20-25 each.

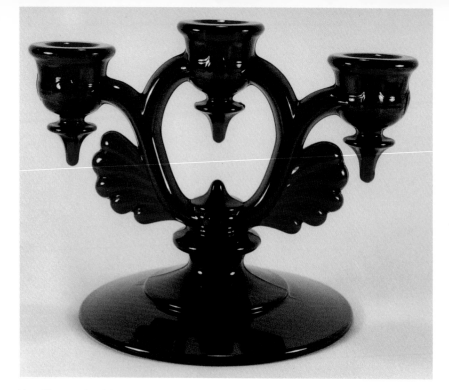

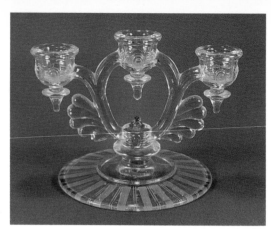

New Martinsville 5" x 7" #73/3 'Moondrops' triple light candelabra. Crystal with etching: $40-45 each; red, cobalt: $70-75 each. (1932-1940).

New Martinsville 5.375" #73/3 'Moondrops' triple light candelabra.
Cobalt: $70-75 each.

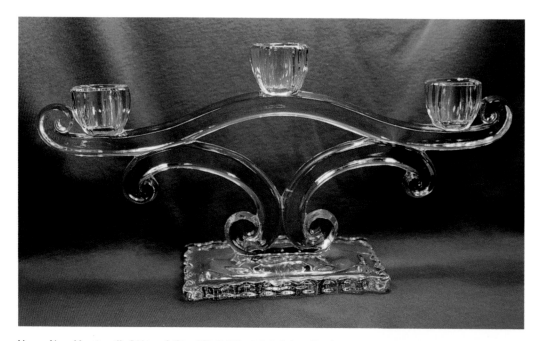

Above: New Martinsville/Viking 6.5" x 13" #425 triple light candle holder. Crystal: $50-55 each. Note: This ornate base is found on newer versions. Reissued by Dalzell as #5215.

Right: New Martinsville/Viking 6.5" x 13" #425 triple light candle holder. Crystal: $65-70 each. Note: The plain base identifies this as an older version.

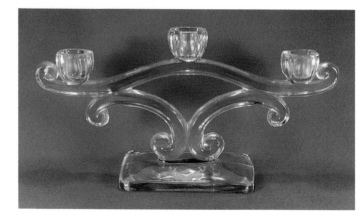

Northwood

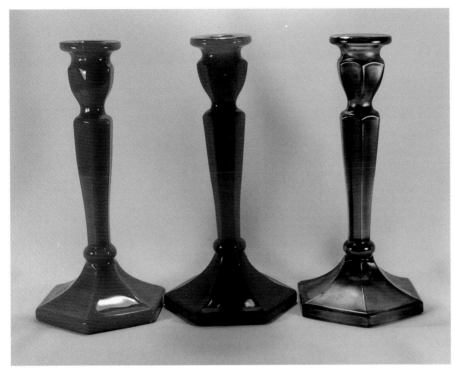

Northwood 8.625" #695 single light candlestick. Chinese coral: $60-65 each; jade green: $45-50 each; russet iridescent: $55-60 each. (1920s).

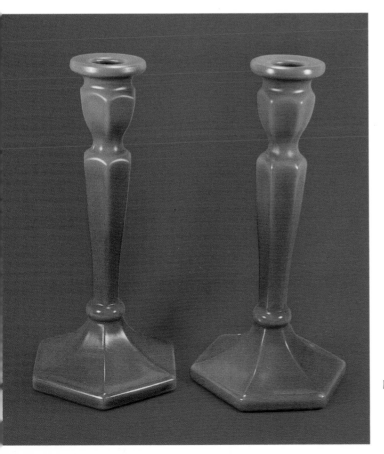

Northwood 8.625" #695 single light candlestick. Blue iridescent: $65-70 each.

Northwood 9" single light candlestick. Jade, blue: $45-50 each.

Paden City

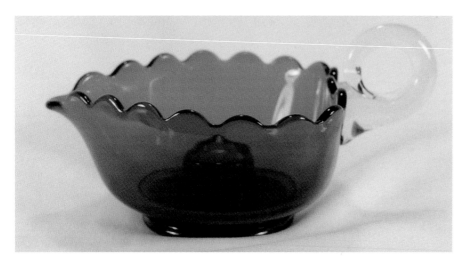

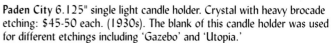

Paden City 3.5" x 6.75" #888 'Plume' single light candle nappy. Green: $45-50 pair; red: $55-60 pair. (1930).

Paden City 6.125" single light candle holder. Crystal with heavy brocade etching: $45-50 each. (1930s). The blank of this candle holder was used for different etchings including 'Gazebo' and 'Utopia.'

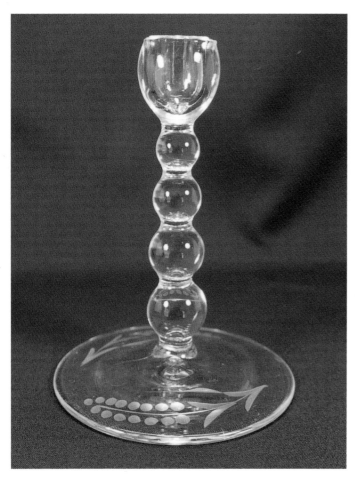

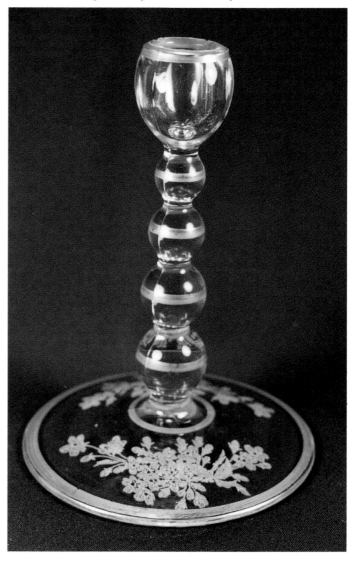

Above: Paden City 6.25" 'Vale' line #444 single light candle holder. Crystal with cutting: $25-30 each.

Right: Paden City 6.25" 'Vale' line #444 single light candle holder. Crystal with etching and gold decoration: $25-30 each. Note: This candle holder has four beads as opposed to three for 'Candlewick'.

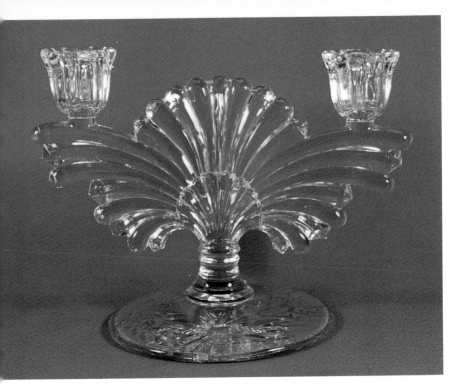

Paden City 5.75" x 8" double light candelabra. Crystal with etching: $55-60 each; crystal without etching: $45-50 each.

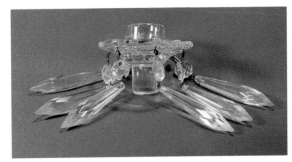

Paden City bobeche and 6 prisms: $20-25 for entire set.

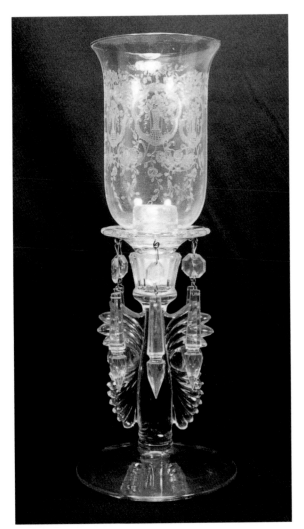

Paden City 6.125" single light candelabra and globe with 'Bridal Boquet' etching (Lotus). Crystal: cannot price.

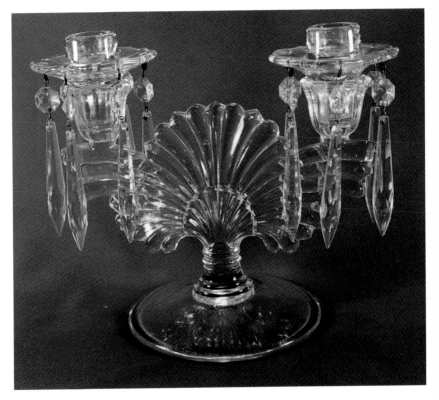

Paden City 7.5" x 8.75" double light candelabra. Crystal: $95-100 each.

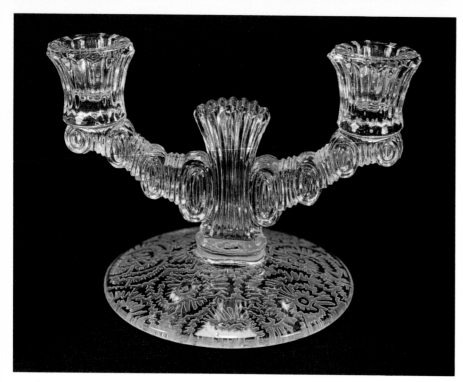

Paden City 4.75" 'Gadroon' double light candle holder. Crystal with 'Frost' etching: $55-60 each; crystal: $45-50 each.

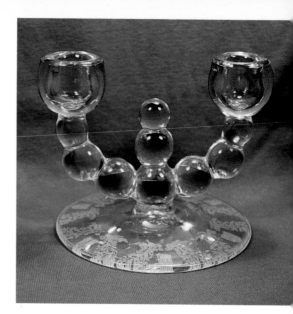

Paden City 4.75" 'Vale' line #444 double light candle holder. Crystal with 'Gazebo' etching: $30-35 each.

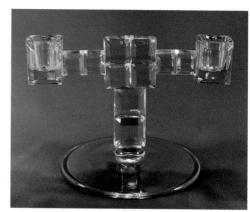

Paden City line #2000 'Mystic' double light candle holder. Crystal: $55-60 each.

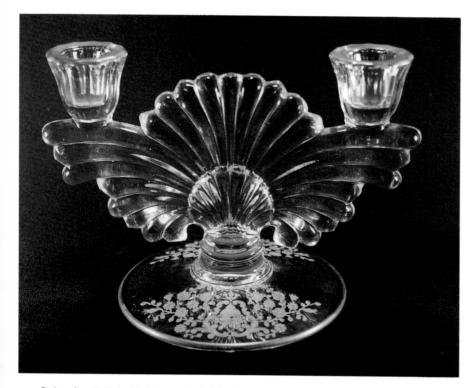

Paden City 5.5" double light candle holder. Crystal with gold deposit: $55-60 each.

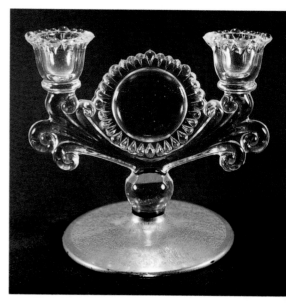

Paden City 5.75" double light candle holder. Crystal with gold deposit: $55-60 each.

Peltier

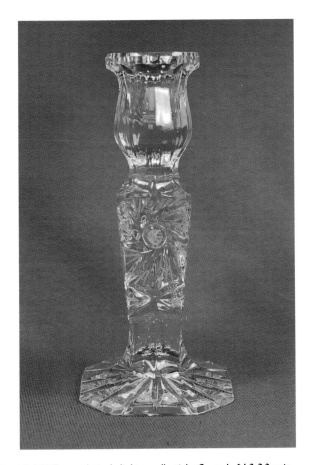

Peltier 3" 'Daisy & Button' votive. Crystal: $3-4 each.

Peltier 2.875" single light votive. Teal: $3-4 each.

Poland

Price Products

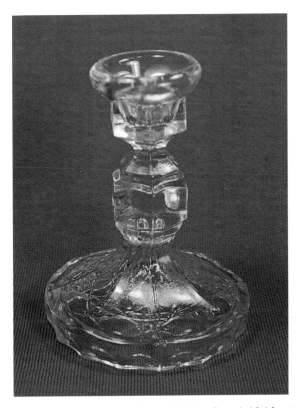

Poland 5.75" 'Lucyna' single light candlestick. Crystal: $18-20 pair.

Price Products 3" single light candle holder. Crystal: $8-10 pair.

Princess

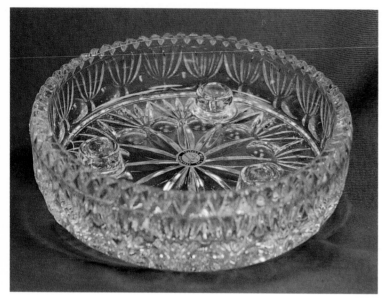

Princess 1.625" triple light candle dish. Crystal: $8-10 each.

Raroy

Raroy 2.25" single light votive. Vaseline: $3-4 each.

Romania

Romania 3.75" single light two-way candle holder. Crystal: $2-3 each.

Taiwan

Taiwan 3.25" swirled single light candlestick. Pink: $6-8 pair.

Above: **Taiwan** 4.75" single light candlestick. Pink milk glass, red: $12-15 pair. Comes in several heights and has rays on the underside of the base.

Center: **Taiwan** 6.25" single light candle lamp. White frosted with pink flowers: $5-7 each.

Taiwan 7.75" single light candlestick. Red: $12-15 pair.

Taiwan 1.25" rose single light candle holder. Pink: $8-10 pair; crystal: $5-7 pair.

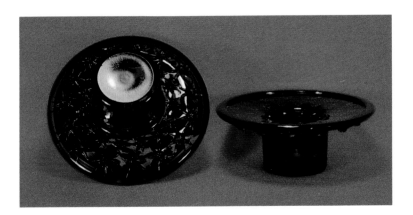

Taiwan 1.25" single light candle holder. Cobalt: $6-8 pair.

Taiwan 6" cherub candle stick. Cobalt: $20-25 pair.

Teleflora

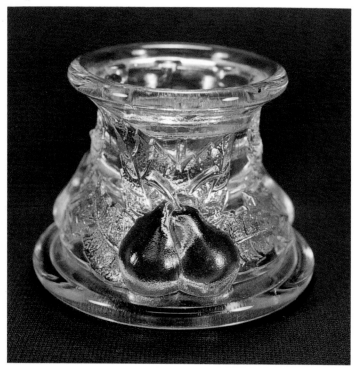

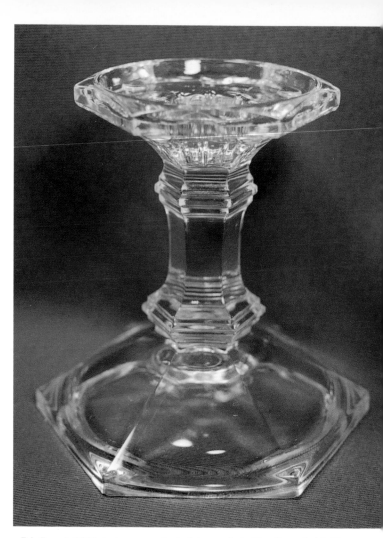

Teleflora 3" pear pattern three-way candle base. Crystal: $22-25 pair.

Teleflora 4.875" dual purpose single light candle holder. Crystal: $8-12 each.

U. S. Glass/Tiffin

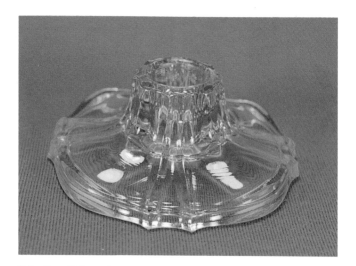

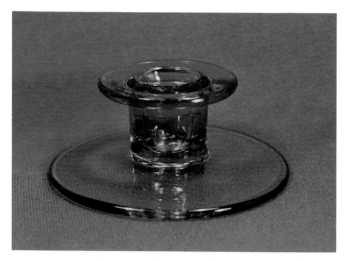

U.S. Glass/Tiffin 1.25" #310 'Bowman' single light candle holder. Transparents: pink, blue, green, black: $35-40 pair; satin finish: $45-50 pair. (1926-1939).

U.S. Glass/Tiffin 1.5" #10 single light candle holder. Transparents: pink, amber, blue, black, crystal, canary, green: $20-25 pair; satin finish: $30-35 pair. (1926-1939). Note: Many manufacturers made a similar candle holder. Identification is very difficult and is based on color lines or decorations.

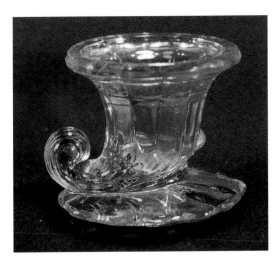

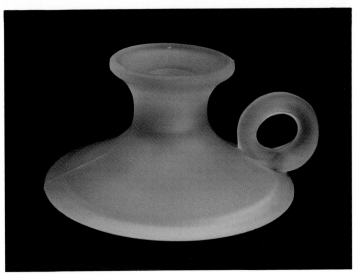

U.S. Glass/Tiffin 2.5" single light cornucopia candle holder. Green: $25-30 each; crystal: $20-25 each. **Note:** Compare to Heisey's 'Warwick' single light candle holder.

U.S. Glass/Tiffin 2.25" #320 single light handled chamber stick. Satin finish: green, amber, pink, black, crystal: $80-85 pair; transparents: $65-70 pair. (1926-1939).

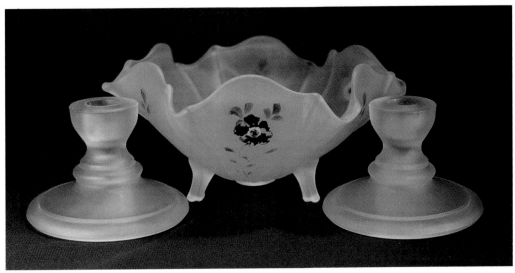

U.S. Glass/Tiffin table center with #310-1/2 bowl and #330 candle holders: $110-120.

U.S. Glass/Tiffin 2.75" #13 single light candle holder. Transparents: canary, amber, sky blue, black: $25-30 pair; satin finish: $40-45 pair. (1926-1939).

U.S. Glass/Tiffin 3" #330 single light candle holder. Satin finish: green, amber, pink: $70-75 pair; transparents: $60-65 pair. (1926-1939).

U.S. Glass/Tiffin 2" #18 single light candle holder. Rose-pink, canary yellow, reflex green: $50-55 pair. (1926-1939).

U.S. Glass/Tiffin 2" #18 single light candle holder. Satin finish: sky blue, black, reflex green, rose-pink: $50-55 pair; transparents: $35-40 pair. (1926-1939).

U.S. Glass/Tiffin 2.875" #9758 single light candle holder. Crystal/green with etching: $55-60 pair. (1929-1936).

U.S. Glass/Tiffin 3.25" #348 single light candle holder. Crystal with etching: $25-30 each. (1926-1940).

U.S. Glass/Tiffin 3.5" swirl single light candle holder. Pink: $35-40 pair; green: $40-45 pair.

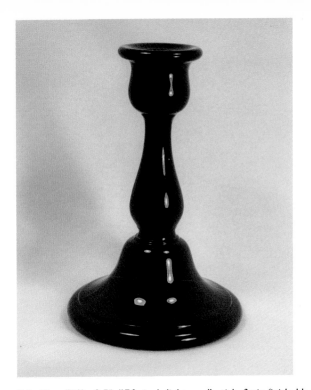

U.S. Glass/Tiffin 6.5" #79 single light candlestick. Satin finish: black, amber, amethyst: $60-65 each; transparents: amber, crystal, canary, pink, green, blue, black: $25-30 each. (1926-1940s).

U.S. Glass/Tiffin 6.75" #81 single light candlestick. Transparents: amber with cutting, crystal, canary, pink, green, blue, black: $50-55 pair; satin finish: $55-65 pair.

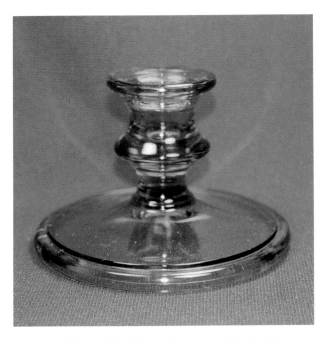

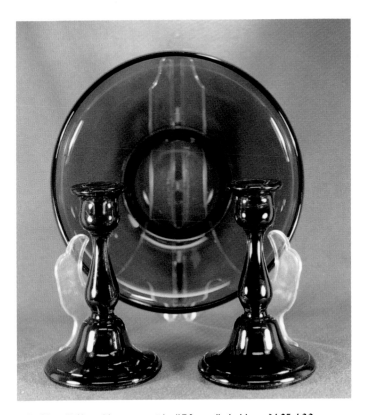

U.S. Glass/Tiffin table center with #79 candle holders: $165-180.

U.S. Glass/Tiffin 3.375" #93 single light candle holder. Transparents: amber, crystal, pink, green, blue, or black: $25-30 pair; satin finish: $30-35 pair. (1926-1939).

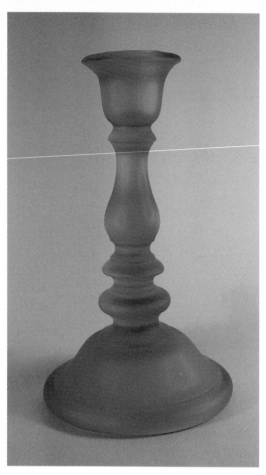

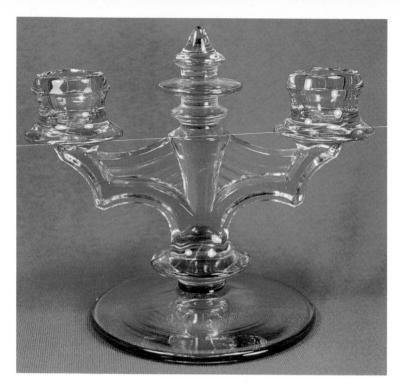

U.S. Glass/Tiffin 5.75" #5831 'Fuschia' blank double light candle holder.
Crystal: $55-60 pair.

U.S. Glass/Tiffin 6.875" #81 single light candlestick:
Satin finish: sky blue: $60-65 pair; reflex green, Saturn green,
or black: $55-60 pair.

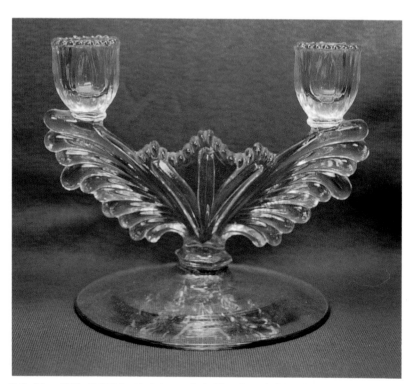

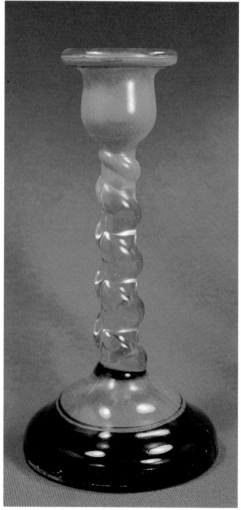

U.S. Glass/Tiffin 5.75" double light candle holder. Crystal: $45-50 pair.

U.S. Glass/Tiffin 7.75" #66 single light candlestick. Orange/
black Art Deco, canary satin, green satin, amethyst, amberina:
$80-85 pair; emerald green: $70-75 pair; royal blue: $90-
100 pair.

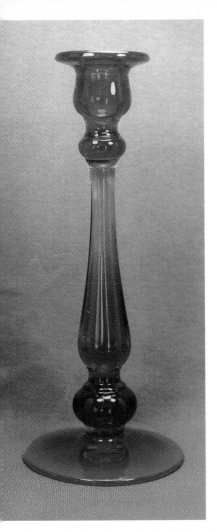

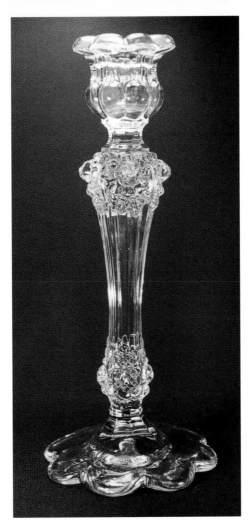

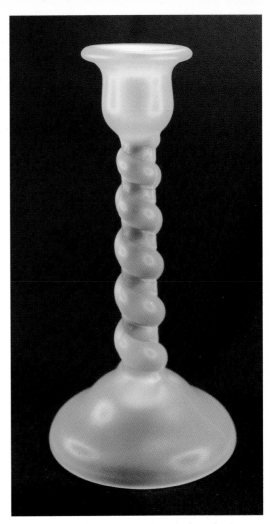

Above: **U.S. Glass/Tiffin** 10" #319 single light candlestick. Amberina: $60-65 pair; satin finish: sky blue, reflex green, canary, pink, black, or crystal: $75-80 pair. (1926-?).

Center: **U.S. Glass/Tiffin** 10" 'Rose' single light candlestick. Crystal: $80-100 pair; sky blue, canary, or green satin glass: $160-175 pair.

U.S. Glass/Tiffin 9" #66 single light candle stick. Satin finish: canary, royal blue, amethyst, emerald green, reflex green, amberina, black: $75-80 pair; transparents: $60-65 pair. **Note:** U.S. Glass/Tiffin's more commonly seen 9" twist (#315) has a flat, not domed base.

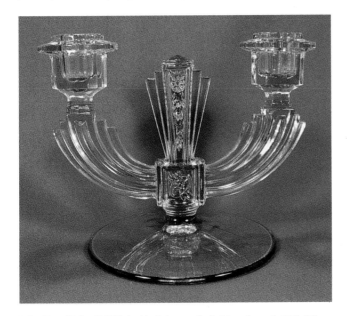

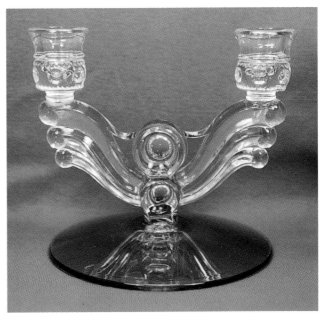

U.S. Glass/Tiffin 5.25" double light candle holder. Crystal: $45-50 pair; black: $65-70 pair; black satin: $75-80 pair. (1936-1940).

U.S. Glass/Tiffin 5.375" #4016 'Kings Crown' double light candle holder. Crystal with cranberry or ruby stain: $60-65 each; crystal: $30-35 each. (Late 1800s-1960s). Made in several colors by Indiana in the 1970s.

Viking

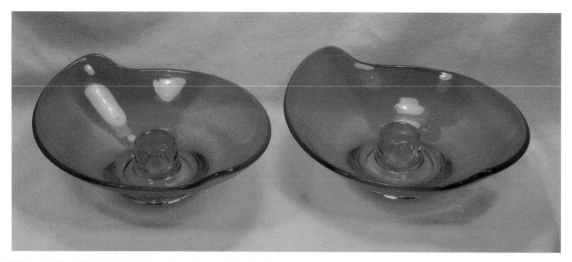

Viking 2.25" x 7" #1196 'Epic' single light candle holder. Red-orange: $20-25 pair.

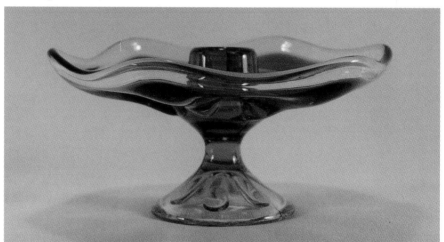

Viking 2.625" x 5.75" single light footed candle saucer. Amberina: $30-35 pair.

Alternative view of Viking 1.5" X 8.25" #6600 series single light candle dish. Orange: $25-30 pair.

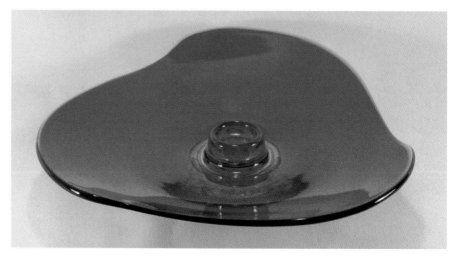

Viking 1.5" x 8.25" #6600 series single light candle dish. Orange: $25-30 pair.

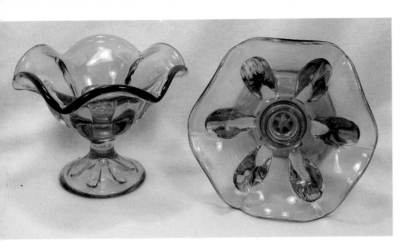

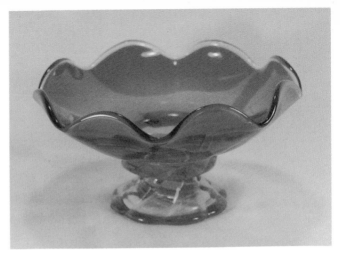

Viking 3.13" #1400 series 'Epic' single light footed candle holder. Amber: $18-22 pair. (1960s).

Viking 3.375" x 6.125" #6600 series single light footed candle bowl. Amberina, blue: $15-20 each; green: $10-15 each.

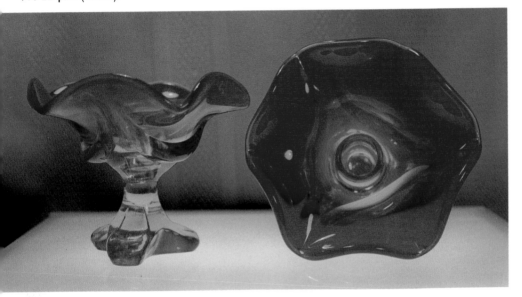

Viking 3.75" single light footed candle holder. Orange: $25-30 pair.

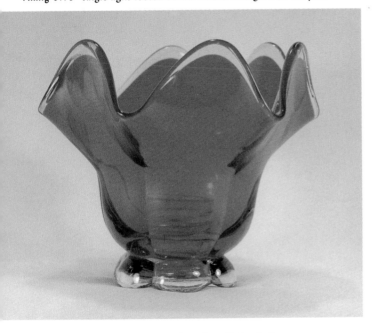

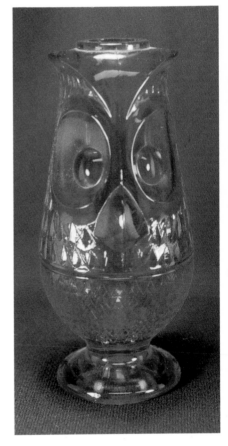

Viking 7.25" owl single light fairy lamp. Orange: $25-30 each. (1981-1982).

Viking 4.5" x 5.25" single light scalloped candle bowl. Orange: $25-30 each.

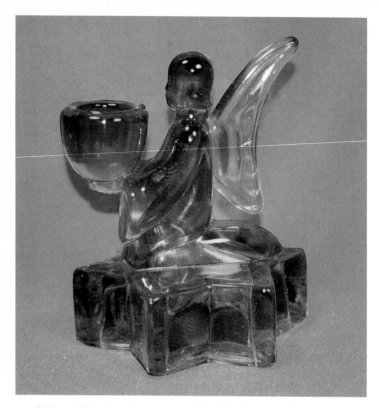

Viking 4.75" single light angel candle holder. Orange: $45-50 pair.

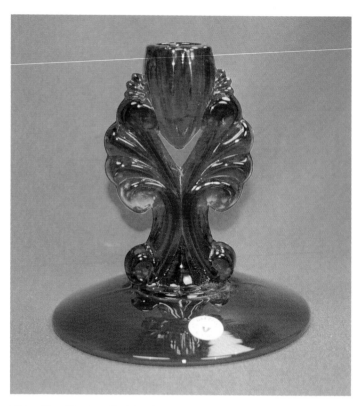

Viking/New Martinsville 5.5" #4554 'Vogue' single light candle holder. Red: $30-35 each; crystal: $25-28 each; cobalt: $30-35 each. (1937-1944). Used for cuttings, etchings, and decorations. Reissued by Dalzell.

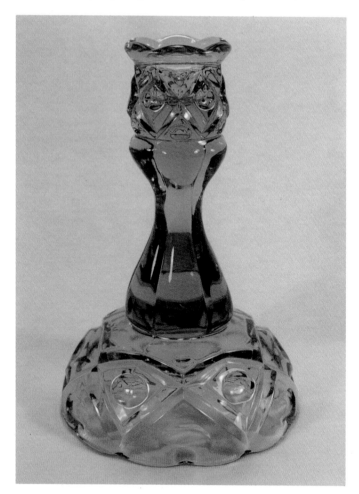

Viking 6" 'Diamond & Thumbprint' single light candle holder. Amber: $15-20 each; red: $20-25 each.

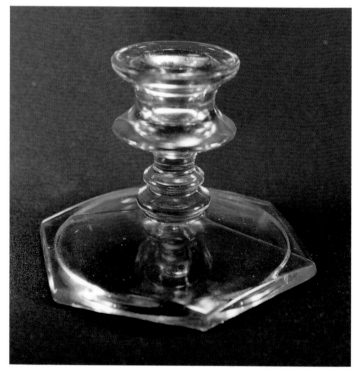

Viking/Dalzell 3.25" single light candle holder. Green: $8-10 each.

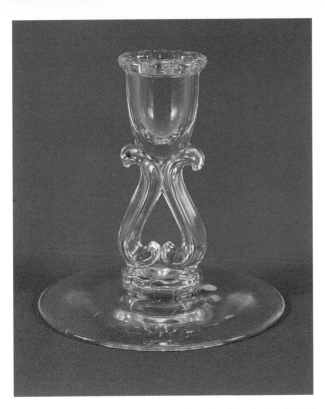

Viking/Dalzell 4" x 6" candle bowl. Blue satin: $15-20 each.

Viking 4.875" #5213 single light candlestick. Crystal only: $20-25 each. (1930s-1950s).

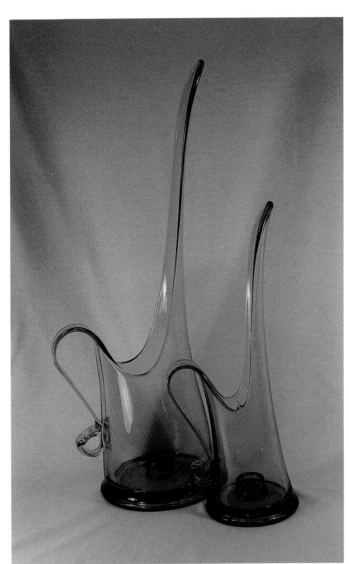

Left: Viking 11.625" single light candle holder. Teal: $25-30 each.

Above: Viking 17.5" and 12" single light candle pitchers: Amber: $30-35 each and $20-25 each.

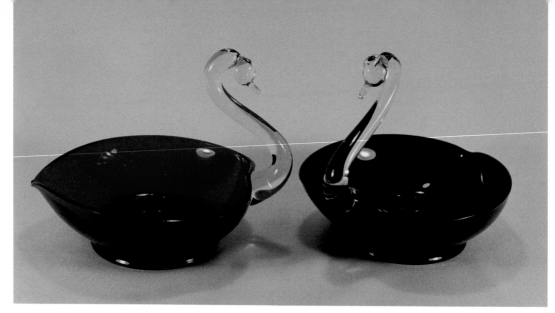

Viking 5" x 6.125" swan-neck single light candle holders. Cobalt, black, ruby: $30-35 each. (c.1950s).

Westmoreland

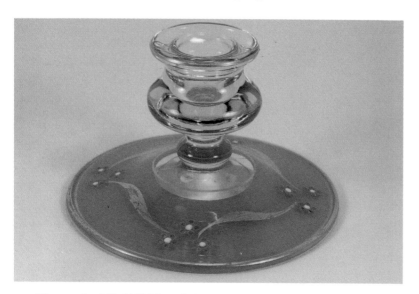

Westmoreland 3" #1054-1 single light candle holder with wheel-cut cased glass base. Orange with decoration: $45-50 pair; undecorated: $30-35 pair.

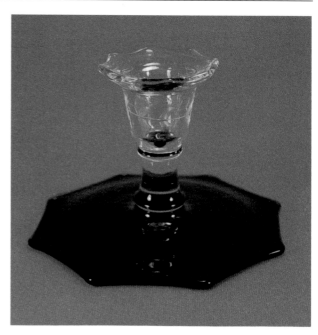

Westmoreland 3.25" #21, line #1211 single light candle holder. Crystal with black cased base and enamel decorations: $40-45 pair.

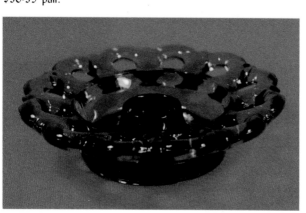

Westmoreland 1" 'Doric' candle dish. Dark blue, red, white milk glass: $5-7 pair.

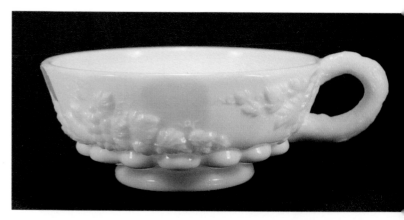

Westmoreland 2" #1881 'Paneled Grape' single light candle holder. White milk glass: $28-32 pair.

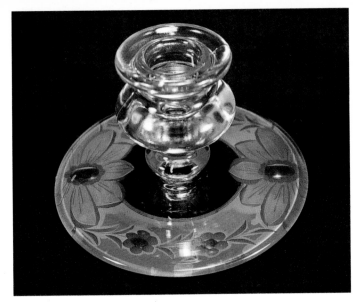

Westmoreland 2.625" #1054-1 single light candle holder. Crystal and blue combination with wheel-cut cased glass base: $45-50 pair. Made for another company as #1735, pattern #308, shown in the 'Fort Dearborn Gift Catalog.' (c.1930).

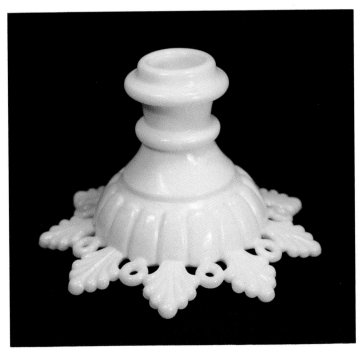

Westmoreland 3.5" #4 line #1875 'Ring & Pearl' single light candle holder. White milk glass, amber, brown mist, apricot mist, antique blue mist, Bermuda blue, golden sunset, antique blue mist, moss green: $25-30 pair; green mist, almond mist: $30-35 pair; lilac mist: $40-45 pair.

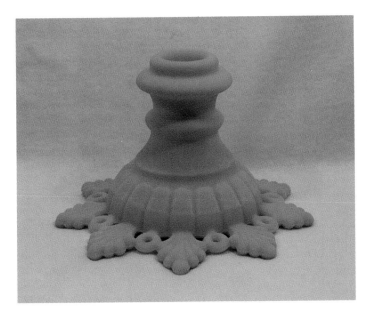

Westmoreland 3.5" 'Ring & Pearl' single light candle holder. Antique blue mist: $25-30 pair.

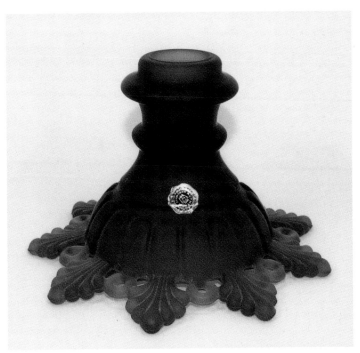

Westmoreland 3.5" 'Ring & Pearl' single light candle holder. Brown mist: $25-30 pair.

Left: Westmoreland 3.375" #71 'English Hobnail' line #555 single light candle holder. White milk glass, crystal: $20-25 pair; pastels: $40-45 pair; golden sunset: $35-40 pair; deep colors: $70-75 pair

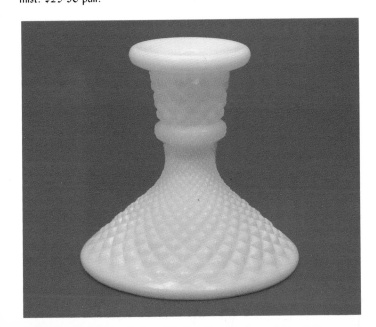

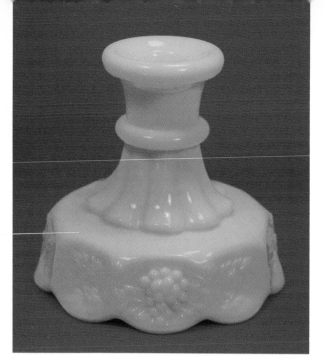

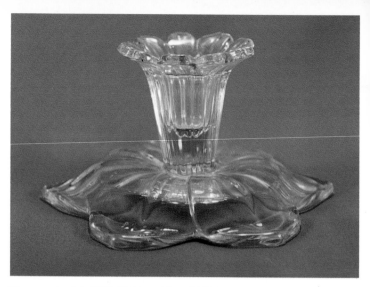

Westmoreland 2.875" #2 'Lotus' line #1921 single light candle holder. Pink, lilac pastel: $30-35 pair; crystal, green, blue, white milk glass, plain colors: $25-30 pair; flame: $45-50 pair; black milk glass, plain colors with hand decorated gold and silver, crystal with ruby stain: $35-40 pair; cased colors: $40-45 pair. (Mid 1920s-1984). **Note:** The flat base on this candle holder is older than the domed base.

Westmoreland 3.875" #20 'Paneled Grape' line #1881 single light candle holder. White milk glass, milk glass mother of pearl, golden sunset: $30-35 pair; white milk glass with 22Kt gold: $35-40 pair; almond mist, green mist, brandywine blue, laurel green, crystal velvet: $40-45 pair; crystal with ruby stain: $45-50 pair; white milk glass with pastel fruit: $60-65 pair; white milk glass with decoration #32 'Roses & Bows:' $80-85 pair. (1940-1984).

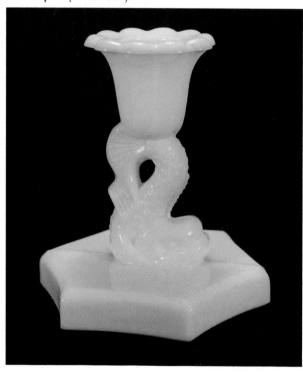

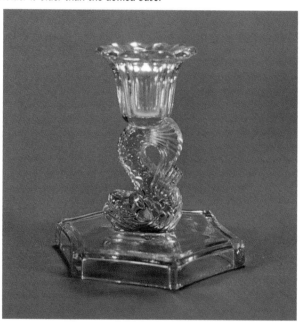

Westmoreland 3.75" #1 'Dolphin' line #1409 single light candle holder. Pink pastel: $40-45 pair. (1924-?). Reissued by Dalzell as #1937.

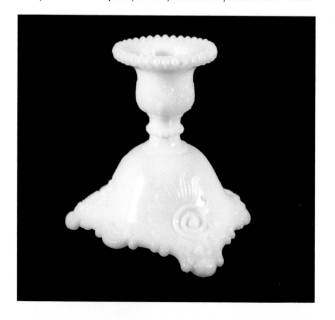

Above: Westmoreland 3.75" #1 'Dolphin' line #1409 single light hex-base candle holder. White milk glass: $25-30 pair; crystal mist: $30-35 pair; almond, almond mist, antique blue, antique blue mist: $35-40 pair; black milk glass, pink pastel: $40-45 pair. (1950-1984). Reissued by Dalzell as #1937.

Right: Westmoreland 4.125" #1872/3 single light candle holder. Milk glass: $40-45 pair; milk glass with gold: $45-50 pair; milk glass with holly: $60-65 pair. Reissued in many colors. Milk glass and crystal mist (with and without decorations) have been reproduced frequently. Summit Art Glass is currently producing cobalt, teal, amberina, cobalt carnival, and others.

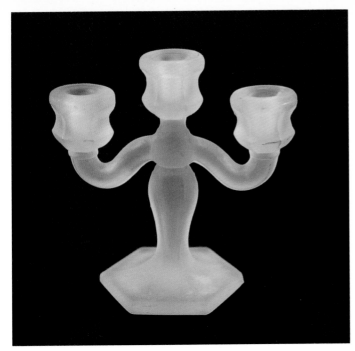

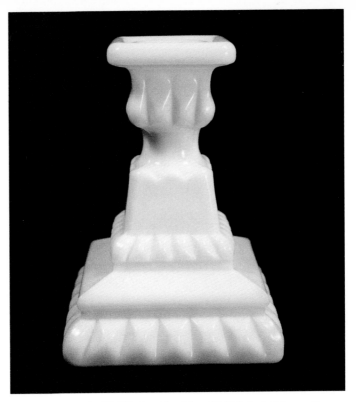

Westmoreland 4.25" #1013/1 triple light mini candelabra. Apricot mist, any color mist: $60-65 pair; crystal, blue pastel, pink pastel: $40-45 pair; lavender, ruby: $55-60 pair. (c.1960s-1980s). Reproduced in vaseline.

Westmoreland 4.5" #3 'Wedding Bowl' line #1874 single light candle holder. Milk glass: $30-35 pair; crystal with ruby stain: $40-45 pair; white milk glass with decoration #36 'Gold Grapes and Leaves:' $45-50 pair; white milk glass with decoration #32 'Roses and Bows:' $50-55 pair. (1930s).

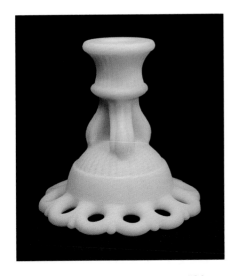

Westmoreland 5.25" #3 'Doric' line #23 single light candle holder. Almond: $35-40 pair.

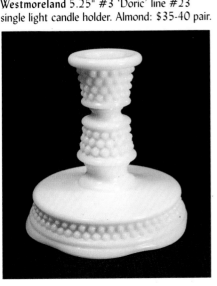

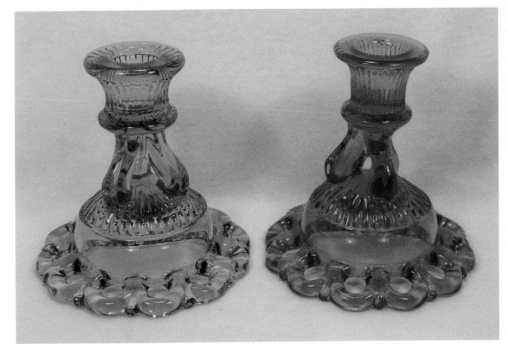

Above: Westmoreland 4.25" #3 line 'Doric' line #23 single light candle holder. Blue, golden sunset, pink, amber, yellow mist: $25-30 pair; white milk glass: $20-25 pair; apricot, blue pastel, pink pastel, crystal, moss, dark blue mist, light blue mist, green mist: $23-28 pair; almond, almond mist, green, pink, Bermuda blue, laurel green, mint green, mint green mist: $35-40 pair; lilac, lilac opalescent, black, flame, ruby: $45-50 pair.

Left: Westmoreland 4.75" #9 'American Hobnail' line #77 single light candle holder. White milk glass: $25-30 pair; lilac opalescent: $35-40 pair; candlelight: $40-45 pair; brandywine blue opalescent: $45-50 pair. Milk glass was produced mainly in the 1950s and opalescents in the 1970s.

Westmoreland 6.25" #38 'Irish Waterford' single light footed fairy light. Crystal with ruby stain, crystal mist with decoration #32, brandywine blue carnival: $75-80 each; crystal: $20-25 each; any mist color with or without flowers: $50-55 each; honey carnival, sky blue carnival: $60-65 each; lime green carnival, almond, antique blue, or mist green with flowers: $70-75 each; violet: $70-75 each; ruby and crystal with blue or green stain: $85-90 each. L. E. Smith is currently reissuing this candle holder.

Alternative view of Westmoreland 6.25" #38 'Irish Waterford' single light fairy lamp. Crystal with ruby stain: $75-80 each.

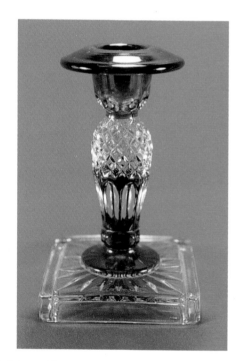

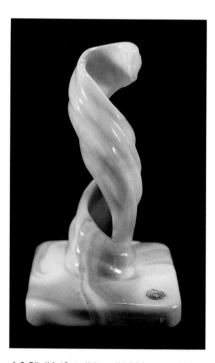

Above: Westmoreland 8" 'Butterfly' line #1972 single light mini lite. Yellow with decal and mist base, any other mist with decal: $35-40 each; any mist without decal: $25-30 each; crystal mist with child's decal or #32 decoration: $65-75 each; almond, mint green, ruby: $40-45 each; any milk glass with decal: $125-135 each. (1972-1984).

Center: Westmoreland 5.75" #24 'Waterford' line #1932 single light candle holder. Crystal with ruby stain: $65-70 pair; crystal: $40-45 pair. (1960s-1970s).

Westmoreland 6.5" #1 'Spiral' line #1933 single light candle holder. Green marble, any marble, lilac: $50-55 pair; white milk glass, golden sunset: $30-35 pair; brandywine blue, all mist greens: $35-40 pair; black milk glass, almond, all other mists: $40-45 pair. White and black milk glass produced in 1930s. A very scarce 4.5" version was also made.

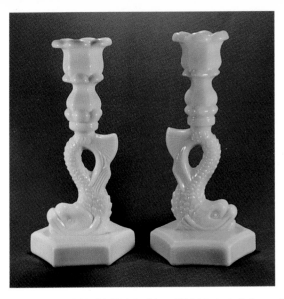

Westmoreland 9" #4 'Dolphin' line #1049 single light candlesticks. White milk glass, crystal, opalescent: $80-85 pair; almond, blue opalescent, all antique blues: $95-110 pair; black milk glass: $120-130 pair; amber, blue, pink, green: $135-150 pair (1920s-1930s); newer mists and pastels: $45-50 pair. Also in 4". Has been reproduced.

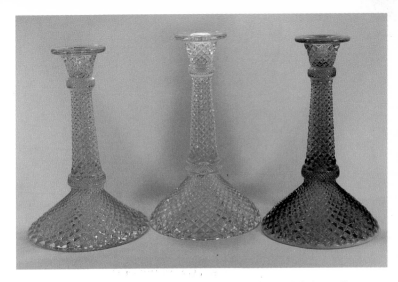

Westmoreland 8" #130 'English Hobnail' line #555 single light candlestick. Pastels: $65-70 pair; crystal: $50-55 pair; deep colors: $110-120 pair. (1925-1980s).

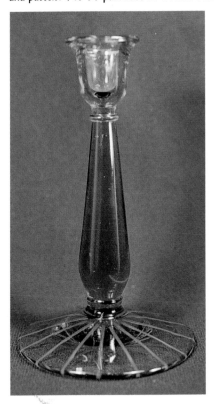

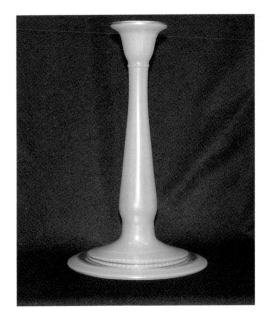

Westmoreland 7.125" #240 single light candlestick. Crystal only: $45-50 pair. (c.1905-924). **Note:** Compare to Imperial's six-sided candlestick.

Above:
Left: **Westmoreland** 6.5" #1042 single light candlestick. Amber, pink, blue, green (all with cutting or decoration): $75-80 pair; crystal with decoration: $45-50 pair; crystal, pink, blue green (all without cutting or decoration): $35-40 pair; Belgian blue, cobalt, red: $110-125 pair. (1920-1940).
Right: **Westmoreland** 9.125" #1042 single light candlestick. Plum over crystal with gold decoration: $75-80 pair; cranberry stained with heavy cutting: $100-130 pair; cranberry stained with cutting and etching: $90-130 pair. (1920s-1940). This candlestick was made with and without the lower ring above the base.
Bottom right: **Westmoreland** 9.5" #1042 single light candlestick. Crystal with green and gold: $75-80 pair; cased glass with cuttings: $75-125 pair.

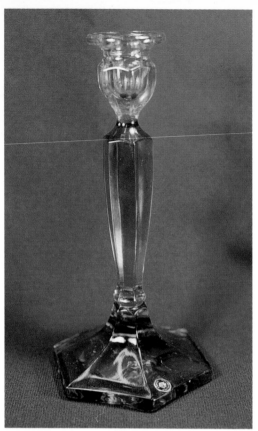

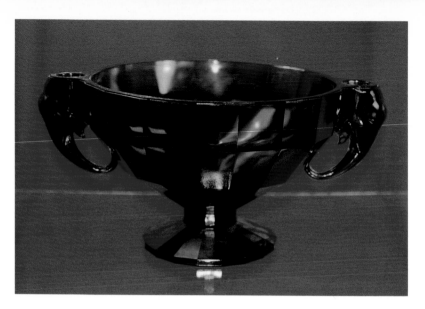

Westmoreland 11" #1932/2 'Bowl with Elephant Candleholders' one-piece console. Teal blue: $70-75 each; crystal: $45-50 each; other colors: $60-75 each. (1932). Reissued in cobalt and black: $30-35 each.

Westmoreland 8.25" #1034 single light candlestick. Amber: $40-45 pair; crystal with decoration, French gray/black, yellow/black, orange/black, green/black: $60-65 pair; black/silver: $100-110 pair; black with satin etching: $125-135 pair. These candle holders have a solid base.

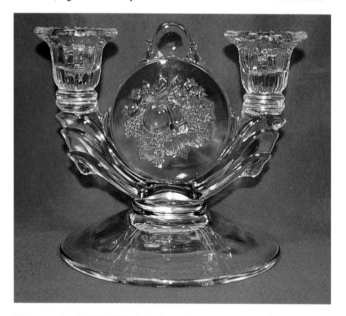

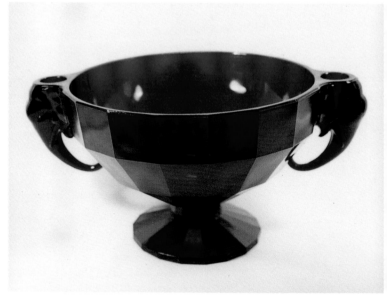

Westmoreland 5.5" 'Della Robia' paneled double light candle holder. Crystal, crystal with fired on colors: $140-150 pair. (1920s-1940s).

Westmoreland 11" #1932/2 'Bowl with Elephant Candleholders' one-piece console. Cobalt: $30-35 each.

1. Unknown 1.25" single light candle holder. Crystal.

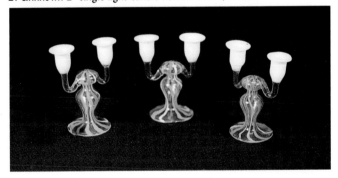

2. Unknown 2" single light candle holder. Green, amber.

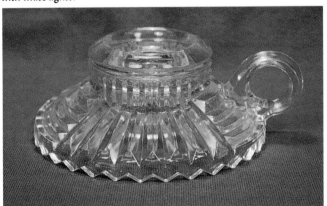

3. Unknown 1.625" double light mini candle holders. Multicolor stripes with white lights.

Some Unknowns

This chapter includes some of our favorite crazy-makers. They look so much like an identified candle holder, but they're just not quite the same! We would really appreciate information from our readers helping us document makers, colors, and price ranges. We have numbered the candle holders in this chapter for easy reference. If you can provide information about any of them, or if you would like to comment on any of the identified candle holders, please write to the authors C/O Schiffer Publishing Ltd.

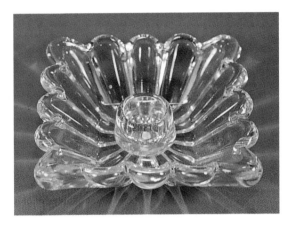

5. Unknown 1.375" single light square candle dish. Crystal.

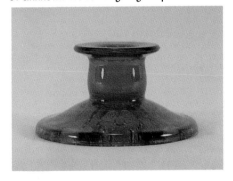

6. Unknown 2" single light candle holder. Red with flower pattern under base.

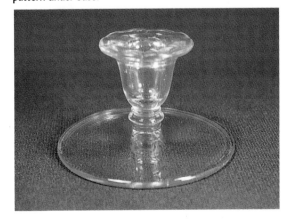

4. Unknown 2.125" single light handled hurricane base. Crystal, crystal with fired on red.

7. Unknown 2.25" single light candle holder. Apple green.

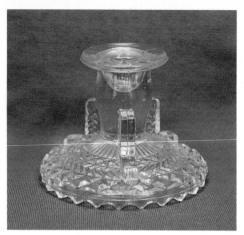

8. Unknown 3" single light candle holder. Crystal.

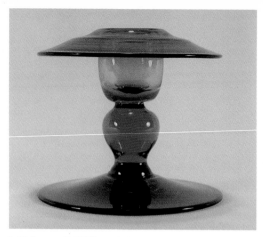

9. Unknown 3.875" single light candle holder. Red.

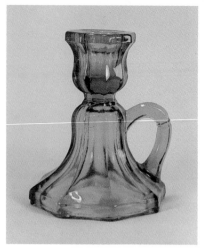

12. Unknown 4.625" single light chamber stick with horizontal groove around handle. Amber, crystal, white milk glass.

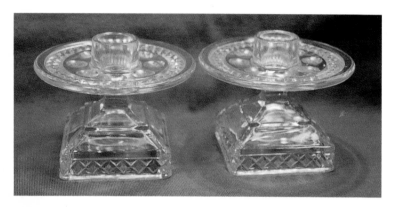

10. Unknown 3.375" single light candle holders. Crystal.

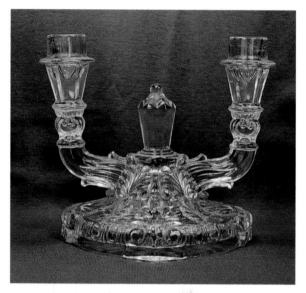

13. Unknown 6.25" double light candle holder. Crystal.

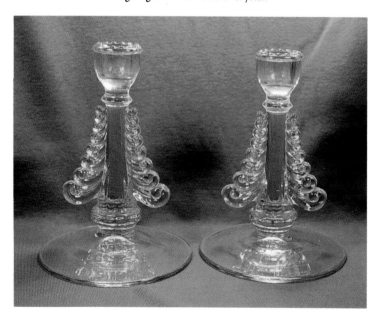

11. Unknown 6.375" single light candle holders. Crystal.

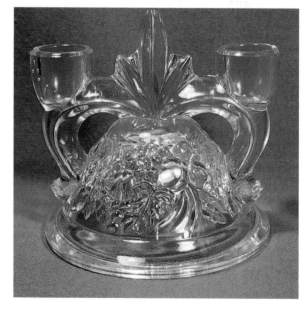

14. Unknown 4.5" double light candle holder. Crystal.

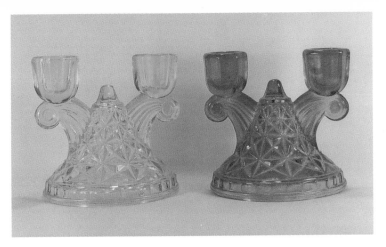

15. Unknown 4.125" double light candle holders. Yellow, orange, green, crystal.

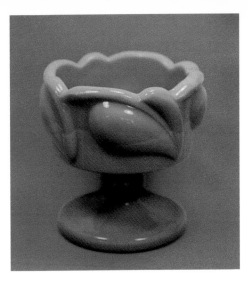

18. Unknown 3.75" single light pedestaled candle holder. Turquoise milk glass.

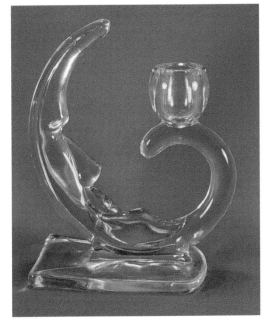

16. Unknown 6.75" single light "Moon" candle holder. Crystal.

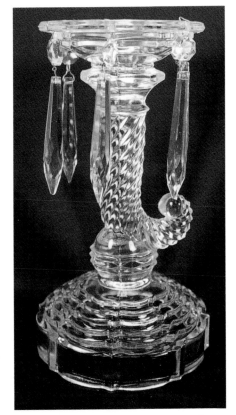

19. Unknown 8.5" single light lustre candle holder. Crystal.

20. Unknown 9.75" single light stemmed candle goblet. Marigold iridescent.

17. Unknown 6.875" single light candle holder. Crystal.

157

21. Unknown 6.5" single light candle holder. Crystal with etching and gold deposit.

22. Unknown 5.375" double light candle holder. Crystal with cutting on base, white milk glass.

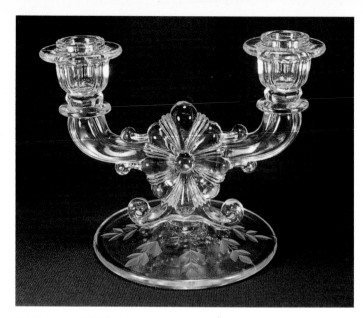

23. Unknown 5.5" double light candle holder. Crystal with etching, crystal, white milk glass.

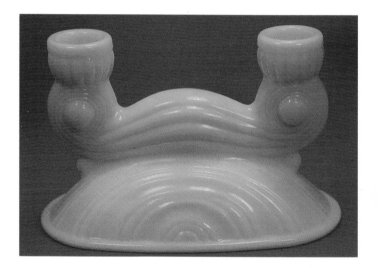

24. Unknown 4" double light candle holder. White milk glass, crystal.

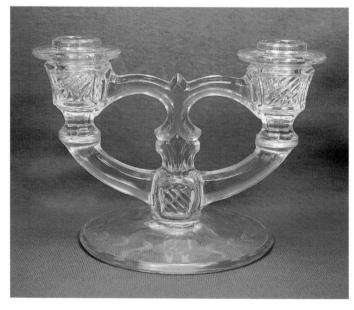

25. Unknown 5.25" double light candle holder. Crystal with etching.

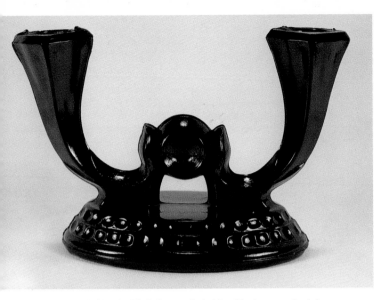

26. Unknown 5.25" double light candle holder. Black, crystal, pink, white milk glass.

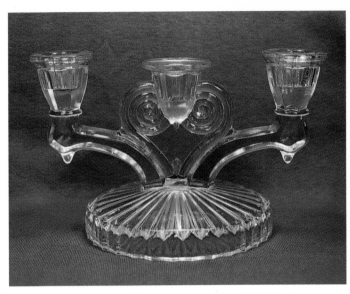

29. Unknown 4.75" double light candle holder. Crystal with rayed base. Base may be nonrayed with berry etching.

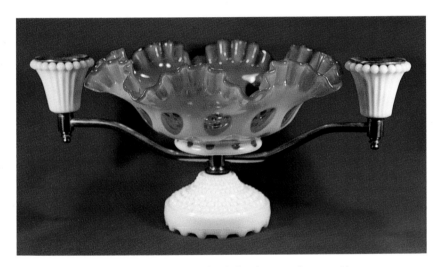

27. Unknown 6.75" double light wedding bowl. Cranberry opalescent with brass/milk glass base and lights.

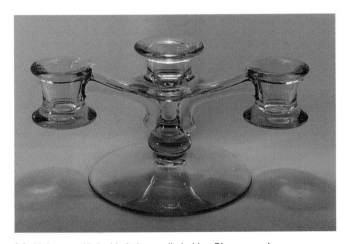

28. Unknown 4" double light candle holder. Blue, crystal.

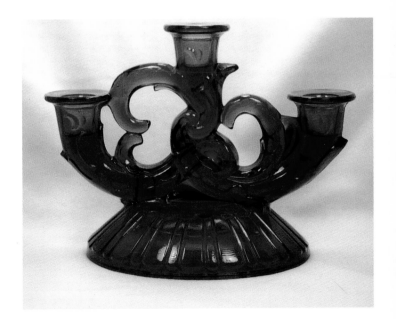

30. Unknown 6.625" triple light candle holder. Cobalt.

Bibliography

Archer, Margaret and Douglas. *Glass Candlesticks*. Paducah, Kentucky: Collectors Books, 1975.

_____. *Imperial Glass*. Paducah, Kentucky: Collectors Books, 1978.

_____. *Glass Candlesticks Book 2*. Paducah, Kentucky: Collectors Books, 1979.

Baker, Gary E., Eason G. Eige, Holly Hoover McCluskey, James S. Measell, Jane Shadel Spillman, and Kenneth M. Wilson. *Wheeling Glass 1829-1939 Collection of the Oglebay Institute Glass Museum*. Wheeling, West Virginia: Oglebay Institute, 1994.

Bickenheuser, Fred. *Tiffin Glassmasters (1929-1941)*. Grove City, Ohio: Glassmasters Publications, 1979.

_____. *Tiffin Glassmasters Book II (1920-1950)*. Grove City, Ohio: Glassmasters Publications, 1981.

_____. *Tiffin Glassmasters Book III (1915-1980)*. Grove City, Ohio: Glassmasters Publications, 1985.

Bredehoft, Neila. *The Collector's Encyclopedia of Heisey Glass 1925-1938*. Paducah, Kentucky: Collectors Books, 1986.

Bredehoft, Tom and Neila. *Fifty Years of Collectible Glass 1920-1970 Volume I*. Dubuque, Iowa: Antique Trader Books, 1997.

Breeze, George and Linda. *Mysteries of the Moon & Stars*. Mt. Vernon, Illinois: George and Linda Breeze, (no date).

Brookville Publishing. *Etchings By Cambridge Volume 1*. Brookville, Ohio: Brookville Publishing, 1997.

Burkholder, John R., and D. Thomas O'Connor. *Kemple Glass 1945-1970*. Marietta, Ohio: The Glass Press, Inc., 1997.

Burns, Carl O. *Imperial Carnival Glass*. Paducah, Kentucky: Collectors Books, 1996.

Daze. Volume 26, Number 6, August 1, 1997.

Felt, Tom, and Bob O'Grady. *Heisey Candlesticks, Candelabra, and Lamps*. Newark, Ohio: Heisey Collectors of America Inc., 1984.

Florence, Gene. *Elegant Glassware of the Depression Era, Seventh Edition*. Paducah, Kentucky: Collectors Books, 1997.

_____. *Anchor Hocking's Fire-King & More*. Paducah, Kentucky: Collectors Books, 1998.

_____. *Florence's Glassware Pattern Identification Guide*. Paducah, Kentucky: Collectors Books, 1998.

_____. *Collectible Glassware From the 40s, 50s, 60s... Fourth Edition*. Paducah, Kentucky: Collectors Books, 1998.

_____. *Collector's Encyclopedia of Depression Glass, Thirteenth Edition*. Paducah, Kentucky: Collectors Books, 1998.

Garrison, Myrna and Bob. *Imperial's Vintage Milk Glass*. Arlington Texas: Collector's Loot, 1992.

Glickman, Jay L. *Yellow-Green Vaseline!*. Marietta, Ohio: Antique Publications, 1991.

Heacock, William. *Fenton Glass The First Twenty-Five Years*. Marietta, Ohio: O-Val Advertising Corp., 1978.

_____. *Fenton Glass The Second Twenty-Five Years*. Marietta, Ohio: O-Val Advertising Corp., 1980.

_____. *Fenton Glass The Third Twenty-Five Years*. Marietta, Ohio: O-Val Advertising Corp., 1989.

_____. *Collecting Glass Volume 3*. Marietta, Ohio: Antique Publications, 1986.

Heacock, William, James Measell, and Barry Wiggins. *Harry Northwood The Wheeling Years 1901-1925*. Marietta, Ohio: Antique Publications, 1991.

_____. *Dugan/Diamond The Story of Indiana, Pennsylvania, Glass*. Marietta, Ohio: Antique Publications, 1993.

Hemminger, Ruth, Ed Goshe, and Leslie Piña. *Tiffin Modern Mid-Century Art Glass*. Atglen, Pennsylvania: Schiffer Publishing Ltd., 1997.

House of Americana Glassware Catalog No. 66A. Reprinted and Copyrighted by National Imperial Glass Collectors Society, P.O. Box 534, Bellaire, Ohio, 1991.

Jenks, Bill, Jerry Luna, and Darryl Reilly. *Identifying Pattern Glass Reproductions*. Radnor, Pennsylvania: Wallace-Homestead Book Company, 1993.

Kerr, Ann. *Fostoria*. Paducah, Kentucky: Collectors Books, 1994.

_____. *Fostoria Volume II*. Paducah, Kentucky: Collectors Books, 1997.

Kilgo, Garry and Dale, and Jerry and Gail Wilkins. *A Collector's Guide to Anchor Hocking's Fire-King Glassware, Volume II*. Addison, Alabama: K & W Collectibles Publisher, 1991.

Kovar, Lorraine. *Westmoreland Glass 1950-1984*. Marietta, Ohio: Antique Publications, 1991.

_____. *Westmoreland Glass 1950-1984 Volume II*. Marietta, Ohio: Antique Publications, 1991.

_____. *Westmoreland Glass Volume 3 1888-1940*. Marietta, Ohio: The Glass Press, Inc., 1997.

Krause, Gail. *The Encyclopedia of Duncan Glass*. Tallahassee, Florida: Father & Son Associates, 1976.

Measell, James. *New Martinsville Glass, 1900-1944*. Marietta, Ohio: Antique Publications, 1994.

Measell, James, ed. *Imperial Glass Encyclopedia Volume I*. Marietta, Ohio: The Glass Press, Inc., 1995.

_____. *Fenton Glass The 1980s Decade*. Marietta, Ohio: The Glass Press, Inc., 1996.

_____. *Imperial Glass Encyclopedia Volume II*. Marietta, Ohio: The Glass Press, Inc., 1997.

Measell, James, and W.C. "Red" Roetteis. *The L. G. Wright Glass Company*. Marietta, Ohio: The Glass Press, Inc., 1997.

National Cambridge Collectors, Inc. *The Cambridge Glass Company 1930 thru 1934*. Paducah, Kentucky: Collectors Books, 1976.

_____. *The Cambridge Glass Company 1949 thru 1953*. Paducah, Kentucky: Collectors Books, 1978.

_____. *Colors in Cambridge Glass*. Paducah, Kentucky: Collectors Books, 1984.

_____. *Reprint of 1940 Cambridge Glass Company Catalog*. Cambridge, Ohio: National Cambridge Collectors, Inc., 1995.

Newbound, Betty and Bill. *Collector's Encyclopedia of Milk Glass*. Paducah, Kentucky: Collectors Books, 1995.

Nye, Mark, ed. *Caprice*. Cambridge, Ohio: National Cambridge Collectors, Inc., 1994.

Over, Naomi, L. *Ruby Glass of the 20th Century*. Marietta, Ohio: Antique Publications, 1990.

Pattern Glass Preview, Issue Number Four. 1185-A Fountain Lane, Columbus, Ohio 43213.

Piña, Leslie. *Fostoria Serving the American Table 1887-1986*. Atglen, Pennsylvania: Schiffer Publishing Ltd., 1995.

_____. *Popular '50s and '60s Glass*. Atglen, Pennsylvania: Schiffer Publishing Ltd., 1995.

_____. *Fostoria Designer George Sakier*. Atglen, Pennsylvania: Schiffer Publishing Ltd., 1996.

_____. *Circa Fifties Glass from Europe & America*. Atglen, Pennsylvania: Schiffer Publishing Ltd., 1997.

Piña, Leslie, and Jerry Gallagher. *Tiffin Glass 1914-1940*. Atglen, Pennsylvania: Schiffer Publishing Ltd., 1996.

Schroy, Ellen T. *Warman's Depression Glass*. Iola, Wisconsin: Krause Publications, 1997.

Stout, Sandra McPhee. *The Complete Book of McKee Glass*. North Kansas City, Missouri: Trojan Press, Inc., 1972.

_____. *Depression Glass III*. Des Moines, Iowa: Wallace-Homestead Book Company, 1976.

Toohey, Marlena. *A Collector's Guide to Black Glass*. Marietta, Ohio: Antique Publications, 1988.

Washburn, Kent G. *Price Survey, Forth Edition*. San Antonio, Texas: Kent Washburn Antiques, 1994.

Weatherman, Hazel Marie. *Fostoria Its First Fifty Years*. Ozark, Missouri: Hazel Weatherman, 1972.

_____. *Colored Glass of the Depression Era 2*. Ozark, Missouri: Weatherman Glassbooks, 1974.

Wetzel-Tomalka, Mary M. *Candlewick The Jewel of Imperial Book II*. Notre Dame, Indiana: Mary M. Wetzel-Tomalka, 1995.

Whitmyer, Margaret and Kenn. *Collector's Encyclopedia of Children's Dishes*. Paducah, Kentucky: Collectors Books, 1993.

_____. *Fenton Art Glass 1907-1939*. Paducah, Kentucky: Collectors Books, 1996.

Wilson, Chas West. *Westmoreland Glass*. Paducah, Kentucky: Collectors Books, 1996.

Wilson, Jack D. *Phoenix and Consolidated Art Glass 1926-1980*. Marietta, Ohio: Antique Publications, 1989.